PEOPLE PICTURES

30 EXERCISES FOR CREATING AUTHENTIC PHOTOGRAPHS

CHRIS ORWIG

PEACHPIT PRESS

PEOPLE PICTURES:
30 EXERCISES FOR CREATING AUTHENTIC PHOTOGRAPHS
Chris Orwig

Peachpit Press
1249 Eighth Street
Berkeley, CA 94710
510/524-2178
510/524-2221 (fax)

Find us on the Web at www.peachpit.com
To report errors, please send a note to errata@peachpit.com
Peachpit Press is a division of Pearson Education

Editor: Susan Rimerman
Copy Editor: Peggy Nauts
Production Editor: Lisa Brazieal
Interior Design and Composition: Kim Scott, Bumpy Design
Indexer: Karin Arrigoni
Cover Design: Mimi Heft
Cover Image: Chris Orwig

NOTICE OF RIGHTS

NOTICE OF LIABILITY

TRADEMARKS

ISBN-13: 978-0-321-77497-2
ISBN-10: 0-321-77497-3

9 8 7 6 5 4 3 2 1
Printed and bound in the United States of America

For my high school sweetheart, soul mate, and best friend—Kelly.

And for our three girls—Annika, Sophia, and the one to be born later this year!

Acknowledgements

Thank you to the editorial and production team for all of their tireless efforts and encouragement: Lisa Brazieal, Peggy Nauts, Kim Scott, Mimi Heft, and Sara Todd, you have made this project a breeze. Susan Rimerman—your editorial insight and direction have been divine.

Nancy Ruenzel, the publisher who has graciously taken a risk on me once again, thank you.

My colleagues at the Brooks Institute, where I teach—thank you for your camaraderie and support.

My sponsors—Lowepro, Epson, Wacom, X-Rite, Really Right Stuff, onOne Software, and Nik Software—I am proud to be a part of your team and I rely on your top-notch gear every day.

Ralph Clevenger, for never doubting that I would one day create a few good frames.

Keith Carter—it is rare to encounter someone so kind and deep. Your influence and friendship have been profound.

Michael Ninness, over this last year you have become a stalwart beacon, springboard, and good friend. I'm grateful for your wisdom, candor, and inspiration.

Bruce Heavin—your friendship, encouragement, and ideas continually spur me on. Thank you for believing in who I am and for seeing me through to who I am yet to become.

Dad—for showing me the way and for planting a seed of passion for photography in my soul.

Mom—for teaching me about creativity and how to care for others with joy in my heart.

God—the giver of light.

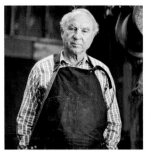

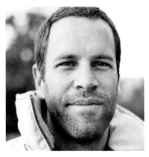

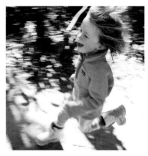

Contents

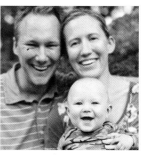

SECTION V **MAKING IT YOUR OWN**

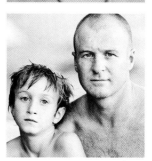

Foreword

Chris Orwig photographed me in Las Vegas a few years ago, and it was a humbling experience as a photographer, particularly for one making his living on assignment for the international NGO and humanitarian community. Chris is a gentle person in the truest sense of the word. He is kind, and if this makes any sense at all, he listens with his eyes. When Chris photographs he slows down. Given his already calm, Zen-like personality, this is an accomplishment. He didn't ask me to grin, to mug at the camera (I did anyway). He just slowed down, looked through the camera, and photographed me. If I hadn't seen the photographs afterwards, I'd have sworn that he never pressed the shutter. He used a couple different cameras, changing them without much thought, keeping his entire attention focused on his subject. I got the sense, being photographed by Chris, that the portrait—not just my portrait, but portraiture as a discipline—mattered a great deal.

The photography of people matters, because it allows us to look at a moment in the life of another person and see the differences and the similarities we share. Acting as both a window and a mirror, the portrait has the power of revelation, showing us something about both the photographer and the subject. This matters because the act of creating it is a relational act and a chance to connect with another person.

The portrait matters because life is fleeting, and we will not be here forever. When I was a teenager I spent hours looking at the work of Yousuf Karsh, poring over portraits of the artists and elite of his time, many of whom are now gone. But lose a loved one, as I have in the last 24 hours, and the value of a photograph becomes all the more evident. We are passing through time, all of us, unstoppably. We will change our times and be changed by them. The person I am now is not the person I will become, and when I get to the end of the time allotted to me, it will feel to me, and my loved ones, I hope, to have been far too short. The portrait cannot undo this, nor slow it down. But it creates milestones for us, way markers that say, "This is who I am, and who I have been."

All we have in life, really, are people and moments. The portrait captures both simultaneously, and tells a story about the characters in our lives. It shows a person in a place and a time in which they will never be again; it stops the clock and says, "Look at this person; she matters. This moment matters." And whether that portrait is serious or the brief result of a cheesecake grin, we're a little closer to seeing the soul.

Portraiture, formal or otherwise, is not a technical pursuit. It's a relational and aesthetic pursuit achieved through technical means. What Chris teaches is what all great portraitists have always known; that it is assumed you will be growing in excellence in your craft, but that the art is accomplished in the moment you connect with a subject and make a photograph that is honest and revealing, not merely representative of the shape of their face and the line of their smile.

Steve McCurry calls it the moment the soul comes into view. That moment doesn't happen when the photographer himself is guarded and impenetrable; we open ourselves to those who are open to us. And so the great challenge of making photographs of people is not which aperture to choose or which lens to use; those are small matters easily learned. The great challenge is a relational one; to create a connection in which the subject feels comfortable enough to drop their guard.

Transparency doesn't come easily to us. We spend a great deal of effort building walls to feel safe. We learn to mug for the camera at an early age, knowing, as the most remote tribes seem to know, that the camera is capable of seeing your soul if not stealing it. It's a gift to be able to sit in front of another human being and photograph them. Even more so when you convince them to drop their guard and be ready for that moment, that rare, beautiful moment when the soul comes into view.

Finding, or waiting for these moments, and making something of beauty and revelation, doesn't happen accidentally. It comes as we study our subject and our craft with discipline and practice. We're lucky if we have a teacher, as we do here with Chris, who is both so capable in his craft, and so open to these beautiful instances when the moment and the soul collide.

—David duChemin
 Ottawa, Canada, 2011

Introduction

Photography is a combination of light and life—what is present in front of and behind the lens. It is the art of looking at the surface and within. And the pictures we make are filled with an autobiographical undertone. Since this book and its pictures are a reflection of me, what's my story? Well, I am a teacher and photographer who loves what I do. But why?

The beauty of making people pictures is that it enriches life and provides a gift that has a broader reach.

Because the camera is a curious and inquisitive tool that allows us to see more clearly, to get beneath the surface of things and to gain depth and insight that otherwise would have been lost. When photographing people, this is amplified to a whole new degree. Whether creating pictures of the young, the old, or life as it unfolds, the camera guides, deepens, and directs. And the pictures that we have made just get better with the passage of time. Revisit your old photographs and many emotions will surface—grief, joy, nostalgia, or regret. Pictures of people carry a greater weight. There's a reason we carry people pictures in our wallets and on our smartphones. There's a reason that people pictures take up more space than any other subject on the pages of all the magazines on the rack.

The beauty of making people pictures is that it enriches life and provides a gift that has a broader reach. Viewing a photograph of a person can endear, excite, infuriate, or even change history's tide. And this book is about the adventure in practicing and learning how to create compelling and authentic photographs of this kind, whether photographing friends, family, kids, colleagues, coworkers, or those you admire and respect.

For some, the word *portrait* carries the baggage of preconceived notions with it. Leave that behind. We are going to use the term in its more meaningful form. Rather than niceness or flattery, our pursuit is pictures that contain depth, honesty, connection, expression, and life. We will delve into how to create portraits that are timeless and true. Rather than being limited by a traditional scope, we will explore a range of portraits including lifestyle, candid, or composed.

Such an endeavor requires more than posing techniques and pushing the shutter release. It opens up the possibility to discover insights into the process and the journey of becoming more creative and alive. The goal isn't a stack of pretty pictures but growth as an artist and a new perspective on life. Accomplishing this will require the courage to try out different ideas, which will include making bold mistakes and bad art.

When I was a child, my artist mom told me that there was no such thing as bad art. I know now that this was a complete lie. Yet it was a lie I needed to hear. It informed me that the goal of art was the creative process of discovery, experimentation, and fun. To this day, I cling to this lie as truth—especially when

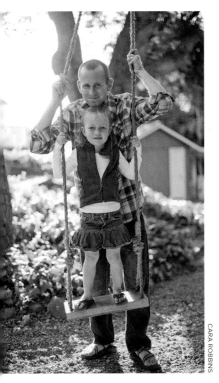

CARA ROBBINS

my pictures don't turn out right. As photographers, many of us are afraid of art. "Who me, an artist? No, I just take pictures and many of them aren't even very good." The same can be said of creativity. "Who me, creative? No, I just tinker and try things out." I like how Paul Arden counters these excuses and welcomes us all in: "Creativity is imagination and imagination is for everyone."

This book is a chance to embrace those ideals and to grow as an artist. Who cares if your pictures aren't perfect? Being an artist is about more than that. The world doesn't need another Ansel Adams, Annie Leibovitz, or Richard Avedon. The world needs you. Art isn't only about the end result but about how you got there. Art is about who you are and who you are to become. It involves being curious, inventive, passionate, brave, and bold. Creating art is about giving and getting more from life. The process changes the way we experience everyday life and expands who we are, how we see, and how we use our time. Art is a catalytic force that ignites, creates, and propels. The end result is nothing short of renewal and rebirth. Are you ready to make the leap?

What you are about to encounter are 30 photographic experiments. There is no quicker way to learn than to try something firsthand. Do these exercises by yourself or collaborate with a group or good friend. All that's required is a camera and natural light.

The author and his family at their home in Santa Barbara, California.

Nikon D3x, 50mm lens, f/1.2

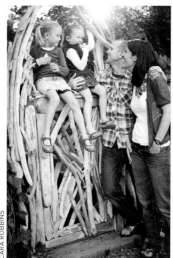

CARA ROBBINS

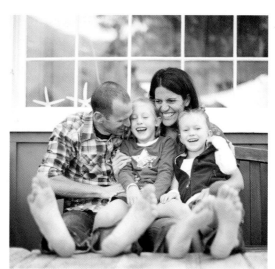

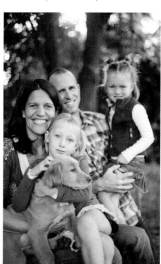

Each exercise begins with a creative concept or thought and leads to detailed steps that you can follow. At the end of the exercise, you will encounter a suggestion for further inspiration to pursue on your own. All of the pictures in this book, except two that my young daughters made and the family pictures here, were created by me. And each picture was made with natural and available light. In the exercises, I've included a variety of pictures that I hope will serve not as examples to follow but as creative lily pads you can use to jump to your own unique vantage point. The exercises are divided up into five sections:

Section I—The Foundation begins with discussing the thoughts, ideas, and concepts that develop the groundwork and set the stage for your photography practice.

Section II—Tell a Story focuses on how we can create pictures that have substance and are filled with a narrative arc.

Section III—Connect explores the importance of making a personal connection with the subject of your frame.

Section IV—Practice Makes Perfect is where you will put your shoulder to the grindstone to hone your skills and try out a variety of formats and techniques.

Section V—Making It Your Own provides you with an opportunity to develop your photographic voice by working on more challenging and rewarding projects.

Make sure to share your ideas and some of your results with other readers at flickr.com/groups/30peoplepictures.

Most importantly, I hope that the exercises will provide you with a vehicle for new ideas and growth that ultimately will further your passion and enjoyment of the art and craft of photography.

—Chris Orwig

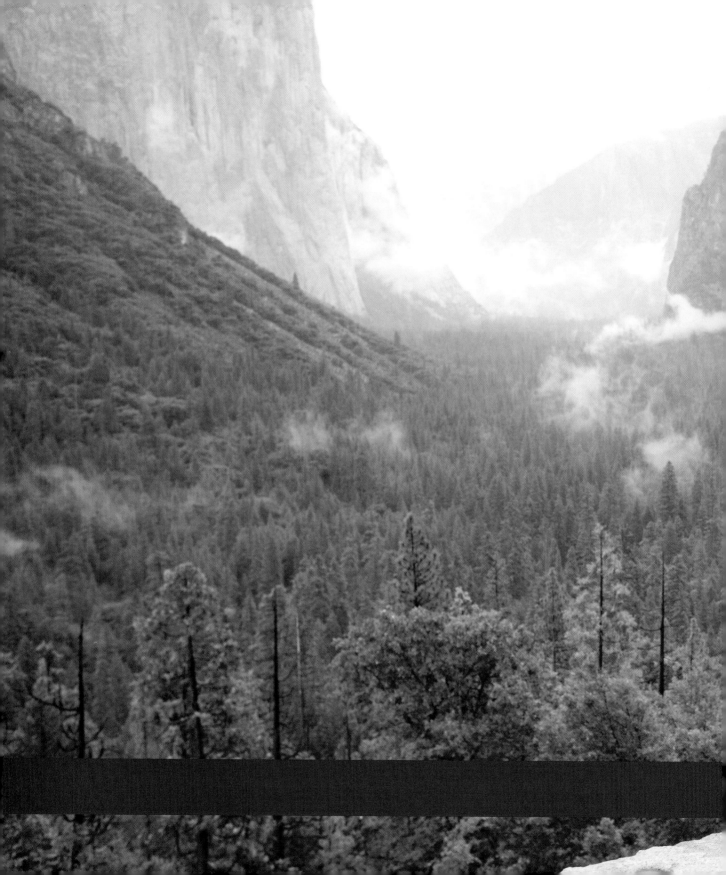

SECTION I **THE FOUNDATION**

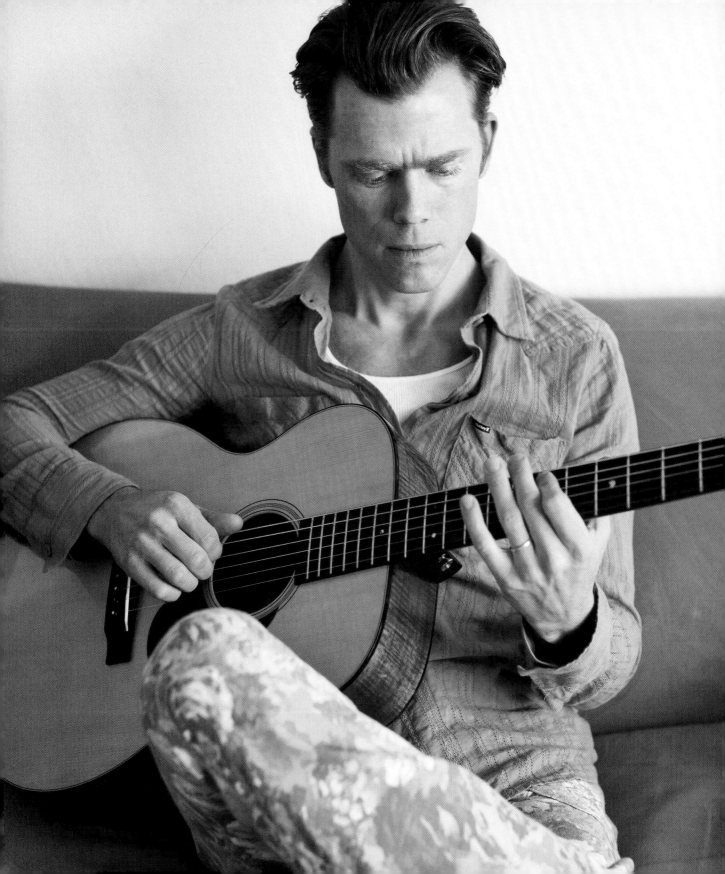

THREE CHORDS AND THE TRUTH

1

EACH SUMMER, my family loads up the car with camping gear and we drive north to the majestic Yosemite Valley. This trip has become a much-anticipated tradition, as it never ceases to revive and revitalize us. Regardless of how many visits we have made, each one builds off the last for an awe-inspiring experience that helps us reconnect as a family and rediscover the wonder of the great outdoors. One summer we invited some new friends to join us on our trip. They had never experienced the joy of sleeping in a tent or the thrill of roasting marshmallows over a campfire.

Curious about camping, they asked, "Do we need a tent? Should we bring our guitar?" Quickly their nervous questions progressed to wilderness survival tactics. "Does the campground serve coffee?" "Will my iPad work?" When they arrived at the campground, it was a comical sight. Their car was filled to the brim with gear. They'd gone on a shopping spree and purchased an oversize tent, enough camping cookware for an army, and every possible camping gadget, essential and nonessential. They had enough gear to outfit an expedition to the South Pole.

The camping trip progressed smoothly and we all had a wonderful time. After a few days, the dad from the other family pulled me aside. He said, "Thank you for inviting us—we're having a great time. My only regret is complicating the trip with all of these extra supplies." These were wise words coming from someone whose camping experiences had only just begun. When it comes to gear, sometimes less is more. Yet it's easy to fall prey to all of the marketing and hype.

PREVIOUS PAGE On this rainy afternoon in Yosemite Valley, no one else was out shooting. Rather than give up, this photographer solved the problem with one simple step.

Canon 5DMii, 16–35mm lens, f/7.1

OPPOSITE Jared Mason is a musician, actor, and Broadway star. In this picture, he is illuminated by a window while playing a tune in his home in New York City.

Canon 5DMii, 50mm lens, f/1.2

Back to Basics with Camera Gear

In photography, the lure to buy more gear has an even stronger pull. It's easy to justify because we deeply rely on technology to amplify our visual voice. We imagine that if only we had a certain camera or lens, then our pictures would be great. This definitely isn't true.

I like the way the singer-songwriter Harlan Howard once described country music: "Three chords and the truth." And so it is with creating authentic photographs—the basics will do. All you really need is a camera and the courage to accept that powerful pictures are made from within. It's who we are that affects the photographs we make.

On assignment and before the official shoot, I captured this candid frame of legendary surf photographer Jeff Divine in his office with a slideshow of his pictures.

Canon 5DMii, 16–35mm lens, f/2.8

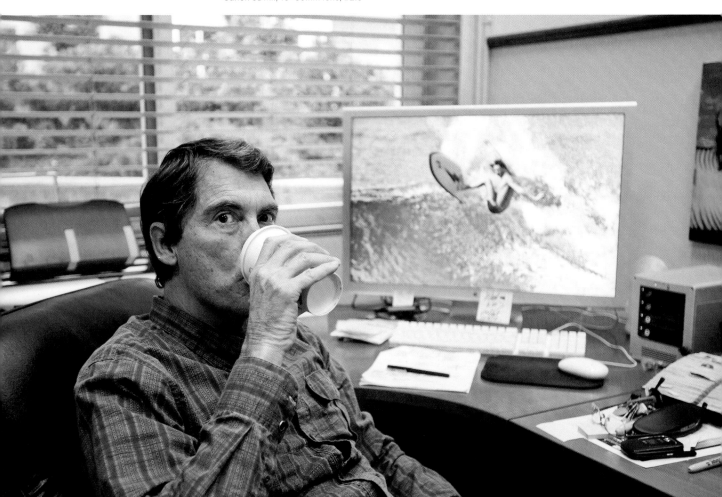

EXERCISE > Pictures in 10 Minutes

Whether you are a seasoned pro or new to the photographic scene, returning to the basics is a great way to revitalize your art. Without all the bells and whistles, habits, typical techniques, fanfare, and hype, picture making is distilled to a more free and pure form. That's what this exercise is about. Let's go back to the basics, use simple gear, and make great pictures in a short amount of time. The goal for this shoot is to create an authentic portrait with a minimum of time and means. Your challenge is to create ten pictures in 10 minutes.

STEP 1 TECHNICAL CONSIDERATIONS

Choose a normal or slightly telephoto lens—somewhere around 50 to 100mm will work best. Choose the f-stop with a shallow depth of field like f/2.8 (or as low as your lens will go). Turn off automatic focus so that you will have to manually focus the frame. Preset these options so that you don't have to fiddle with them during the shoot.

STEP 2 SELECTING THE SUBJECT

Select a subject who is an acquaintance, family member, or friend. Don't make the choice based on whether or not someone looks like a model. Choose someone who you enjoy and who you think leads a quality life. Contact the subject and ask if he or she would be willing to participate in a brief 15-minute portrait shoot.

STEP 3 CHOOSING A LOCATION

The location choice is entirely up to you. Consider photographing your subject where he works or lives. Or choose an outdoor location that is inviting like a park, lake, or beach. Most important, pick a natural spot that fits with what you want to do.

STEP 4 THE SHOOT

Arrive at the location early to pick out the perfect portrait spot. When the subject arrives, greet him with a warm handshake and smile. Express gratitude that he is giving you his time. Without skipping a beat, so as not to lose momentum, walk the subject over to the location where you want him to stand. Explain that your goal isn't to create a stylized picture but to capture something real.

LEARNING OBJECTIVES

- Explore how to create strong portraits with a minimum of gear.
- Rediscover the value of shooting at a slower pace while manually focusing the frame.
- Have fun photographing an acquaintance or friend—it will remind you that photography doesn't have to be overly complex.

> TIPS

When shooting be patient, as manual focus requires that you slow down.

Even though the photo shoot is brief, don't panic or rush. In between shots take a deep breath and recompose casually.

Let go of the need to create the perfect shot. Strive for honesty versus something that is flattering and fake.

On the surface, this exercise appears to be easy to accomplish. Don't let the simplicity fool you; this will be a challenging and rewarding task.

EXERCISE DETAILS

Goal: 10 portraits. **Tools:** Camera; normal or slightly telephoto lens. **Light:** Natural light. **Location:** Indoors or outdoors. **Theme:** Back to the basics. **Duration:** 15 minutes.

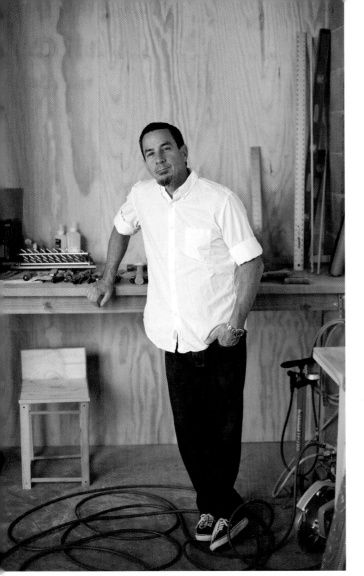

Use manual focus and compose the first shot. Take your time and snap a few more frames. Talk to the subject. Provide a few encouraging words and posture or pose suggestions to put him at ease. Keep the shoot simple, natural, and free. After 10 minutes, call it a wrap and thank the subject for his time.

STEP 5 POSTSHOOT REFLECTIONS

After the photo shoot, select the picture that you like best. Create a print of it and show it to a few friends. Explain that the goal was to create an authentic image in a short amount of time. Ask for feedback and consider their thoughts. ▓

LEFT Style savant, clothing designer, and surfboard shaper Shawn Stussy in his workshop.

Canon 5DMii, 50mm lens, f/2.0

OPPOSITE It's best to avoid shooting in the harsh midday sun, but this is one of those photos that proves some rules are meant to be broken. Here rock climber, big wave surfer, and all-around adventure man Jeff Johnson peers through his trusted camera during the middle of the day.

Canon 5DMii, 50mm lens, f/3.2

August Sander ❭ Further Inspiration

August Sander lived from 1876 to 1964. His lifelong project was "People of the Twentieth Century" and involved photographing people of his native Westerwald, Germany. He photographed subjects from all walks of life in the pursuit of understanding who they are. Sander's pictures have an honesty that reveals people whose lives have come and gone in a tenuous historical time in his part of the world. View his work online and consider how he didn't leave home or travel the world to develop such a strong body of work. Take notes on the pictures that strike a chord. In response, write down your emotions and ideas.

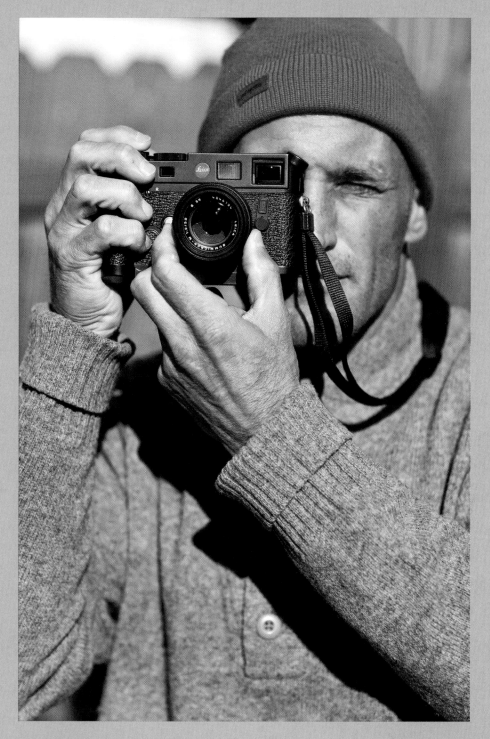

"I hate nothing more than a sugary photograph with
tricks, poses, and effects. So allow me to be honest and
tell the truth about our age and its people."
—August Sander

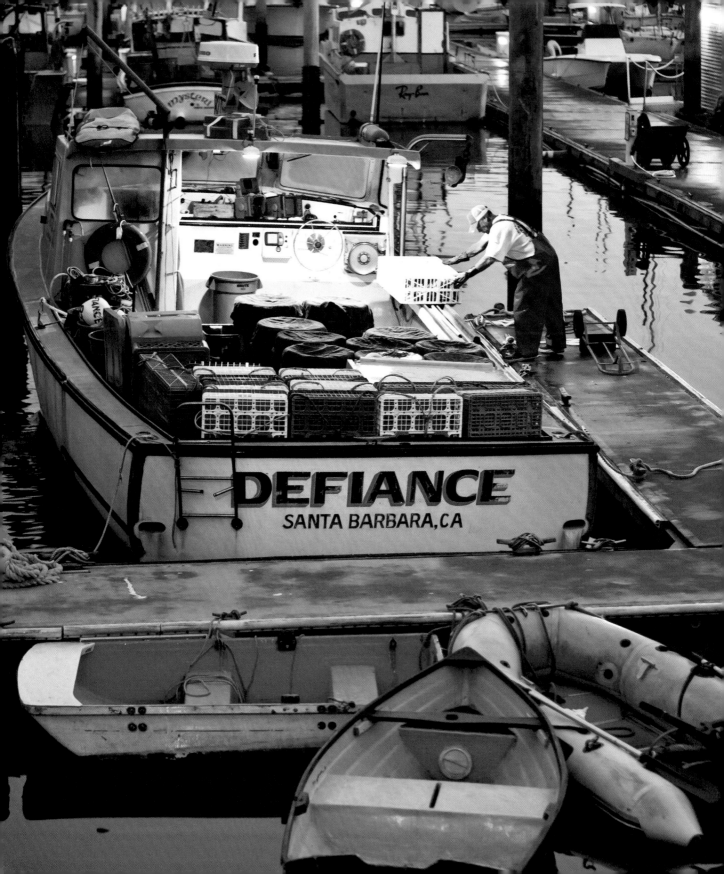

MEDIOCRE OR MAGNIFICENT

2

THE TYPE OF PHOTOGRAPHS you make is completely up to you. Most people start off in photography excited but uncertain because of their lack of technical skill. And rather than taking the time to learn the basics, many give up too soon. Content to shoot a high volume of frames, they use a process that is like rolling the dice. Luck favors quantity, and so this does yield an occasionally interesting shot. But this haphazard approach of shooting too many frames will never satisfy your soul. The inconsistent results eventually weaken even the most enthusiastic new photographer's resolve. Eventually, these photographers dry up and feel blah. What started out as pure excitement has become a shrug.

One reason so many photographers end up drifting down this desert path is that they neglect to define their craft, vision, or purpose. The crossroads are clearly marked—are you interested in pushing a button or is your passion something more profound? In other words, how mediocre or magnificent do you want your pictures to be? We've heard it a million times—being a photographer is much more than carrying a camera in a bag.

Being a commercial fisherman requires audacity, guts, and strength. And Defiance is the perfect name for this fishing boat. If photography were a voyage, what name would your vessel wear?

Canon 5DMii, 70–200mm lens, f/2.8

Tap Your Inner Strength

The problem with most of us is that we are too soft. We follow popular opinion and listen to the voices that predetermine what is good or bad. We defer to the experts and neglect to nurture our own talents. We abandon our nascent curiosities, which impedes the growth of many of our best ideas. We forget that being a good photographer doesn't flow from following another's path.

Good photography comes from inner strength and resolve. It comes from your gut. It requires a private tenacity that consistently chants, I will not give up. And it comes from an unquenchable desire, no matter how unlikely, to create something magnificent and maybe even profound.

Scott Soens is a photographer and artist whose work is cohesive and strong. He's driven and accomplished in an understated and authentic way.

Canon 5DMii, 50mm lens, f/2

EXERCISE 〉 Clarifying Your Craft

Making pictures of people is the most common photographic act. Humans like pictures of themselves. And that's the first problem. Whether capturing our daughter's first steps or someone's cliff diving next to a waterfall, we are easily swept away by the people within our frame.

This excitement leads to lowering our critical skills and taking pictures even if we have no idea if they will turn out right. If we can only develop a critical eye, our enthusiasm will not go to waste. In this exercise, that's exactly what we are going to do.

STEP 1 DEFINING THE TASK

You need to dedicate time to defining and clarifying your craft, like cleaning the fog off of a lens to restore the view. Start by writing down a list of the top 20 pictures of people you like most.

STEP 2 CREATING AN AGENDA

Greatness of any form requires an intimate and critical familiarity with one's craft. Observing is not a passive act, so watch with these three elements in mind: celebration, collection, and critique. Most mediocre photographers don't get past the first one, while the magnificent constantly do all three.

In your journal, write down these three words: celebration, collection, and critique. Leave space in between to add more notes as you progress.

STEP 3 CELEBRATE AND VIEW

The celebration is easy; something that we naturally enjoy. Take one hour to celebrate photography in a way that you don't typically do.

Try one of these ideas: Visit a museum exhibit and look at a range of the art, go to the library and look at various photo books, take a drive and study the pictures plastered on billboard signs. Whatever activity you choose, slow down and pause with each picture you see.

STEP 4 COLLECT AND SAVE

Waking up your senses requires collecting and saving the pictures that inspire us most. Set aside 45 minutes to go through four of your favorite magazines. Find the pictures that inspire you most, tear out the pages, and tape them to the journal pages.

LEARNING OBJECTIVES

- Strengthen your resolve to make magnificent photographs.
- Establish habits that you can integrate into your life that will help your vision stay clear.
- Develop a working definition of what makes a photograph good.

〉 TIPS

Take time to reflect on photography rather than making pictures all the time. This will enable you to eventually capture photographs that have more depth.

When photographing people, camera work is the lesser half of the art. Good photographs are a result of coordinated efforts of the heart, soul, and mind.

Making great photographs requires that you make up your mind. Tenacity and determination are par for the course.

Who you are affects the pictures that you are able to make.

EXERCISE DETAILS

Goal: Clarify the type of pictures you want to make. **Tools:** Notebook or journal.
Theme: Inner strength and resolve. **Duration:** 2 hours.

OPPOSITE While this photograph is contemporary (it was captured just a few weeks ago), the imperfections of the expired film suggest the passage of time. The subject has a forward-looking and modern gaze. It is a picture that is both simple and complex.

Wood large format 4 x 5, 90mm lens, f/5.6, Polaroid Type 55 Film

Next, do a search on how to take a screen shot and save pictures of the photographs that inspire you most in a folder on your desktop. Allocate a fixed amount of time, 45 minutes, for visiting your favorite photography sites. The practice of savoring inspiration is a habit worth integrating into your regular life. Anytime you come across a picture you like, collect and save it.

STEP 5 CRITIQUE AND DEFINE

Critiquing photographs takes more intention and thought. It requires evaluating and responding to the pictures on each page. This begins by writing your own definition of what makes a people picture good. Consider the ideas below as inspiration for your own photos. After reading the quotes, take 15 minutes to craft an idea of your own.

> "Good art is not what it looks like, but what it does to us."
> —*Henry David Thoreau*

> "A great portrait can have beautiful lighting, a curious location and a pleasing composition, but it's a sense of vulnerability that really makes a picture exciting for me." —*Chris Buck*

> "The difference between an average photograph and a really fine photograph is the willingness to admit doubt." —*Evan Chong*

> "A good portrait is like a good song. You can listen to it again and again."
> —*Platon*

> "A good photograph is one that communicates a fact, touches the heart, and leaves the viewer a changed person for having seen it."
> —*Irving Penn*

Books 〉 Further Inspiration

If you are interested in enriching your photographic journey, consider reading one of the following books. These will give you access to deeper ways of thinking about, understanding, and viewing pictures. They won't tell you how to press the button or what camera model is best. Rather, this selection of titles focuses on the more thoughtful side of our craft.

On Photography, by Susan Sontag
The Nature of Photographs, by Stephen Shore
Why People Photograph, by Robert Adams
The Mind's Eye, by Henri Cartier-Bresson
On Being a Photographer, by David Hurn and Bill Jay.

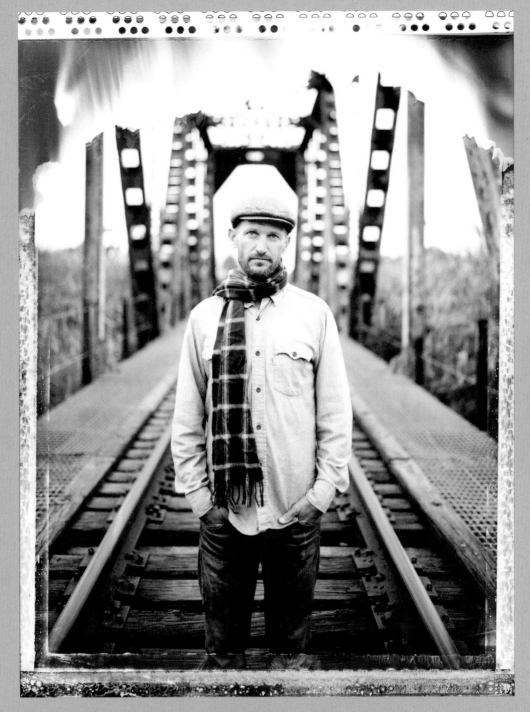

"Like the collector, the photographer is animated by a passion that, even when it appears to be for the present, is linked to a sense of the past."

—Susan Sontag

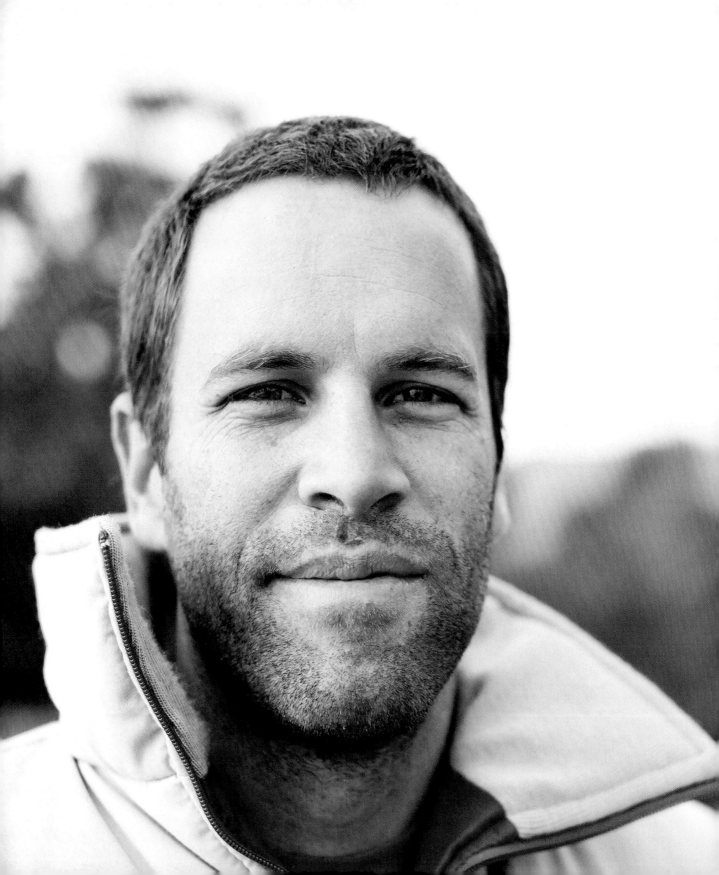

STYLE AND SUBSTANCE

STYLE IS LIKE the inaudible hush you experience when everything seems right. Like when you walk into someone's well-designed home. At least that's what I felt when I crossed the threshold of a musician's beach bungalow for a photo shoot. It was impossible to say what stood out the most, because nothing stood out at all—everything fit together and belonged. The warm welcome, humble furnishings, stack of colorful surfboards, barefoot kids running on the bamboo floors, the living room full of vintage instruments, and the eclectic art. Everything came together in such a California beach-cool and natural way.

Style is something that is difficult to pin down, yet seeing is often how we notice it first. That's why it's easy to misinterpret style as surface, but that just isn't quite right. Style is something more permanent and profound. I prefer to think of style as an inner core. In photography, strong style is the substance that immediately defines and unifies one person's work. The best style is something that is distinct and sets us apart.

Jack Johnson is often described by what he does: musician, surfer, filmmaker, artist, and environmentalist. The way he lives his life and approaches his craft goes far beyond such ordinary terms. It's not what he does but how he does it. Jack has a style that is distinct and completely his own. Here he is pictured just steps from the beach near his home.

Canon 5DMii, 50mm lens, f/2.5

My daughter Annika sitting on a Costa Rican beach. This picture contains a few elements of style that I value most: authentic, natural, warm, hopeful, beautiful, beach, travel, and love.

Canon 5DMii, 50mm lens, f/2

Stitching and Thread

My photography students constantly wrestle with how to develop a visual voice or style of their own. In an effort to help, I once asked a classroom full of students if they were ready to begin creating a cohesive visual direction for their work. Without hesitation, they all replied, "Yes." I replied, "OK, here's the first step: Describe your photographic style." This was a setup, because I knew they wouldn't come up with much. For beginning students, style is too elusive and difficult to verbally describe. As predicted, no one knew what to say; it was too nebulous of a task. Everyone slunk down in his or her chair.

Next I said, "OK, that didn't work, let's try something else. This time describe the type of photographic style you aspire to by comparing it to food." Their answers came quickly and they were colorful and true. Let me share a few that stood out. Dawn, a student from Texas, enthusiastically explained, "I want my photographic style to be like a soufflé. At a distance it seems simple but really it's layered and complex...and it's filled with a surprise!" Oddur, a student from Iceland, replied, "Every New Year's Day my extended family would gather and we would eat one special spoonful of caviar. I want my photographic style to be like caviar—it's not something everyone likes, but those who like it are committed beyond means."

What wonderful and poignant descriptions about photographic style! As we went around the classroom and each student shared, we were all on the edge of our seats. Suddenly, we were given a clue about the personal thread that held together each student's work, like the stitching that held together the folded sails of their ship. When they lifted the sails up, we could see the threads that had always been there. By raising the sails, it enabled them to be filled with a fresh breeze.

EXERCISE › Defining Your Style

Style is something that doesn't happen all at once but one picture at a time. Trying to make style happen quickly is contrary to its path. After years of shooting we can look back and of course it all makes sense. Looking forward seems like an impossible task. In order to create powerful people pictures, you need to articulate the inner core or substance of the photographs that you want to make. That way, regardless of the subject, your work can have a cohesive thread.

Here are a few steps to help you make this process more concrete by developing comparative terms. For most of us, our style isn't exactly where we'd like it to be. Therefore, approach this exercise by describing the style you would like to have.

STEP 1 25 OBJECTS

Take 15 minutes to brainstorm about physical objects—write without restraint the things you like most. Here are a few ideas to help you start: flip-flops, mountain bike, cooking knife, hand-knitted blanket, driftwood, bright yellow tent. After you have compiled a list of 25 items or more, circle the top five.

Next write down the top five on a separate sheet of paper and add descriptions of why you like each item. Write the descriptions in a way that helps you uncover your own photographic sensibility. For example, I like driftwood because it has traveled a long way through rivers and oceans, and it has been softened and has settled on the shore. I like that it is natural, imperfect, and unique.

STEP 2 SEASONAL COLORS

Color has the power to evoke feeling and mood. Artists pay attention to color and use it to convey ideas. My mom is an artist and has a set of favorite colors for each time of the year. Following her footsteps, take 15 minutes to write down the colors you associate with the four seasons—winter, spring, summer, and fall.

Next find some colored pens or an old box of crayons. Create small color palettes for each season and write about the moods that each season evokes in you. Don't worry about being critical; just write what you feel. For example, spring is green, bright, and healthy. Alive and verdant—spring is yellow, fuzzy duckling yellow. Soft, full of hope, and sincere. After writing about all four seasons, choose the color palette and mood that best describe the style of pictures you would like to make.

> TIPS

Using comparative terms to describe your style may feel silly or trite. Yet don't pass on this exercise until you have given it a try. Using comparative language can be a powerful method for unlocking ideas that you carry inside.

When describing your photographic style by comparing it to something else, it might seem obvious at first. So try comparing notes with a friend who takes photos. By doing this you'll discover just how distinct all of your answers actually are.

EXERCISE DETAILS

Goal: Clarify your vision, voice, and style. **Tools:** Notebook or journal. **Theme:** Style.
Duration: 1 hour.

STEP 3 WEATHER

Weather creates atmosphere, emotions, and depth. Who we are and the photographs we make are directly and indirectly affected by the weather where we live. Take 15 minutes and write down the weather details for your ideal photo shoot. If you had your way, what type of weather would you request: the subdued quiet that comes from a thick and muted fog, the drama and excitement from a passing storm, or the optimism of the bright morning sun? Describe the weather that matches the photographs that you want to make.

STEP 4 MUSIC

I once asked photographer Rodney Smith what music he would choose to be a sound track to his life's work. Without a pause he responded, "Aaron Copland!" and then he continued in a more quiet tone, "if ever I could create a photograph with the same intensity of his songs."

How about your own photographic work; what music would you choose to accompany your pictures and why? If there isn't a particular musician or composer that you like, try choosing an instrument or more generalized style of music. Take 15 minutes and listen to your favorite type of music, then pick the option that fits best.

STEP 5 FOOD

Now it's your chance to answer the question that I asked my students. Take 15 minutes to describe the photographic style you would like to acquire. Make a comparison to food and provide a reason why. After you have answered this yourself, ask a few colleagues for their own response and compare notes. ▪▪

Mark Tucker › Further Inspiration

Mark Tucker's pictures have a style that is easy to recognize. It is personal and reflects who he is and how he lives. While his style remains authentic to his internal voice, it is also highly valued in the commercial world. Visit marktucker.com to view his work.

As you look at his pictures consider his own description of his work. He recently described his photographs as "organic portraits, real and ordinary people, human connection, texture, available light, keep it simple, history, f/2.8 or wider, no ringlight or high-pass filter allowed."

Then in summing up his style he said, "In short, I'm pretty old-timey."

"Style has no formula, but it has a secret key.
It is the extension of your personality."
—Ernst Haas

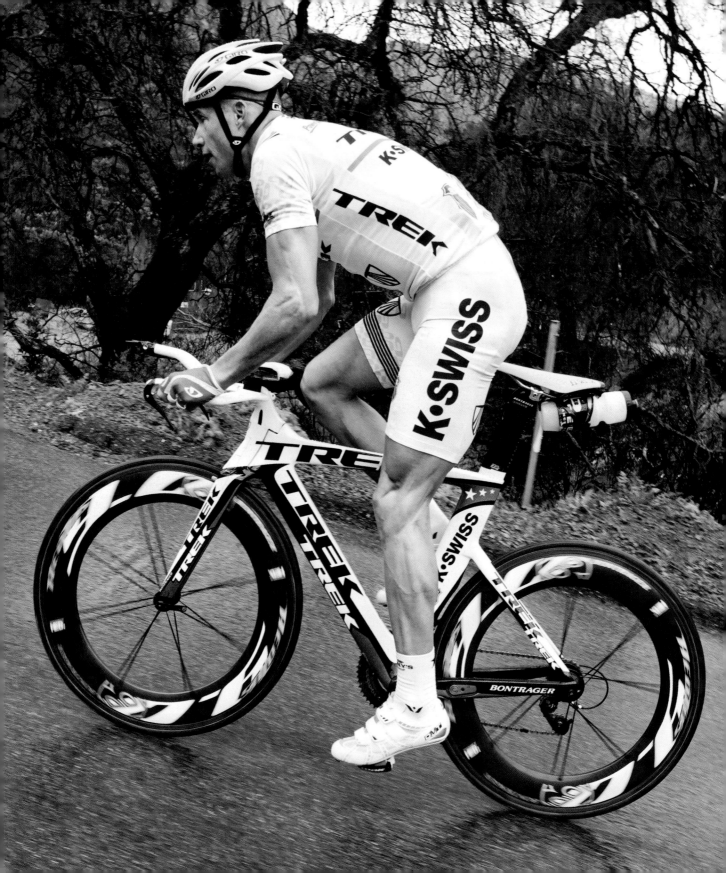

ENDURANCE

4

ENDURANCE ATHLETES fascinate me the most. I think this is because their efforts have so many parallels to life—they are in it for the long haul and their goal is to win. Chris Lieto is one of those athletes. A top ironman triathlete, he approaches his sport with vigor, intelligence, and fight. One week of Lieto's training regimen is like a superhuman feat. Each year he begins his preparations with a 300-mile ride along the California coast. When I asked him about this tradition he explained, "To be good at a long-distance sport, you have to put in time building a strong foundation."

Many aspiring triathletes have wondered about Lieto's secret to success. Why is it that he shines so bright? I once heard him quote Viktor Frankl, who said, "What is to give light must endure burning." And enduring is something that Chris does better than anyone I know.

Building a strong photographic foundation requires the same type of endurance, commitment, and resolve. To be good at photography, we have to train. One of the most effective ways to do this is to set your digital camera down and to capture photographs using film.

I was on assignment to photograph Chris Lieto, four-time Ironman Champion, for a cover and feature story in *Triathlete* magazine. The first part of the shoot involved capturing some pictures of Chris in action while he was riding up a world-class climb in the Santa Barbara Mountains. This is what he calls fun and the definition in his leg muscles tells a thousand tales.

Canon 5DMii, 24–70mm lens, f/5.6

Training with Film

Digital is exciting but it can be too casual and quick. The instant feedback on the LCD screen and the ability to go from capture to output in a short time is like an ironman training by riding his beach cruiser around town. It's just too easy. Sure, digital capture allows you to quickly see what mistakes you have made, yet it removes the sting—it's like working out and never being sore.

Working with film requires that you are present and committed to each shot. It is a combination of the mechanics of the cameras, the cost of film, and the lag of processing time that forces you to slow down. The process is methodical, and this can help you become connected to your pictures in a completely different way.

Different types of film allow you to express in different ways. For this shot I chose an ultra-high ISO film to give it a gritty and grainy feel.

Hasselblad 503CW, 80mm lens, f/8
Ilford Delta 3200 Professional Black and White Print Film

EXERCISE » Three Days of Portraits with Black and White Film

I was visiting with the singer-songwriter Seal at his home in Beverly Hills, and we were talking about photography. He said something profound. "When I shoot with digital, I look for the flaw in the frame. When I shoot with film, I embrace the mistake." The promise of digital is perfect pixels or at least software to make them that way. Film doesn't make such a claim, and this can help us create a distinct and sometimes more expressive type of look.

Don't get me wrong, I fully embrace digital and work in Photoshop practically every day. Yet shooting with film leads to different results and it is the best photo teacher that I've found. In the long run, whatever the format, the experience of shooting with film informs how to create a more authentic and handcrafted look. Let's explore how we can shoot with film in order to improve our skills.

STEP 1 FIND A CAMERA

If you are a native digital photographer, finding a film camera may seem like a difficult thing to do. Start off by asking family members or friends. Send out a mass e-mail to see if anyone has one you can borrow. Look at online ads or try visiting a thrift store. If you can't find one, you could always buy a plastic "toy" camera like a Holga or Diana for a relatively small amount. Consider the expense part of paying your dues. Ideally, find a camera that you've never used before.

STEP 2 CHOOSE FILM

When it comes to choosing film, consider this advice from Robert Frank, one of the most important 20th-century photographers, who shot exclusively with black and white film. His words about the format are poetic and true: "Black and white are the true colors of photography. They symbolize the hope and despair to which mankind is forever subject."

There is something different about shooting with black and white film. It is a simplification that opens up potential for the more profound. The most classic black and white film is Kodak Tri-X, and this might be a good place to start.

STEP 3 DAY 1–POUND THE PAVEMENT

Shooting with film is difficult, like riding a bike up a hill—but the more you do it, the higher the elevation and the better the view. You have to let go of making perfect or memorable shots. Instead, square off with the challenge and accept the

LEARNING OBJECTIVES

- Build core foundational skills by shooting with film.
- Make a concerted effort to slow down and capture intentional shots.
- Experiment with making pictures without looking at an LCD screen.

> **TIPS**

Shoot on a regular basis. As Robert Frank once said, "Like a boxer trains for a fight, a photographer needs to practice by getting out and taking pictures every day."

Getting good at photography requires learning about the traditions of the past.

When composing with black and white film, consider each color as brightness and tone.

EXERCISE DETAILS

Goal: 30 black and white people pictures. **Tools:** Camera; lens of your choice.
Light: Natural or available light. **Location:** Outdoors or inside. **Theme:** Endurance.
Duration: Three different days.

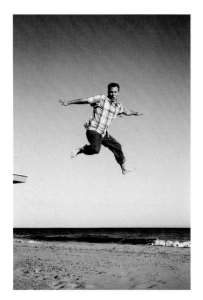

ABOVE Sometimes having a camera and shooting with film will provoke a response. Here Ryan volunteered to leap off of a lifeguard tower at the beach.

Canon Eos Elan II, 24–105mm lens, f/5.6, Agfa Scala Black and White Film

OPPOSITE Photographer and Brooks Institute faculty member Eliot Crowley sitting on the school's back steps.

Hasselblad 503CW, 80mm lens, f/5.6, Tri-X Black and White Film

mistakes. The goal isn't a few lucky snaps but building a foundation that will last.

Begin by loading the Tri-X film and bring your camera with you wherever you go. If you can't figure out how to load the film, look it up online. Throughout the day capture candid or posed photographs of people who catch your eye. Work up close or far away—it's completely up to you. Capture ten pictures of people.

STEP 4 DAY 2–WINDOW LIGHT PORTRAIT

Ask a friend if you can make a window light portrait of her. Make the shoot casual or formal. Choose a window without directional or direct sunlight. Position the subject next to the window and fire away. As a way to test the film, bracket your exposure by capturing photographs that are properly exposed, overexposed, and underexposed. Make ten window light portraits.

STEP 5 DAY 3–OUTDOOR PORTRAIT

With your camera in hand, head to an interesting outdoor location. Photograph a stranger or someone you know. Don't worry about the quality of light or the time of day. Let go, relax, and try to work with the light and location that you have. Create ten outdoor portraits.

STEP 6 MAKE PRINTS

Take your film to your local photo lab or mail it to a service like Richard Photo Lab in Los Angeles. Ask the lab to develop the film and make prints.

STEP 7 REFLECTION

When your film and prints are ready, go pick them up and set aside some time. Pull out your journal and open it to a new page. Write down your thoughts about what you hope to find inside. Slowly tear open the envelope and look at the pictures one by one. Set aside the top five photos and tape them to your journal's page. Write notes about each picture and why you think it works. If none of the pictures turned out, repeat the seven steps. ▦

Robert Frank 〉 Further Inspiration

Robert Frank's best-known book, *Americans*, is a work of singular force. It was released in 1959 and had a tidal wave effect. Initially, the book was rejected and reviled. The problem was that Frank showed Americans in a way that was different than they were typically seen.

Rather than wholesome advertising shots, Frank captured a more diverse and honest view. Eventually, his work caught on so much that many argue it changed the direction of the photographic craft. Do an online search for his work and study the black and white pictures that he made.

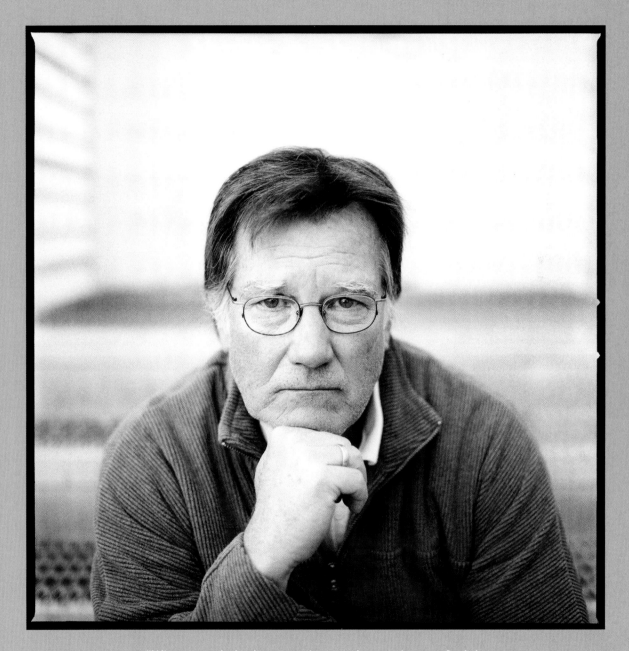

"When people look at my pictures, I want them to feel the way they do when they want to read a line of a poem twice."
—Robert Frank

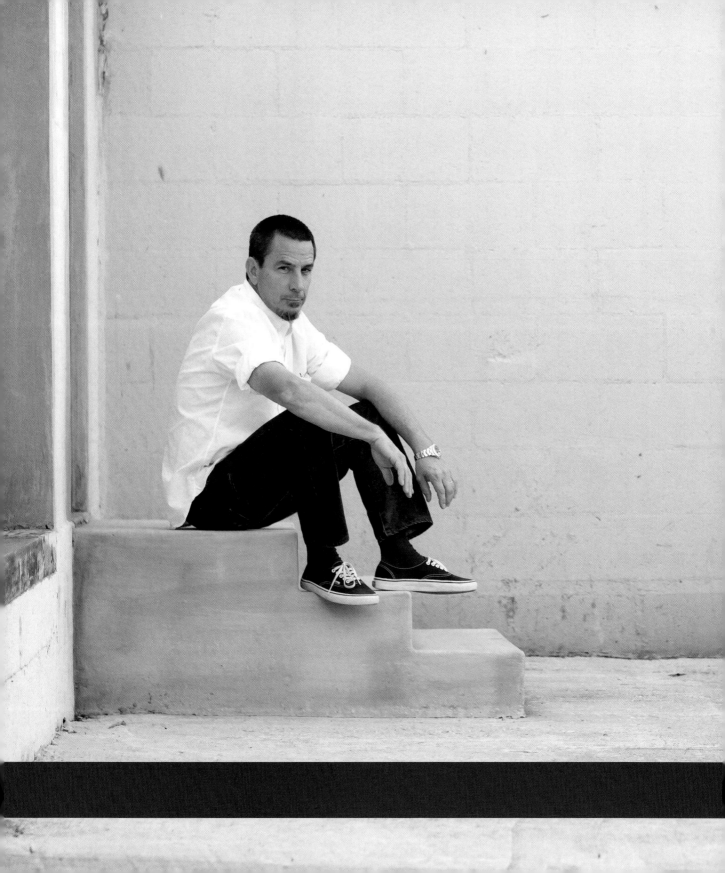

SECTION II **TELL A STORY**

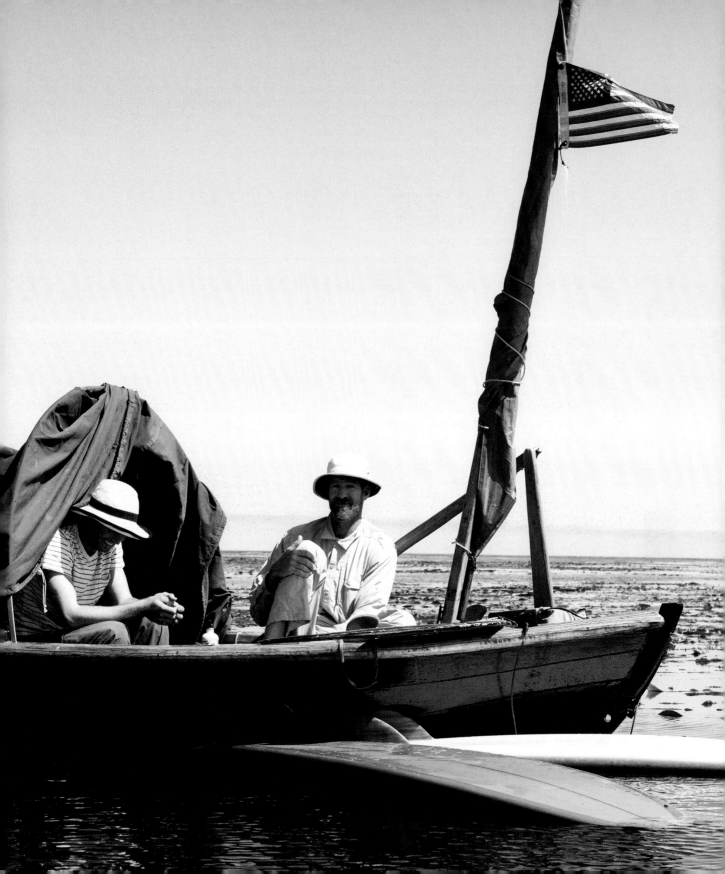

THE PLOT THICKENS

5

I HAVE A FANTASTIC UNCLE named Jim. When I was a young child, he convinced my brother and me that an alligator lived in the closet underneath the stairs in his house. He and his sons (my cousins Steve and Jon) would always have an adventure, trick, or story up their sleeve. They taught us how to build elaborate Lego sets, light firecrackers, do flips into the pool, and literally eat the icing off of the cake. When it came to boyhood fun, they were true sages who showed us how to live.

We hung on each of their words as if they were sacred text. And they were storytellers of Biblical scale. They could weave together stories that would make us laugh without control and shiver in fear. But after returning home to our friends, if we tried to retell one of their tales it just didn't work. Even if we memorized every detail of the scene, without Uncle Jim telling the stories, the inspiration was lost.

It was from these early childhood experiences that I was first exposed to the idea of storytelling as an art form that requires a special touch. It begins with understanding that good stories are built with common elements. Each story must have a cohesive, convincing, and captivating plot. The structure or the framework is the plot and it's relatively easy to describe. The characters are revealed and the events take place and the plot matters. Yet, as every talented storyteller knows, it's not the plot by itself that makes a story ring true.

In metaphorical terms, if storytellers were chefs, the plot would be the basic ingredients used to bake bread. What makes a plot come alive is the magic a chef (or my Uncle Jim) would provide. This magic is based on the plot's narrative appeal.

PREVIOUS PAGE Photography is the art of knowing what to crop out, include, combine, or juxtapose in the frame. This act of arranging details, helps compose a narrative tale.

Canon 5DMii, 85mm lens, f/6

OPPOSITE At first glance, what looks like a couple of guys out for an afternoon trip is actually an epic ocean travel saga. In this small hand-built boat, they traveled for hundreds of nautical miles exploring the wilderness of the sea.

Canon 5DMii, 50mm lens, f/8

If the plot is the overarching story, the narrative is the part that consists of the small details and the way the message is told. It's the aesthetics that make a story stick or the yeast that makes the bread rise. If the plot thickens, without good narrative, even the most interesting story won't have an appetizing appeal.

Adding the Small Details to Build Narrative

Narrative is that extra little detail that means so much. And narrative shows up in all the arts, from figure painting to photography and feature films. In fact, it's because of narrative's powerful appeal that filmmakers can successfully remake movies over time. Although they use the same structural plot, it's the new narrative twist that makes dozens of movies like *King Kong*, *Frankenstein*, *The Italian Job*, and *Willy Wonka and the Chocolate Factory* work so well.

In photography, narrative is the extra ingredient that makes a picture take root in our heart. A photograph without narrative may have the perfect plot, but it will just seem bland. In contrast, the people pictures with narrative depth are like a savory visual feast. The nuances, details, and aesthetics wake up our imaginations and entice our senses like the aroma of fresh-baked bread.

This crumbling hand-painted wall illuminated with soft dappled light and the sideways glance of the subject creates an interesting narrative tone.

Canon 5DMii, 50mm lens, f/4

EXERCISE › Narrative Portraiture

Approaching portraiture from a narrative point of view can be an exciting and rewarding endeavor. Soon you will realize that with just a small shift in perspective, your pictures can connect with a larger audience and have a more lasting impact. Here's the best part: Narrative portraiture doesn't require a specialized set of skills, traveling to exotic locations, elaborate set design, or highly conceptual ideas. Rather, making narrative portraits is simple and something anyone can do.

STEP 1 CHOOSING A SUBJECT

Select a subject who has an interesting personality, is dramatic, or has a vibrant point of view. Consider contacting a local acting club or theater and inquire if there is an actor interested in taking part in a portrait project. If you are going to be working with a professional, be sure to offer something in exchange for the subject's time. Or find a friend who has a colorful and engaging personality. Either way, once you have found your subject, set up a time and place for the shoot.

STEP 2 LOCATION AND DESIGN

Choose a location that catches your eye. Look for small details that set the stage for the story you want to tell. Consider approaching the location like a set designer or stylist would do—are there any specific props, artifacts, or wardrobe elements that will make the plot become more rich?

STEP 3 THE SHOOT

On the day of the shoot, think of yourself as the director and the location as a stage. Welcome the subject and express excitement about a chance to collaborate. Begin by explaining your idea for the visual story that you want to tell. Ask the subject if she has any ideas of her own. Begin shooting and capture images in a free-flowing way. Your goal is to capture one single image that best reveals a narrative idea. In order to achieve this, provide directorial feedback and praise to your subject, yet don't overdramatize the "script." After shooting for 30 to 45 minutes, call it a wrap.

> TIPS

If the photo shoot isn't going as planned, don't force it but instead try something new. Always keep in mind that the most powerful stories aren't forced and have a natural flow.

If you are stuck trying to come up with narrative ideas, draw inspiration from the theater, movies, books, and music that you like most.

One of the best sources of narrative inspiration is to look to the past. History is a wealth of archetypical and abstract tales.

EXERCISE DETAILS

Goal: Single narrative portrait. **Tools:** Camera; normal or telephoto focal-length lens. **Light:** Natural or available light. **Location:** An environment that acts like a stage. **Theme:** Narrative portraiture. **Duration:** 30 to 45 minutes.

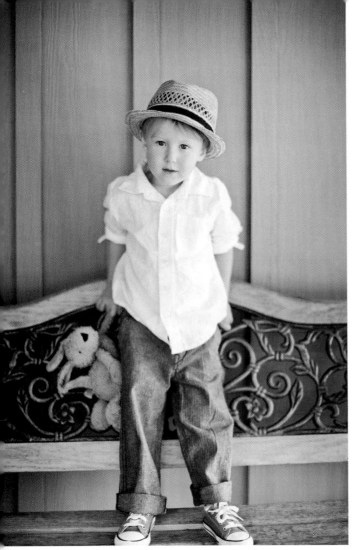

STEP 4 PRINTING ONE SINGLE FRAME

When it comes to storytelling, it's easy to become long-winded and just say too much. With photography this often happens by showing too many shots. The goal for this shoot is one singular frame. Select the picture that you connect with the most and that tells the story best. Make a print of it and tack it up on your wall. Ask others for feedback and consider their advice. ⊞

LEFT Sometimes creating narrative is about responding to what you see. When Stuart climbed on this wooden bench, his hat, simple clothes and stuffed animal were all classic details that caught my eye.

Canon 5DMii, 50mm lens, f/1.2

OPPOSITE In most photographs, it's the combination of elements that make it work. Jeff Johnson stands in front of an old paint drop cloth (see Exercise 13). His straw hat and denim shirt and the vintage tone create a mood and establish a narrative thread, inviting the viewer to linger, reflect, and gaze.

Canon 5DMii, 85mm lens, f/2

Sam Jones 〉 Further Inspiration

Sam Jones is a master storyteller with pictures and films. His photographs are full of life and each one stands on its own. A single frame contains just enough elements to make you wonder and think. He is able to catch the action midway through the scene and tell an interesting and narrative-rich story.

While many of his pictures are obviously staged, they don't feel stiff. He brings a cinematic but still casual or intimate feel to his images. You can view his work at samjonespictures.com. Take special note of the various ways he uses narrative devices to convey and compel his story.

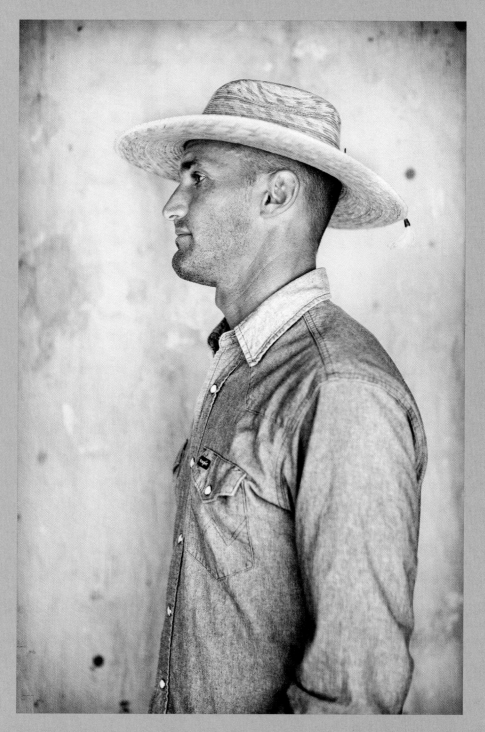

"I've always tried to create an environment that seems part of a bigger story, and then capture a small part of it."
—Sam Jones

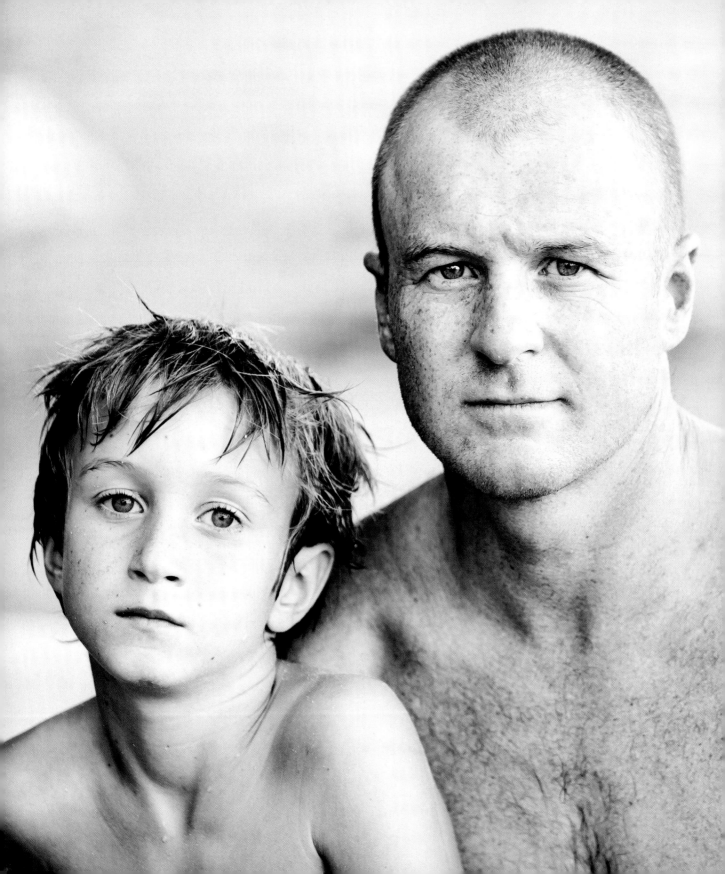

POETRY AND PICTURES

6

THE BEST POEMS take an ordinary idea and make it meaningful. That's why good poetry can be as lavish as a castle or as simple as an old wooden barn. As I mentioned in my previous photography book, *Visual Poetry*, poetry and photography run along parallel paths. Poets and photographers work with limited means. Whether is the brevity of words or the four sides of the frame, both disciplines employ a minimalist approach to communicate and convey a spectrum of ideas.

Good poetry provides a break from our congested world. Poetry slows, stops, and occasionally reverses time. The best poetry makes us pause, feel, and think. Like breathing in crisp mountain air, the inhalation makes us feel like we are breathing for the first time in years.

While poetry is expressive, the poet doesn't have her head in the clouds. She is rooted and down-to-earth. In contrast to fiction, fantasy, or make-believe, the poet works with ordinary life. Rather than invent something that isn't there, she captures life in an interesting way. Like the photographer, the poet stops, notices, records, and reframes.

Moments after bodysurfing, father and son sit quietly on their local Costa Rican beach. There is a bond between these two that is genuine and strong. The placid intensity of their gaze resonates with poetic truth.

Canon 5DMii, 70–200mm lens, f/3.5

Discovering Observation and Control

Like lines of poetry, each girl holds her driftwood stick. Two look down and two are engaged—a perfect pattern. This timeless picture is set in a natural and unhurried way of best friends.

Canon 5DMii, 70–200mm lens, f/5.6

The best poetry is made from a perfect mix of observation and a careful assemblage of words. The best photography follows a similar path. Except instead of ordering and positioning words, the photographer uses the frame to vocalize or articulate an idea.

For the photographer, poetry is perhaps one of the best comparative forms of art. The poet and the photographer pursue their craft with the same measured resolve. They both work with passion and vigor because every detail counts. Both require a mix of observation and control. Both disciplines require tenacity and a strong internal drive. The pursuit of their craft involves going against the tide. Yet, being good at either trade doesn't require an advanced degree. What's needed are some basic skills, a bold heart, keen eyes, and a desire to capture and convey those things that matter most.

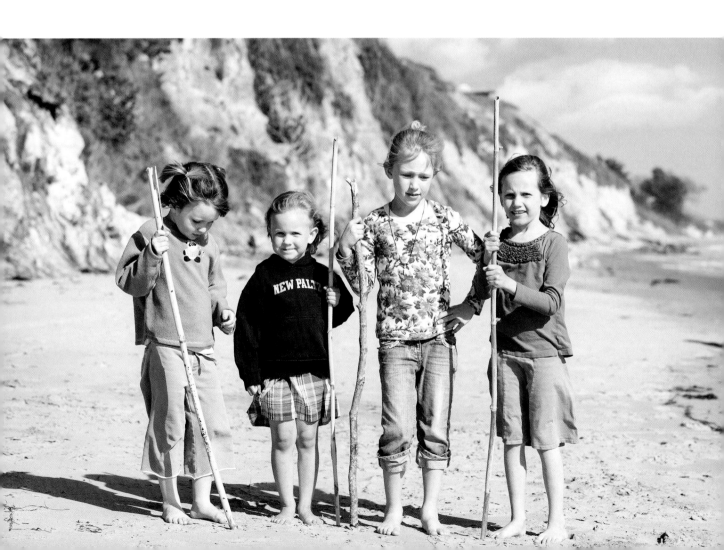

EXERCISE › Less Is More

Less is more is a timeworn yet useful cliché. Everyone likes the saying, but few of us actually put it into practice. Less requires that we get rid of too much of our stuff. In the West, we are driven to gather, collect, and consume. Our high-end giant-megapixel cameras help us do this with even more force. Yet, the poet reminds us of the perils of going down that path exclusively. The poet gently asks us to invite the cliché in. He asks us to consider if the term might actually be true as it relates to photography. Follow these steps to see for yourself.

STEP 1 CHOOSING A SUBJECT

Visual poetry has less to do with subject matter and more to do with your approach—will it be straightforward and obvious or a bit more scaled back? Is your goal to capture something literal or perhaps more iconic or abstract? Literal subjects can be interesting at first, yet they quickly lose their worth.

Begin by brainstorming subjects that fit into a specific category like surfer, farmer, musician, or mechanic. Make a list. Next, choose someone from your list who has an additional point of interest or appeal. For example, select the surfer who doesn't just rides waves but also plays in a band and has a Ph.D. in astrophysics.

STEP 2 PICKING A LOCATION

Choose a location that has a nice natural light source but isn't overly complex. Poems that become complex can feel forced or clichéd. Don't use any props and don't provide any wardrobe requests. Keep it natural; otherwise the photo shoot can become like writing a poem and relying too heavily on the use of rhyme. Rhyme and rhythm are important, yet the best poems are made up of carefully selected words that convey a poignant idea. Set up a time to meet for a 30-minute photo shoot.

STEP 3 PRE–PHOTO SHOOT PLANNING

Remember as a kid when your teacher asked you to put on your thinking cap? Before this shoot let's do the same. Take out an imaginary "poet's cap" and place it on your head. As you put it on say to yourself, "Reduce, simplify, and deepen." Select one camera and lens and plan to use natural light. Then try to arrive at the location a few minutes early to have enough time to read through the lines of a favorite poem or song. Take a deep breath and slow down.

EXERCISE DETAILS

Goal: 10 to 15 poetic pictures of someone. **Tools:** Camera; normal or telephoto focal-length lens. **Light:** Natural or available light. **Location:** Simple setting. **Theme:** Poetic pictures. **Duration:** 30 minutes.

LEARNING OBJECTIVES

- Explore how to say more with less by developing a more poetic approach to people photography.
- Discover how to create less obvious and more imaginative pictures of people.
- Develop an artistic understanding of the comparative qualities of photography and poetry.

› TIPS

Poetic pictures often take a more thoughtful and less aggressive approach. Let go of any anxiety and take a deep breath. Relax and look for the more reflective shots.

If poetry just isn't your thing, try reading the lyrics to one of your favorite songs. Consider how the brevity of the lyrics has the potential to make the music more profound.

The best poets rarely get a poem right the first time. Rather than rush the process, they revise again and again. While shooting, take the time to make the pictures right.

STEP 4 PHOTO SHOOT

Meet your subject in a relaxed yet intentional way. Make good eye contact and shake hands and say hello in an unrushed and unhurried tone. Begin shooting and look for the less obvious and straightforward shots. Try tilting the camera or changing its height. Shoot from high or low points of view while moving your feet. Like a good poet, try to say more with less.

All the while, make these movements with natural fluidity and ease. If something isn't working out, don't let that throw you off track. Capture the elements of the person in a way where each shot acts like a written line or phrase of a poem. Keep shooting until you have captured 10 to 15 interesting shots.

STEP 5 PRINT AND HANG

Purchase some twine and clothespins. Select your favorite 10 to 15 pictures and print them out in a smaller size. Assemble the photos together by hanging them on the string. Experiment with the sequencing and which photos best create a poetic reflection of the shoot. ⊞

ABOVE Poetic license is the freedom to stray from convention to convey a thought or emotion. In photography this means taking the liberty to communicate in a way that is indirect.

Canon 5DMii, 85mm lens, f/2

OPPOSITE Tom Curren is one of the most significant and influential surfers of all time. His surfing embodies style, expression, and soul. Through years of experience, refinement, and skill, he makes riding giant ocean swells look simple and unrehearsed. Curren, always a deep thinker, looks forward to what's ahead.

Canon 5DMii, 50mm lens, f/5

Poetry Aloud ❯ Further Inspiration

Getting good at photography requires constantly seeking inspiration from a wide variety of sources. If you want to capture more poetic frames, why not go to the source? But rather than reading poetry, take some time listening to it read and rehearsed. Begin by doing an online video search for a mix of classic and contemporary poets like Billy Collins, Dylan Thomas, Robert Frost, W.S. Merwin, Kay Ryan, and William Butler Yeats. Take time to listen to the words and let the meaning, mood, and emotion sink in. When you find a poem you connect with, try closing your eyes and listen to it again. In a journal, write down what affected you most. Then ask yourself if there are any lessons poetry could provide for your photographic approach.

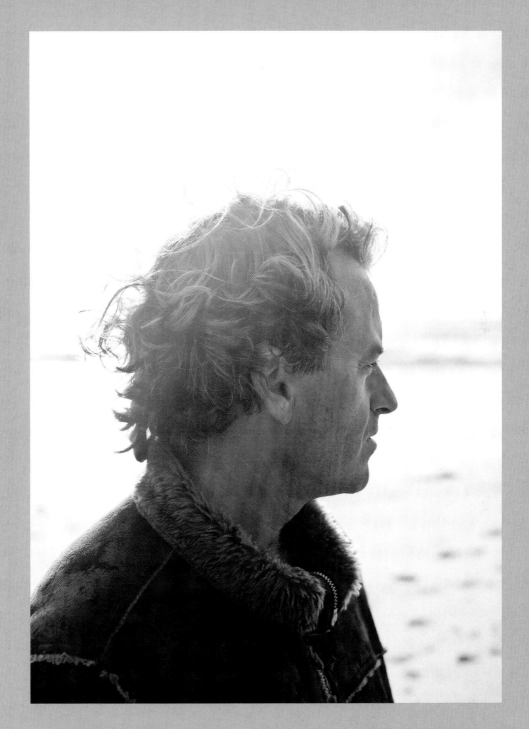

"A line will take us hours maybe;
Yet if it does not seem a moment's thought,
Our stitching and unstitching has been naught."
—W.B. Yeats

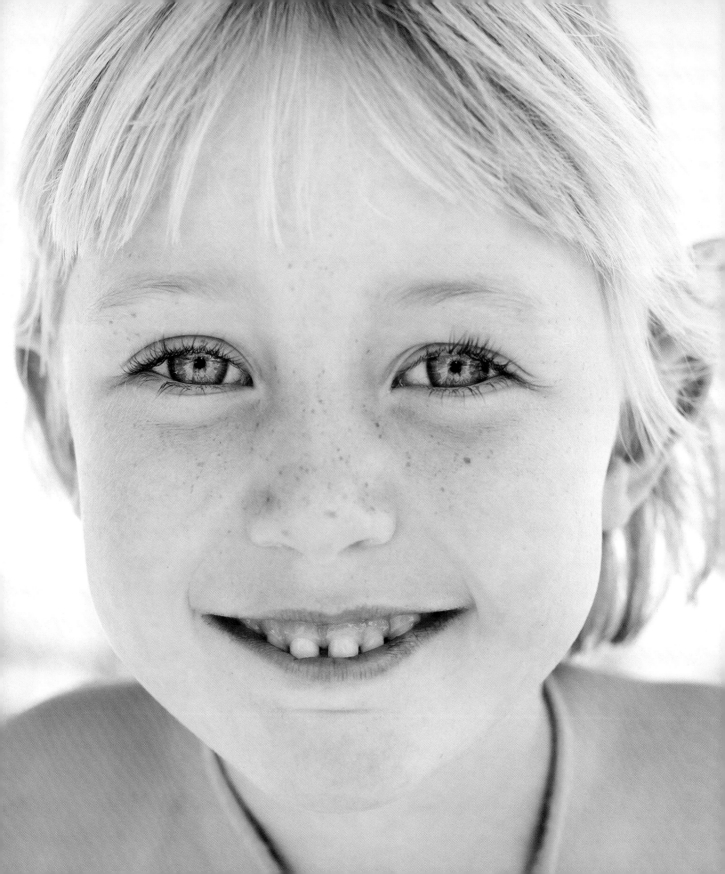

LANGUAGE THAT LIBERATES

READING A QUALITY BOOK is perhaps one of the most liberating and comforting acts. As the saying goes, there's nothing like curling up with a good book. In a practical sense, reading is therapeutic—it helps us regain composure and calm down. Like huddling close to a fire on a rainy day, we curl up with books because words have the ability to soothe our soul and take us to a faraway land.

I have deep respect for novelists who understand the potential of descriptive verse and wield that power with the precision of a sword. It is stunning to me that novelists can create images that cut right to the core without any visual support. My favorite authors are those who use words to create mental images that are descriptive, resonant, and true. And they accomplish this without the crutch of having pictures on the page. Even in our mutual blindness, they open our eyes to new ways to see.

Language clearly affects how and what we see. Perhaps even more profound, language gives us a point of view that is out of the box. Rather than remaining stuck with life as it is, words help us imagine there is more.

It was high noon and the light was harsh at our local beachside park. As I was pushing my daughter on the swing, I noticed the swing-set structure provided about two feet of shade. I pushed the swing into the shaded area, and it became the perfect moment to capture those eyes that sparkle like the sun. For me, this image is a verse that says, "Whatever your age, wherever you go, you will always be my little sunshine..." and this picture is my proof.

Canon 5DMii, 50mm lens, f/5.6

Words as a Hidden Resource

As a photographer, if you pay attention to language, you will find a secret source for picture ideas. Consider these descriptions of the penguin from different authors that I found while visiting a zoo. The first one constructed an image of the penguin as "the best-dressed bird." The second one created a more melancholy and empathetic tone. She described the penguin as "one of the only flightless birds." As photographers, paying attention to such descriptive language can provide us with different visual images or photographic ideas. If ever I needed to go and photograph penguins in the wild, I would know where to start.

The first penguin description heightens our awareness of how a happy and well-dressed penguin appears. As a photographer you could use a zoom lens to capture a penguin on top of an iceberg waddling in his tuxedo suit. The second description draws our attention to how the penguin might feel. This idea could be photographically captured, by getting close and showing the penguin with wings open in wishful thought as he watches geese flying overhead.

The best language is a liberating force. It opens the zoo exhibit cage door so we can flap our wings. Whether photographing penguins or people, good language helps us to move beyond one-dimensional ideas. With language as a source, we can come up with more interesting and story-filled pictures.

This trio had just bought mistletoe at a local Christmas fair. We walked away from the event and I thought about how to capture a less literal Christmas portrait without a plastic Santa Claus or blinking lights. Then I spotted this artist's house—the perfect setting.

Canon 5DMii, 35mm lens, f/4

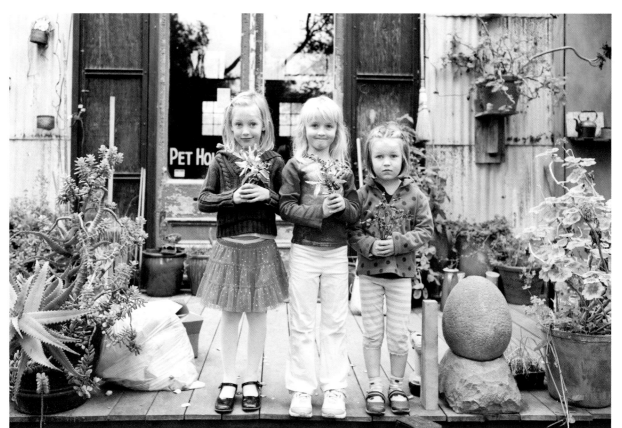

EXERCISE 〉 Making Descriptive Portraits

In creative writing literal and straightforward typically falls flat. A literal picture says too much too quickly and removes the mystery. In contrast, it's the descriptive or figurative language that excites our mind. Rather than photographing someone directly, imagine you were taking a creative-writing class and make pictures that speak with a more descriptive and liberating voice.

STEP 1 DESCRIPTIVE PORTRAIT BRAINSTORMING

Set aside 15 minutes to generate portrait ideas based on creative descriptions or words. Try thinking about curious or clever ways to describe the type of people pictures you might want to make (see the exercise in Chapter 3). Or experiment with a literary device like metaphors or similes.

A metaphor is a figure of speech that says one thing equals a different thing. Here are a few examples: He is a pumpkin, she is my sunshine, and her home was a prison. A simile is a figure of speech that involves comparing one thing to another. For example: Your eyes are like the sun. His face is like a worn-out book. Her singing is like rain in the summertime.

Whatever method you choose (creative descriptive words, metaphor, or simile), write out a few ideas. Let the ideas flow without evaluation or critique. Get as many written down in 15 minutes as you can.

STEP 2 SELECTING YOUR FAVORITE IDEAS

Consider whom you would like to photograph and the pictures you would like to make. At this stage don't worry about what the shot will actually look like; rather, focus on the concepts. Most importantly, have fun thinking about how you implement these ideas in order to make more descriptive pictures. With these details in mind, select the best five to ten ideas from the brainstorming. On a 4 by 5 index card or something similar, write down the ideas you liked most.

STEP 3 PLANNING THE PORTRAITS

In a journal, sketch out a few locations and people you would like to photograph based on your favorite ideas. Choose between setting up photo shoots or just making casual pictures of people you know. If you're interested in more formal pictures, contact the subject and set up a time to meet. For a more natural approach, just bring your camera with you and take pictures of people you know.

EXERCISE DETAILS

Goal: 10 descriptive portraits. **Tools:** Camera; normal or telephoto focal-length lens. **Light:** Natural or available light. **Location:** Your choice. **Theme:** Creating portraits inspired by a creative use of words. **Duration:** Ten minutes per photo shoot.

LEARNING OBJECTIVES

- Discover how to make story-filled pictures by seeking inspiration from the written word.
- Explore how to approach photography the way a novelist approaches writing.
- Create less literal and more figurative, vivid pictures.
- Learn techniques for generating creative ideas that translate into more thought-provoking pictures.

〉 TIPS

If you are having a hard time coming up with descriptive ideas, start by doing an online search for literary devices.

Generate ideas by doing an online search for topics like adjectives, clichés, idioms, metaphors, or similes. Or look up resources that provide information about how to write more powerful short stories, novels, or descriptive verse.

When photographing people try to get beyond surface descriptions like age, gender, height, and size. Try thinking about people in more figurative and descriptive ways. Doing this can help you see with new eyes.

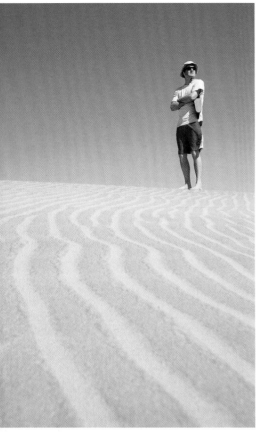

STEP 4 IMPLEMENTING YOUR IDEAS

For the photo shoot, keep your gear simple and pack just a camera and one lens. Bring the 4 by 5 index card with your favorite descriptive ideas in your pocket. Before the shoot, take a few minutes to review the ideas. Use them as internal guiding principles to influence the type of pictures you will make and to try to bring them to life. As you are photographing the subject, let go and get beyond the literal to more descriptive ideas.

Keep the photo shoot short and to the point. Try to work in a nimble and agile way rather than forcing something that isn't there. After a few minutes of shooting thank the subject for his time.

STEP 5 ADDING VALUE WITH CAPTIONS

After the photo shoot, select your favorite ten portraits and make small prints. Set the prints out on your desk and let them sit there for a few days. Then take a few minutes to come up with captions for each frame. A good caption is like a bonus, providing the viewer with inside information that makes the photograph an even more delightful experience. Limit the captions to a few words or a short phrase. Write the captions underneath the printed pictures and share them with a few colleagues or friends. Ask them for any further feedback or ideas. ⊞

ABOVE World traveler and adventurer, Martyn Hoffman, looks back without regret—arms crossed and feet firmly planted on the shifting sands—at an important crossroads in his life.

Canon 5DMii, 70–200mm lens, f/9

OPPOSITE Douglas Kirkland is a legendary photographer, who has created iconic images of everyone from Marilyn Monroe, to Michael Jackson, to Angelina Jolie. This recent portrait captures how I see him—humble, quiet, and relaxed. In the garage of his Hollywood hills home, I asked him to turn his back to the opening of the garage, which created a bright and white scene. There is an ethereal element to this picture—a way of tipping my hat to the beautiful pcitures he has made.

Canon 5DMii, 85mm lens, f/1.2

Christopher Wilson 〉 Further Inspiration

Christopher Wilson's pictures are like novels rolled up into one page. The pictures contain so much depth, intrigue, and story. It's no wonder he has a client list that is vast and deep. View his work at christopherwilsonphotography.com and write down descriptive phrases that come to mind. Be sure to explore his portfolio, stock images, and video work as well. Throughout it all you will encounter vivid and descriptive photographs.

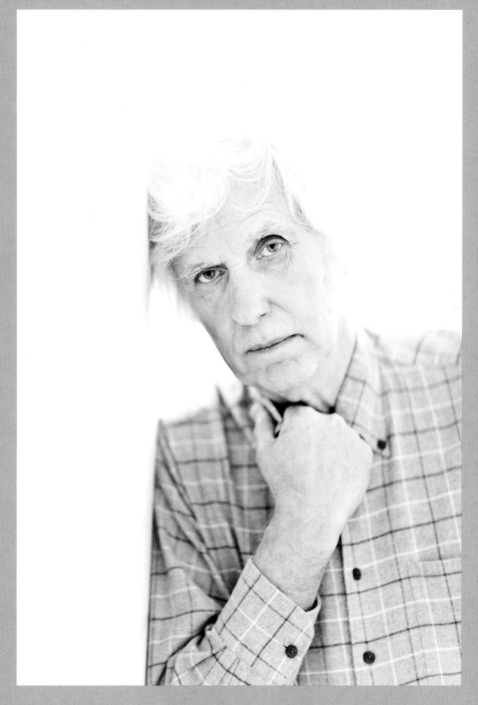

"I don't have a defined style, but what you do see in my portraits is that I'm connected to my subjects. You can't be afraid to look someone in the eye and get to know who they really are."
—Douglas Kirkland

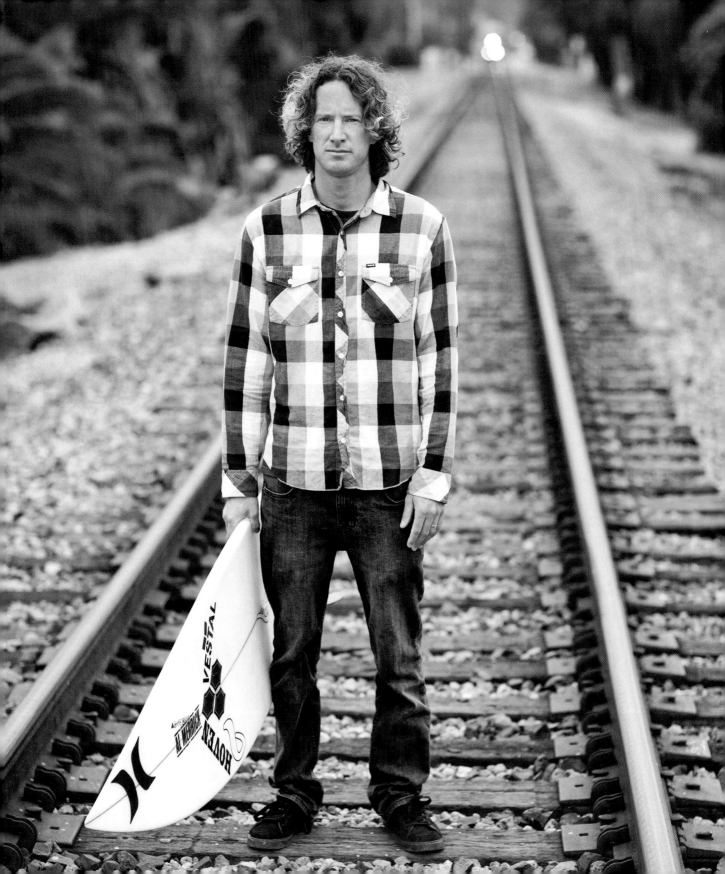

RESONATE

CONTRIVED, FAKE, FRAUDULENT, and insincere: These are qualities that people and cultures across the world reject. We're hard-wired to value genuine, authentic, and real. Whether at the cinema, viewing photographs, or reading a magazine, we want to believe in what is in front of our eyes. We want the subject or story line to be based on something that isn't a veneer, that isn't hollow and thin. We crave substance that is dependable and deep.

This is also true with good literature, nonfiction and fiction alike. We read a book hoping to be swept away by its truthfulness. Yet here is where we encounter an interesting twist. We value the story whether or not the story is fictional. Whether the tale is about Huckleberry Finn or Harry Potter or whether it's Hemingway's *Moveable Feast*, its authenticity comes from how it connects with deeper or larger truths that we know.

With photography and other forms of art, we want our work to have impact and a large reach. With this in mind, we often fall into the trap of creating something novel. Sure, newness is an integral aspect to all good forms of the creative arts, yet the shock factor fades by the week. Sometimes, by tapping into a larger, more enduring truth we create work with a substantial and widespread appeal.

Rather than asking someone to act or perform, sometimes letting them be works best. Look for those moments just after the subject exhales and faces the camera without putting up a front. Here Timmy Curran, a professional surfer, world traveler, and musician, stops and stands in silence as the train approaches.

Canon 5DMii, 85mm lens, f/2.2

Images with a Long Shelf Life

It's the art that connects with what we know and hold to be true that has the power to transcend the limits of the page. Here is where we discover one of those great empowering ideas—creating strong photographs is about more than capturing something unique. Rather, it's the pictures that resonate and have the longest shelf life.

Digesting this idea will change how you make pictures. Rather than trying to shoot to win contests, to gain clients, or to elicit comments on Flickr or your blog, you will make pictures with a different goal in mind. The celebrated author W.H. Auden put it best: "Some writers confuse authenticity, which they ought to always aim at, with originality, which they should never bother about." When creating pictures of people, authenticity is the key.

In traditional photography the darkroom was the creative epicenter. Here fine art photographer Keith Carter sits in his darkroom. The walls are a like pages from his journal which visually represent personality, passion, loss, connection, and ideals.

Canon 5DMii, 16–35mm lens, f/2.8

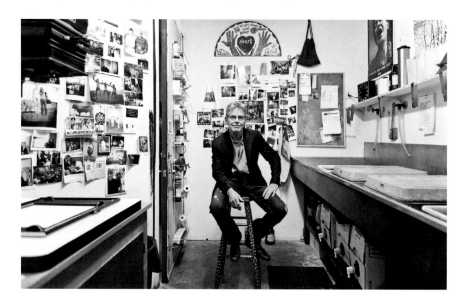

Fletcher Chouinard is an artist and surfboard shaper with a distinct style. Step into his office and you can instantly see what interests him most—skateboards, surfboards, waves, friends, maps, and quirky keepsakes from his travels. Fletcher has figured it out—creativity is an outward expression of what's on the inside. His office is like a visual map of his personality—a telling portrait without him there.

Canon 5DMii, 16–35mm lens, f/2.8

EXERCISE 〉 Drawing a Visual Map

Good stories resonant and connect with the deeper concepts. Good pictures wake up latent ideas. They bring to the surface something the viewer didn't know that he knew. For the photographer, making this type of photograph comes from digging into the authentic stories of one's own life. In this exercise, you will be creating a series of hand-drawn visual maps. Think of this as a way to brainstorm ideas for creating more authentic photographs.

STEP 1 SETTING THE STAGE

Visual maps are similar to a tree. The main idea is the trunk with others sprouting like branches and leaves. Begin by visiting visualthesaurus.com to get some ideas. At the Web site, start off by doing two separate word searches on *new* and *true*. While our maps won't be identical to these, the concept is the same. Now that you have an idea of what the maps might look like, it's time to gather a few supplies. Get out some paper (or poster board) and a good set of colored pens.

STEP 2 VISUAL MAP #1—WORD SELF-PORTRAIT

Choose your favorite colored pen and write your name in the middle of a new page. Select a series of different-colored pens and begin to write adjectives that describe who you are. Here are a few to help you generate your own ideas: edgy, artistic, adventurous, melancholy, thoughtful, optimistic.

Write what first comes to mind and continue writing until you have at least 30 on the page. Try not to judge or critique the words on the page. Then highlight or circle the ones you think fit best and connect the words with lines.

STEP 3 VISUAL MAP #2—TRAGEDY/LOSS

Choose a dark-colored pen and write your name in the middle of a new page. Select a muted-color pen and write down a nutshell version of the tragedies or loss that you've experienced in your life. Include everything from losing your favorite toy in first grade to the more profound. Keep writing until you have included loss from the different stages of your life.

At the bottom of the page add the quote, "From crisis comes opportunity." Choose a different-colored pen and write notes about how certain challenges have shaped who you are. You don't need to respond to each loss; just pick a few that have helped you become a stronger or better person.

STEP 4 VISUAL MAP #3—INTERESTS/PASSIONS

Write your name in the middle of a new page. Next write down all of the interests, passions, sports, and hobbies that you have pursued throughout your life.

EXERCISE DETAILS

Goal: Create 4 visual maps. **Tools:** Colored pens and paper. **Theme:** Becoming in tune with who you are. **Duration:** 15 minutes per visual map.

LEARNING OBJECTIVES

- Explore the value of creating a visual map that reflects who you are.
- Uncover what makes you tick to integrate it into your photographic work.
- Develop an internal compass that will guide what and how you photograph.

〉 **TIPS**

If you aren't the "art school type," this kind of exercise may initially seem like fluff. Don't underestimate the power of taking time to define who you are and what kind of pictures you want to make. I've had many resistant students later express gratitude after completing this exercise.

I love teaching, but sometimes the student work that I see is shallow and trite. Rather than developing a voice of their own, these students follow a mainstream trend. This exercise will help you overcome following someone else's lead.

For an extra challenge, do this exercise with a colleague or peer. Share and compare your maps for an even more profound effect.

Include everything from building a tree fort as a kid to learning how to play the cello as an adult. Make the map as exhaustive as you can, and then go back and circle or highlight the items that stand out most.

STEP 5 VISUAL MAP #4–CONNECTIONS

Write your name in the middle of a new page. Next write down many of your current connections in life. Include people you know through work, family, hobbies, and sport. Continue writing until you have at least 30 on the page. Next, choose a different-colored pen and write down connections that you would like to pursue. For example, ask yourself if there is a travel club you would like to join or a local artist that you would like to meet.

STEP 6 VISUAL MAP #5–GOALS

Write your name plus the word *photography* (or your photography business name) in the center of the page. Next, write the photographic goals that you would like to achieve. Don't worry about whether or not the goals are too outlandish or too small. If a thought crosses your mind, write it down. Include goals about people and places you'd like to photograph. Do you have any publication goals? After you have at least 25 goals on the page, circle or highlight the top 5.

STEP 7 SUMMARY

After completing the visual maps, tack them up on your wall. Consider how this can help you make pictures that are more authentically aligned with who you are.

The strongest artists haven't lived a rosy or privileged life, but are in tune with who they are. They create art from their inner core. By becoming more familiar with the idiosyncrasies, interests, and challenges of your own life, you can begin to authentically take pictures that matter most to you. These visual maps can act as a compass and guide that will lead you to fulfill your inner drive.

Finally, share your maps with a few friends and then write down ten pictures of people that you would like to make. Hold on to this list. You can use it in later exercises in the book. ▦

OPPOSITE After making a visual map of my own, a theme of the sea and surfing kept coming up. I decided to photograph Jack O'Neill, inventor of the wet suit. I wanted to create a portrait of this aging surfer, who made such an impact on those enjoying the frigid waters of the sea.

Canon 5DMii, 16–35mm lens, f/2.8

Todd Selby 〉 Further Inspiration

Todd Selby is often referred to as a "hipster environmental portraitist." I think the descriptions are fitting. His work is curious, cluttered, and creative. Selby's style is a perfect reflection of who he is and he has figured out what he likes most—photographing people who live creative lives and showing their space. Discover his work online here: toddselby.com. With the mind of a critic, browse through the pictures and write down six adjectives that you believe describe his personality.

"Style is a simple way to say complicated things."
—Jean Cocteau

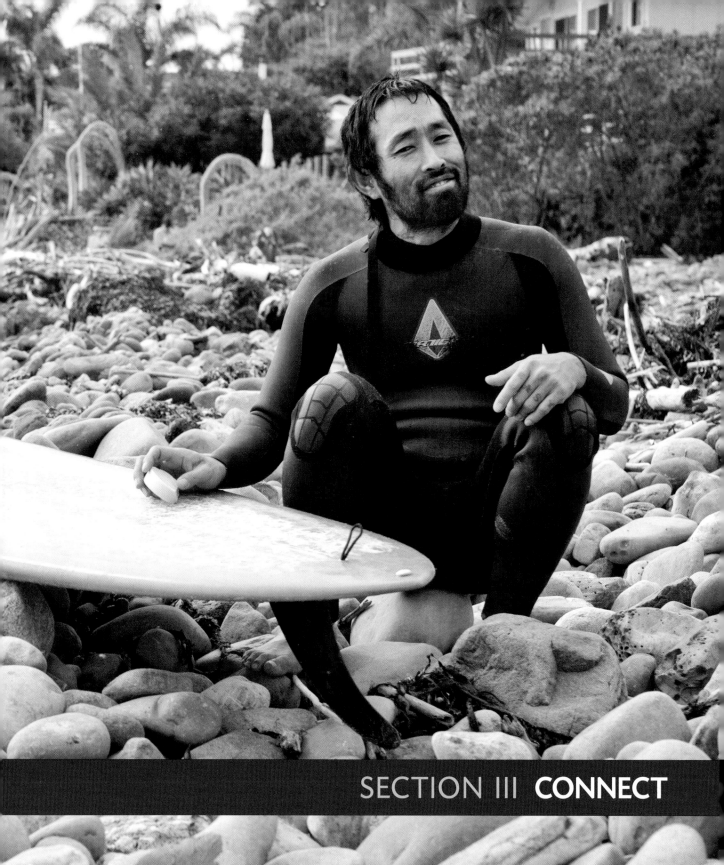

SECTION III **CONNECT**

EMPATHETIC

ALMOST EVERY PHOTOGRAPHER agrees that it's better to be on the view-finder side of the lens. Making a picture is a simple delight. Being photographed is complicated and confusing. It is like looking in a mirror but not being able to see your reflection except through someone else's eyes. It can be a perplexing experience; some consider it a slight inconvenience while others outright abhor it. Perhaps this is so because of what a camera potentially reveals.

Hang a camera on your shoulder and everyone is at ease. Point a camera at a person and the ease dissipates quickly. The reaction is usually part excitement, part nervousness. A camera's gaze is not neutral. It's as if a camera reveals our innermost ideas, thoughts, and insecurities. That which is not readily apparent is unveiled.

The photographer intimately knows the power and potential of the camera's gaze. As Rodney Smith aptly explains, "The camera sees the world with more acuity or resolve. It can penetrate deeper. It can see sharper. It can give insight your own eye can't." Thus, prodding into or putting a spotlight on someone else's life is just fine, but shining a light into the dark recesses of who I am? Well...I'm not so sure about that.

OPPOSITE Photographer Shaun Walton takes his time to focus and frame. He he is looking for something deep. And here, we discover that having a camera pointed at you is a great reminder of what it's like to be on the other side.

Canon 5DMii, 50mm lens, f/2.8

PREVIOUS PAGE "Only a surfer knows the feeling," and you can tell that this surfer understands this phrase. This picture is a moment of connection as he pauses, just before heading out to ride the waves.

Canon 5DMii, 50mm lens, f/5.6

The Bitter Taste of Trust

Daisy, our three-month-old golden retriever, was sick. Like any good puppy parent would do, we rushed to our vet. After some analysis the doctor informed us she would be OK but would need to take some pills. With a strong yet empathetic tone, he explained that the medicine was extremely bitter and that I would have to put it in the back of her throat. He told us that in veterinary school he tasted this medicine and it was so bitter that he threw up. Here was a doctor I could trust, someone who has tasted the medicine he prescribed for our dog.

Most photographers rarely go this far but wonder why their portraits fall short. When there isn't a connection, you can see it in the subject's expression or eyes. In contrast, powerful pictures are always the result of establishing empathy and trust. Empathy is not about understanding another's pain from a distance, it is about *entering into* the situation of another's world. Empathy requires solidarity.

In people pictures you can develop empathy by having your picture taken by someone else. Understanding this perspective will help you forge a bond with your subjects and your pictures will evolve from hollow to something that rings true.

Under the dark cloth, fine art photographer Joni Sternbach prepares to make a portrait. Sternbach shoots with great concentration and intent. After she created my portrait, I made a few of my own.

Canon 5DMii, 50mm lens, f/1.2

EXERCISE › Your Portrait

I enjoy being a photography teacher because every day I'm surrounded by people making pictures. It's interesting to see how students carry themselves, how they interact with subjects, and how they handle gear. While I try to learn as much as I can, this type of watching is mostly a passive act.

Not until someone asks me to step in front of his camera do I truly understand his "game." Something different happens when you become involved. That is exactly what this exercise is about. You will stop taking your own pictures and have yours made instead. Do this by asking two or more photographers to create a portrait of you.

STEP 1 CONTACT TWO PHOTOGRAPHERS

Find a local photographer or friend whose work you admire. Explain to her that you are interested in having a particular type of portrait made. Describe what you like about her work and ask her if she could do that for you.

STEP 2 PHOTO SHOOT

Throughout the photo shoot try to go with the flow while observing how the photographer works. Commit to the process and do your best to be vulnerable, honest, and present. Let go of the controls and let the other photographer lead the way.

STEP 3 PHOTOGRAPHER INTERVIEW

After the shoot, ask the photographer a few questions. In order for this to be successful, write a list before the shoot. Here are a couple of ideas: 1) What is your goal when photographing people? 2) What do you think makes a portrait good? 3) Do you have any helpful portrait techniques that you use that you could share? 4) What advice would you give someone wanting to create better portraits?

STEP 4 POST–PHOTO SHOOT REFLECTIONS

After the photo shoot, take a few minutes to jot down the photographer's strengths and weaknesses. After reflecting on how the photographer worked, write down how you would change or modify your own process.

STEP 5 REPEAT THE PROCESS

After completing the first photo shoot, repeat this process with a second photographer. ⚏

LEARNING OBJECTIVES

- Gain empathy for what it is like to be photographed.
- Learn new techniques for creating portraits.

> **TIPS**

Taking the risk to ask someone to create your portrait will make you a better photographer.

Always be on the lookout for the chance to learn from other photographers.

For an extra challenge after having your potrait made, ask the photographer to take her portrait.

EXERCISE DETAILS

Goal: Develop empathy for your photographic subjects. Learn from experiencing how another photographer works. **Tools:** Journal to record your thoughts and reflections. **Light:** Natural or available light. **Location:** Indoors or outdoors. **Theme:** The other side of the lens. **Duration:** Two photo shoots, 30 minutes each.

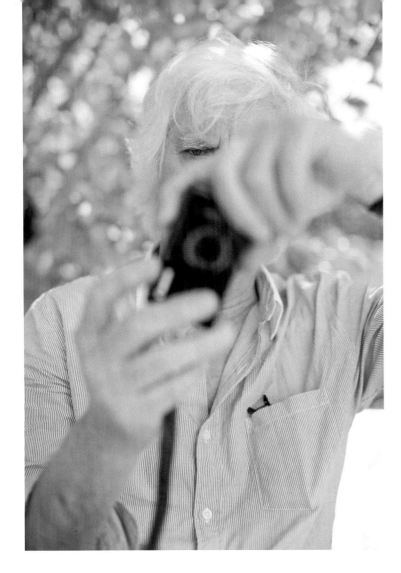

LEFT The best photographers always have a camera by their side. I was having breakfast with photographer Douglas Kirkland, and we both noticed the light change from bad to good. Like a friendly duel, we both created a frame.

Canon 5DMii, 50mm lens, f/1.2

OPPOSITE Jeff Lipsky is a humble and down-to-earth celebrity and fashion photographer. I think it is his relaxed, honest, and upbeat approach that helps him capture portraits of the well-known in an authentic and uncontrived way. I know this firsthand. After I photographed him, he photographed me. A fair exchange.

Canon 5DMii, 85mm lens, f/1.2

Tim Mantoani 〉 Further Inspiration

A portrait of a photographer is an interesting topic because photographers are typically *unseen* subjects. And it's the photographer's job to make the unlikely interesting and to show us something we haven't seen before.

Since 2006 Tim Mantoani has been photographing famous photographers holding one of their iconic images. His project "Behind Photographs" beautifully illustrates this concept of the faces behind the lens. View these remarkable images on his Web site (mantoani.com) and read his story about the project. Then take a few minutes to brainstorm a project that you would like to pursue. The best projects start with simple ideas.

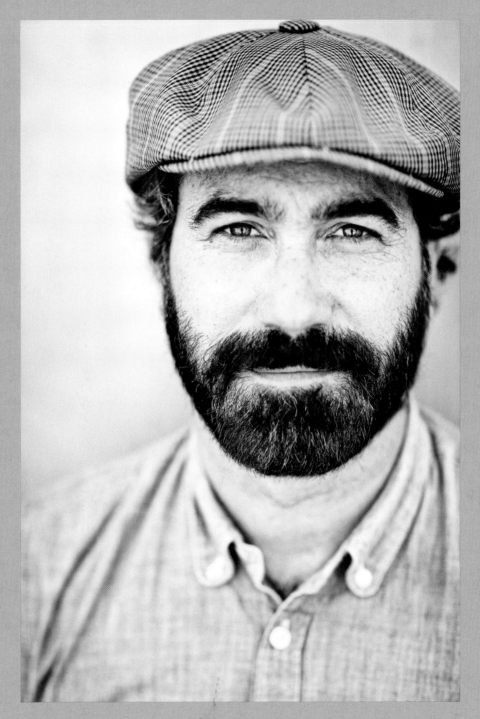

*"The fastest way to becoming a great photographer is to focus.
Pick one thing that you are passionate about and shoot that
once a day, once a week, once a month, or whatever you can."*
—Tim Mantoani

10

TURN YOUR CAMERA AROUND

BECOMING A MORE THOUGHTFUL and engaged photographer requires that we reflect upon, and seek to understand, who we are and who we want to become. It is easy to skim the surface of our story and disregard the details of our life as banal and bland. Yet your own story is one of a kind and worth exploring more.

We have to grind and mill the contents of our life to be able to tell better photographic stories. Each life story is made up of tragedies, blessings, anxiety, peace, loss, love, dreams, devastation, joy, and more. By tapping into the entirety of our lives we can tell a fuller story with photographs. One way to experience the harvest of this labor is to create a story-filled self-portrait.

Some pictures are taken while others are made. Self-portraits by their very nature are pictures that require thinking, planning, and preparation. It's the setup and process that lead to making a picture that reveals.

Canon 5DMii, 50mm lens, f/2

Tell Your Story

My grandfather was an artist with a vibrant zeal for life, but he died before I was born. His creative spirit lives on. Using a self timer, I captured this portrait of me holding the only item of his I own—his camera.

Canon 20D, 50mm lens, f/4

As humans, we are fascinated by our own likeness, whether for curiosity, vanity, or self-reflection. Seeing ourselves in visual form raises the questions of age, identity, and the core of self. Some, like Narcissus or Lady Gaga, have been caught up and tangled in the pursuit of these questions. Others, like Socrates, found higher ground by following the statement, "An unexamined life is not worth living." That is the tack or the goal of this exercise: Create a series of self-portraits that conveys and clarifies who you are.

EXERCISE › Self-Portrait

Photographing people is a heightened experience that momentarily allows you to forget about yourself and to focus on another. Photography liberates you to tell another person's story. But such focus causes us to forget what it is like to be on the other side of the lens. By turning the camera around and creating self-portraits, this exercise will help you develop as an artist as you dig into your life.

The goal is to create a series of self-portraits that helps you examine your life and depict a portion of your life story. Aim to create portraits that aren't just visually interesting but have something to say.

STEP 1 REFLECTION SELF-PORTRAIT

Photograph yourself in any type of a reflective surface—mirror, water, or the side of a shiny black car. Try to find a surface that allows you to include a few telling personal details. For some ideas and inspiration do an online search for Vivian Maier self-portraits.

Shoot pictures that are up close and far away. Orient the camera in vertical and horizontal positions.

When taking the pictures, think about what you must look like from the subject's point of view when you are capturing her. You'll notice that the camera blocks much of your face, making it difficult to connect.

Continue shooting until you have ten good photographs.

STEP 2 OUTDOORS SELF-PORTRAIT

Using the self-timer on your camera and without a tripod, create a well-composed photograph of yourself out in the world.

Experiment by placing your camera in different locations. Try to place it on a rock, hanging in a tree, or on the ground pointed up.

Most importantly, get outside and create a portrait in a setting that you have never been pictured in before.

Strive to create five interesting photographs.

STEP 3 ARM'S-LENGTH SELF-PORTRAIT

Use wide (16–35mm focal length) or normal (50mm focal length) lenses, hold your camera at arm's length, point it toward you, and fire away.

Try positioning the camera high and low. Think of this as a chance to study what type of looks you can create from different perspectives and at this close of a range.

LEARNING OBJECTIVES

- Reflect on your own life using your camera.
- Understand what it's like being photographed.
- Experiment with different self-portrait options.

› TIPS

Take time to think about the pictures that you will make. Self-portraiture can be trite or profound—it depends upon you.

While self-portraiture can be uncomfortable, commit to the process as a chance to learn something new.

Self-portraits help us discover and grow, but they are not made only for the photographer. The best self-portraits can be a revelation or a simple gift for those that you know.

EXERCISE DETAILS

Goal: Create 30 self-portraits. **Tools:** Camera and 16–35mm or 50mm lens. **Light:** Natural and available light. **Location:** Indoors or outdoors. **Theme:** Honest and telling self-portrait. **Duration:** 60 minutes.

ABOVE A self-portrait taken in a artist friend's home. Together the decor and reflection make for an interesting frame.

Canon 5DMii, 50mm lens, f/2.8

For even more creativity, try lowering your shutter speed to 1/30 of a second and spin in a circle so that you are sharp and in focus while the background blurs.

Take enough pictures until you have sufficiently experimented with this technique.

STEP 4 POST–PHOTO SHOOT REFLECTIONS

After the photo shoot, take a few minutes to jot down what you learned from this experiment, both in being the subject and how you appear when you are shooting others. ▦

OPPOSITE While I was setting up a camera, my daughter Annika, who was six years old, asked if she could take the picture herself. I loaded the film, focused the camera, and walked away. This picture wasn't mine, but hers. Patiently, she stared into the lens and waited. Then she pushed the shutter release and created her first ever self-portrait. As a father, this image was a gift that makes my affection even more deep.

Wood large format 4 x 5, 90mm lens, f/5.6, Polaroid Type 72 Film

Great Self-Portraits > Further Inspiration

Throughout the history of photography, many of the greatest photographers have created iconic self-portraits. Dedicate time to studying these portraits and others of the photographers who inspire you. To find such images do an online search for the photographer's name and the word *self-portrait*. For starters trying searching for Ansel Adams, Joyce Tenneson, Anton Corbijn, Alfred Stieglitz, Elliott Erwitt, Annie Leibovitz, Bill Brandt, Henri Cartier-Bresson, Eugène Atget, and Richard Avedon.

Studying other forms of art is an essential way to deepen your photography. For further inspiration on self-portraiture beyond photography, explore the rich tradition of classic and contemporary painter's self-portraits. To begin your study, do an online search for a specific artist like Francisco Goya, Vincent van Gogh, Pablo Picasso, or Chuck Close. Next, broaden your search by looking up topics like *Wikipedia self-portraits* and *Renaissance self-portraiture*. As you view the self-portraits, evaluate the expression, composition, color, tone, and mood. Write down descriptive adjectives that describe your three favorite paintings. Consider the commitment, resolve, and sheer number of hours it took to make those paintings. Perhaps this will challenge you to invest more in your own self-reflective artistic endeavors.

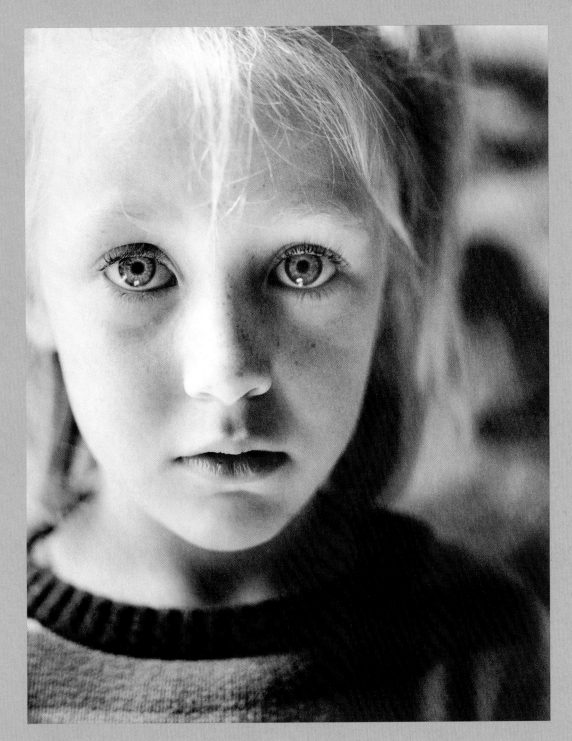

*"Affection is responsible for nine-tenths of whatever
solid and durable happiness there is in our lives."*
—C.S. Lewis

FORGING RELATIONSHIPS

11

BUILDING RELATIONSHIPS is something every people photographer must constantly do. Being successful at this isn't so much about personality—shy versus outgoing, quiet versus loud—but about expressing real enthusiasm and interest in others. A relationship builder is someone who actively listens, asks meaningful questions, and remembers the details of another person's life.

Portrait photographers who get beneath the surface of things are those who have invested the time to develop these core relationship skills. The ability to make that connection is what differentiates mediocre pictures from something more profound.

The art of relationships cannot be forced or contrived. When photographing people, this means that you may have to let go of your photographic agenda. Relationships rarely flourish with competing goals. Here we discover one of the great paradoxes of people photography: To make good people pictures, we have to let go.

I met with Keith, an author, to create some portraits for his upcoming book. His writing style is personal and down-to-earth. I wanted to capture that style so I took time to talk with him in a relaxed yet significant way throughout the shoot in his backyard. Compare this portrait to one I captured moments later, which is more intense, in Exercise 12.

Canon 5DMii, 85mm lens, f/1.2

People Before Pictures

I wanted to capture Joe and Tischa Curren in a non-traditional pose. While talking and laughing with them, I asked Joe to step back a few feet and used a shallow depth of field. The end result works for me as it shows them both together and apart.

Canon 5DMii, 50mm lens, f/1.2

Photographer Brooks Jensen says it well: "The first and most important aspect is to connect with people. What happens with the camera is a reflection of how well that connection was made in the first place." For the ambitious photographer, this appears to be a counterintuitive strategy, but it works. You focus on the person and become a people person rather than a photographer who is always asking for something or just getting in the way.

Putting people before pictures requires courage and a counterintuitive mental shift. Having this perspective means that you will miss certain shots, and that's OK. After doing this for a while, you'll soon discover that the pictures that you missed weren't worth much anyway. In contrast, the photographs, friendships, and growth that you gain will far outweigh the loss.

EXERCISE › People Skills

Most of us think of ourselves as good communicators with good people skills. While this is probably true, good isn't good enough. In people photography you need to become an expert in forging relationships. As any talented people photographer will tell you, good pictures are a result of who you are and of how you relate to the subject. Try the following steps to hone and develop your skills.

STEP 1 MAKE EYE CONTACT

To strengthen how you see, dedicate an entire day to looking at each and every person you encounter directly in the eyes. Make eye contact with strangers and hold your gaze. When appropriate, smile with your whole face, including your eyes. Wait for the other to look away. Smile at others in meaningful ways that you genuinely feel. With your loved one when you come home from work, really look deeply into her eyes. Let your eye contact communicate your love, resolve, tenderness, and care.

Do all of this without camera in hand. Focus your eyes, pause, and connect. This exercise will open new doors to confidence and connection that you never felt as keenly before. At the day's end, take a few minutes and reflect on what you learned. Share the experience with a friend or fellow photographer. Challenge each other to develop more sensitive and focused eyes.

STEP 2 ACTIVE LISTENING WITH A FRIEND

Good communication is a two-way street. It requires dialogue, which is made up of two halves—talking and listening. Talking comes a bit more easily for most of us. Here's a chance to improve your ears and your listening skills.

Set up a time to meet with a friend. Do what you would normally do with that person—go to a coffee shop, go mountain biking, whatever you like. Throughout the visit, focus on being an attentive listener. Listen with your posture and nonverbal movements. Be relaxed, nod your head, and lean forward. Ask insightful questions and wait for the response. Be patient and use encouraging words to invite him to continue talking. Use phrases like, "Tell me more about that." Resist the urge to talk or take over the conversation.

When we ask good questions and actively listen it communicates respect, value, and appreciation. Good listening requires paying attention with your ears, eyes, and heart. Being a good listener creates a bond. Take time to listen to the stories of those you photograph, and your pictures will resonate in a more magnetic way.

> ### LEARNING OBJECTIVES
>
> - Hone and develop relationship skills with and without a camera.
> - Learn the value of eye contact and active listening.
> - Discover the value of conversation and connection with the subject while making pictures.

> ### › TIPS
>
> *Skip this exercise and your pictures will suffer. Good people pictures are not the result of technical expertise. It's the connection that will help your pictures be set apart.*
>
> *When appropriate, don't be afraid to stop taking pictures and to focus on the person. While this may feel counterproductive, this focus will help you capture something more profound.*

EXERCISE DETAILS

Goal: Develop people skills. **Tools:** Camera and lens of your choice. **Light:** Depends on location. **Location:** Indoors or outdoors. **Theme:** Making the connection. **Duration:** 30 minutes for photo shoot.

OPPOSITE I was visiting a friend in Texas and he took me to his favorite lunch spot. The restaurant had a warm, vintage style. When I met the owner, I was taken by her kind and smiling eyes. She was the perfect reflection of her shop. I asked if I could make a portrait. Of the two frames I made, this was the one I liked most.

Canon 5DMii, 85mm lens, f/2.2

STEP 3 WHERE THE RUBBER MEETS THE ROAD

Developing relationship skills without a camera is essential. Using those skills with a camera in hand is a completely different challenge; shifting instead to technique, composition, vision, and light. This step is a chance to embolden your skills so that you don't forget about the relationship part.

Set up a time to photograph someone who interests you. Perhaps you'll choose to photograph a few good friends, the shop owner at your favorite deli, a teacher you respect, or an accomplished rock climber who lives in your town.

Arrive for the shoot early. Tardiness typically shows you don't really care. While you are waiting, read a book or make yourself busy so the subject doesn't feel like she's been making you wait. After greeting the subject give her a gift, something small to say thanks for her time such as a note and a gift card for the local ice cream shop. Starting off with gratitude will set the stage for more meaningful pictures. Take about five minutes for the meet and greet.

STEP 4 CUT TO THE CHASE

Begin shooting right away and keep it completely conversational. Ask questions and listen. Cut to the chase and ask the subject about her life and about what matters most. Do whatever it takes to keep the conversation going. Sure, you will get some pictures where her mouth won't be in the right position; let those photographs go. Look for the in-between moments and keep the subject engaged. The shoot should last no more than 30 minutes.

Before too much time has passed, end the shoot. Calling the wrap early makes it seem less painful; it's a breath of fresh air. Thank the subject for her time and end on a high note (five minutes).

STEP 5 ACKNOWLEDGEMENT AND THANKS

Right after the shoot, show your appreciation by following up with a handwritten note—no texting or email allowed! Keep it simple and express your gratitude for her time. William James said, "The deepest principle in human nature is the craving to be appreciated." Drop the note in the mail that day. You will be surprised by how many doors can be opened by old-fashioned mail. ▪

Richard Avedon ❯ Further Inspiration

Richard Avedon is one of the most highly celebrated photographers of all time. His portraits are engaging, complicated, and full of the contradictions and vitality of life. Avedon's work has an intensity that is impossible to ignore. His pictures help us know people in a completely different way. How did he create such stark and revealing pictures? Much of it was because of who he was. He was a conversational genius and he had an uncanny way of drawing people out. To learn more about how Avedon worked, invite some friends over and watch the film *Richard Avedon: Darkness and Light.*

"I am a person who wants to look into someone's eyes and know them."
—Richard Avedon

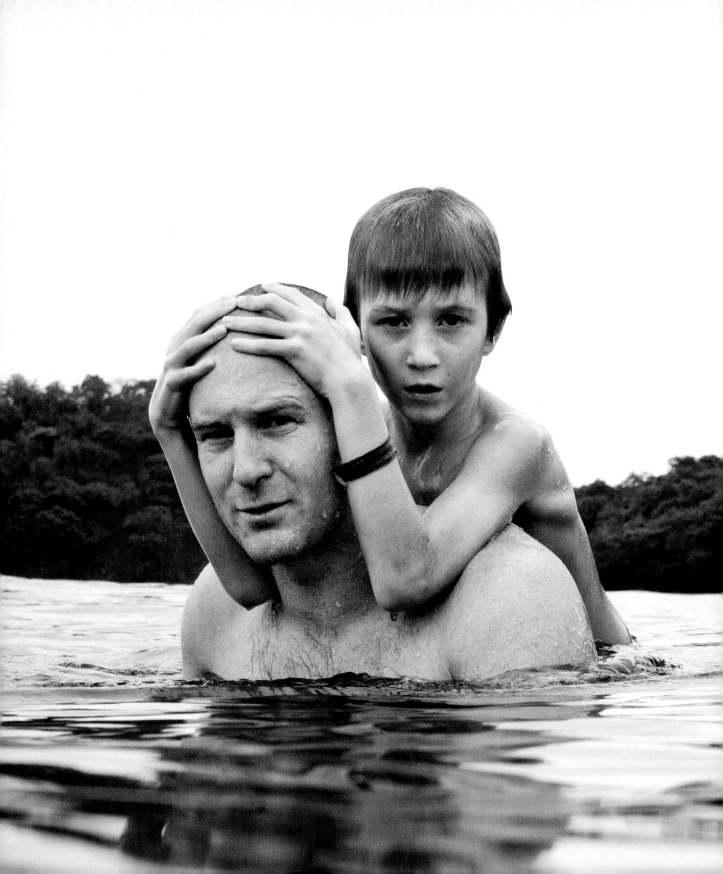

BE QUIET

THE INCREMENTS OF TIME have been sliced and diced into smaller and smaller pieces. Life moves like a time-lapsed movie. The day-to-day details are lost and sometimes disappear. We drive to work but don't really remember what happened between leaving home and pulling into our parking spot. Such speed deadens our senses. Memories blur and moments become fuzzy. We listen but don't really hear. There is just too much to take in, so we don't.

For the casual observer, this isn't ideal. For the photographer, this is a dangerous state and contrary to who we are.

We like to look at pictures of people who are present and engaged. It slows us down. It draws us in. Even more, quiet pictures reflect how our memory captures events. We remember the iconic still moments, those moments where time becomes quiet and is momentarily frozen. Creating pictures like this is an extremely difficult task, not because of the person being photographed but because of you.

To create people pictures that are still and serene, we have to model and embody the tone or mood we want to capture. Sound simple? It's much easier said than done. Interacting with people is a mixture of excitement, nervousness, anxiety, hope, and connection. We are easily swept away by it all.

It's almost like giving in to the temptation to read a really good book too fast. Drawn in by the plot, characters, and story we want to skim and skip ahead. Yet, such speed would only lessen the value. We would miss the nuances, subtle expressions, and intriguing use of words. We would find out what happens, only to have missed the main point.

Father and son pause during a lull while bodysurfing at Guacamaya Beach in Costa Rica. This image was captured quietly and without an exchange of words.

Canon 5DMii, 50mm lens, f/16, Del Mar Housing

In my own experience, when I have rushed a photo shoot the picture taking was exciting. Afterward, the resulting photographs made my stomach ache. When I have taken the time to be quiet and to slow down, reviewing the final photographs was a process full of delight; each photograph was a surprise! Silence, slow pace, and patience are worth the extra effort. There is a greater chance for the pictures to speak with their own words.

What You Do with the Time

What does it mean to be quiet and to slow down? Is this really possible? Making people pictures requires you to think on your feet and react to light, expression, composition, movement, and tone. With people, sometimes you have 3 minutes, other times 30 minutes. Is it about having more time? No. It's about what you do with the time that you have. And that's true with life as well, isn't it? Regardless of how much we wish it weren't so, there are never more minutes in a day. Living life, and taking pictures, is about making the most of each minute that we have.

Perhaps it is about approaching a situation with a bit of serenity? Or even better, becoming a more stress-free and observant person. Taking good pictures is not only about your gear and subject, it's about you. Becoming a good photographer is about becoming someone who is different than the crowd. Develop a calm and quiet disposition, a peace of mind that isn't dependent on situations or circumstances, and your photographs will speak volumes.

The first few portraits I made of fine art photographer Keith Carter in his studio were rushed and didn't turn out so well. Realizing my mistake, I took a deep breath and slowed down. With simple and quiet words, I provided direction to Keith on where to stand and then pushed the shutter release just a few times.

Canon 5DMii, 16–35 mm lens, f/2.8

EXERCISE › Silent Pictures

For some this exercise is going to be one of the most difficult within this book. Yet perhaps it will be one of the more rewarding—making portraits without speaking or using words. Doing this exercise will help you to become a more observant photographer. And ultimately this will lead to new ways of thinking and seeing, which in turn will lead to creating much more powerful pictures. The basic requirements are to take a deep breath, slow down, and make pictures without exchanging any words. By exaggerating things a bit, you will learn even more.

STEP 1 PLANNING

Set up a 30-minute photo shoot with a subject of your choice. Before you meet up, explain the overall vision, flow, and details (as described below) for the shoot.

STEP 2 PHOTO SHOOT, PART 1–CONVERSATION

For the first 10 minutes of the shoot, meet your subject and talk with him with a calm demeanor. Explain that you are doing this shoot as an assignment to grow as a photographer and ask for his help in this process. Share your vision by articulating what type of images you want to create; something that is silent and strong. Explain that you don't want the pictures to be theatrical or contrived—the goal is authenticity. Talk about the flow of the shoot—10 minutes conversing, 20 minutes shooting, and 10 minutes reflecting back on the shoot. Explain that during the 20-minute shoot it will be completely silent, that the goal will be to be patient, quiet, and still. The communication will be nonverbal with gestures and you will only be taking ten pictures.

STEP 3 PHOTO SHOOT, PART 2–SILENT PICTURES

For the next 20 minutes, be patient and quiet as you work. Aim to create 10 strong portraits.

STEP 4 PHOTO SHOOT, PART 3–CONVERSATION

After the 20 minutes have passed, graciously thank the subject for participating in this project. Ask him or her about the experience, what worked, and what didn't. Ask the subject for advice on how you could nonverbally communicate even better.

LEARNING OBJECTIVES

- Sharpen observation skills.
- Become a more patient photographer.
- Learn to connect with a subject without words and develop nonverbal communication skills.
- Build the habit of pressing the shutter release more intentionally.
- Create quiet and strong pictures.

› TIPS

Ask your subject for help in learning to be a better photographer. Make the photo shoot a collaboration between you and the subject.

Remember, there is value in the process regardless of whether the pictures make it into your portfolio or not. The goal is growth.

During the shoot, you may be tempted to fill the "quiet void" with words. Resist that urge and stay committed to silence.

EXERCISE DETAILS

Goal: Create 10 portraits. **Tools:** Camera, lens (preferably between 50mm–100mm). **Light:** Natural or available light. **Location:** Indoors or outdoors. **Themes:** Silence and strength. **Duration:** 40 minutes.

STEP 5 REFLECTIONS

Take 10 minutes to jot down your own reflections about the exercise. Write down both the positive and negative. Write about what you learned. Next, outline a few action steps that you can take the next time you are photographing a person. Finally, whether or not the exercise was a success, consider doing it a second time with another person to grow even further. ▦

LEFT Employing the techniques described in this exercise, helped this subject become more engaged. After waiting in silence, I made two frames.

Canon 5DMii, 85mm lens, f/2

OPPOSITE Kelly Slater is a ten-time world champion surfer, who leads an exciting and busy life. His voice mail box and schedule are always full. Yet I wasn't interested in capturing the bustle and excitement of surf stardom and fame. I was looking for a more authentic moment where Slater was quiet and engaged.

Canon 5DMii, 50mm lens, f/1.2

Henri Cartier-Bresson ⟩ Further Inspiration

Part of the inspiration for this exercise comes from the photographer Henri Cartier-Bresson. He once photographed Ezra Pound and the entire photo shoot was quiet. He sat with Pound for over 30 minutes and not a word was exchanged, yet a few powerful photographs were made.

Being quiet was not the norm for Cartier-Bresson, but silence was a significant part of his photography. He walked and worked quietly. And this was true in all of his work from street photography to portraits.

Not only was Cartier-Bresson quiet, he approached things slowly. He advised, "We must avoid snapping away, shooting quickly and without thought, overloading ourselves with unnecessary images that clutter our memory and diminish the clarity of the whole."

Take some time to study the work of Henri Cartier-Bresson and imagine how he tiptoed. Look up his work online and consider watching the movie *The Impassioned Eye* or buying one of his many books, like *Henri Cartier-Bresson (Masters Photography Series)*. Listen to his photographs and you will hear a distinct voice; a voice that is not loud and overstated but one that is quiet and strong.

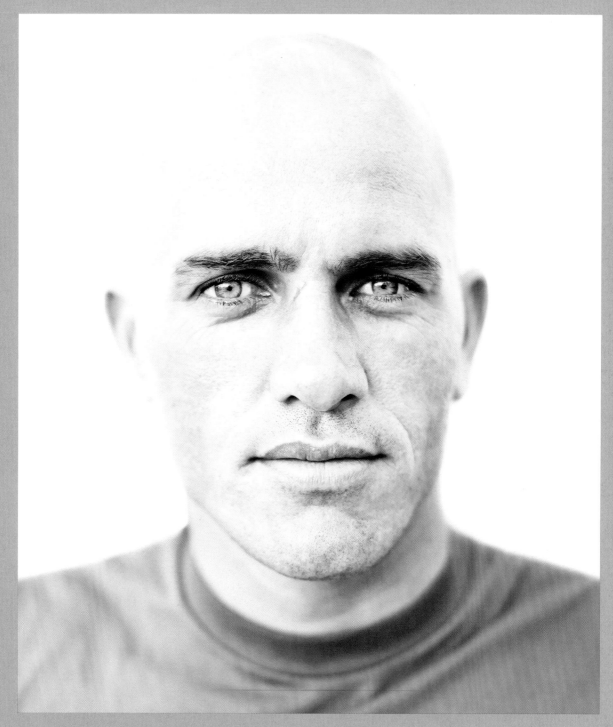

"In a portrait, I'm looking for the silence in somebody."
—Henri Cartier-Bresson

SECTION IV **PRACTICE MAKES PERFECT**

LIGHT AND AUTHENTICITY

PEOPLE PHOTOGRAPHERS tell stories with light. Sometimes these stories stay on the surface and reflect what's on the outside. Other times the light reveals what the human eye cannot see. The light becomes a soft beam that shines into the darkness, exposing inner truths that are buried deep within.

Light is valuable, and we pay attention to it in so many different ways. In photographs, the eye first looks at areas of brightness and then to focus, contrast, and color. Creating effective photographs calls for deepening our understanding of this and developing a special sensibility to the moods of light, ranging from delicate and fragile to unforgiving and harsh.

When it comes to creating pictures of people, I've found that natural and available light gives pictures a more authentic voice. There is something unique that happens when working with the natural elements. Whether inside or out, it adds a reality to the pictures that is inviting and true. And isn't authenticity what we really value and want?

I was assigned to shoot a professional athlete for the cover of a major magazine. The photo editor explained that he didn't want the typical athlete plastered with logos and lit with artificial light. He wanted a more natural and authentic mood. This window light picture was the one he selected for the cover.

Canon 5DMii, 85mm lens, f/1.6

PREVIOUS PAGE Improving in the arts, whether music, poetry, or pottery, requires passion, which fuels practice. Musician Timmy Curran knows this well; whether on the road or at home, his guitar is always close by.

Canon 5DMii, 16–35mm lens, f/2.8

Less Gear and More Agile

Windows are a wonderful source both for the quality of natural light and for the simple means of creating pictures that put the subject at ease.
LEFT Melissa stands by a window at work.
RIGHT Geivan sits next to his bedroom window.

Left: Canon 5DMii, 85mm lens, f/1.2
Right: Canon 5DMii, 50mm lens, f/2

Creating authentic photographs doesn't require using elaborate studios setups and excessive amounts of gear. In order to grow as a photographer, why not disregard all of the typical sales-driven marketing advice? Try something different and test the old adage that less is more. When you take a minimalist approach, choosing a simple location and using less gear, you become more agile as a photographer and you make less noise. With less of you, there is more potential for the subject to be at ease and for you to create lasting images.

EXERCISE › Windows and Garage Doors

Position someone next to a window or inside an open garage and they will most likely be at ease. People like to be on the inside looking out, gazing at the world and weather outside. For centuries artists have used the soft illuminated light that only a window can provide. This tradition is deep and wide; now it's your turn to contribute to this large genre of art.

Think of the following steps as a chance to follow this type of less-is-more approach. This is an opportunity to work with two similar types of available light and with just one camera and lens. The goal is to create ten good portraits in each place.

STEP 1 WINDOWS

Find a window without directional light—i.e., where the sun doesn't stream directly in. Look for indirect light that is exquisite and soft. Set up a photo shoot with a subject for a short duration of time, say 10 to 15 minutes. After a 5-minute meet and greet, start off the shoot by trying different ideas out: Change your subject's angle and position, and have him stand or sit. Really work the scenario and do this as a way to figure out what is possible. It's OK if you make mistakes; the point is to experiment within the setting.

Eventually, near the end of the shoot settle down into the position you think is working best. Inform the subject that you want to create a portrait that is present and engaged. Ask him to take a deep breath. Be patient and look for the moment that is best.

STEP 2 GARAGE DOORS

For those who prefer subtlety, one of the best and most underused locations is an ordinary garage. The simplicity of the garage makes it a bit easier to let loose as a photographer and your subject will feel at ease.

Open the garage door and position the subject in the shadow near the edge. You will discover the light is like nothing else you have seen. If necessary, hang a backdrop behind the subject to cover up all the clutter. The garage creates a box, which protects the subject from direct sun. The sky adds a sparkle to their eyes. In a sense a garage door opening is like a big window without glass. And if the driveway is a light-colored concrete, it can act as a reflector bouncing the fill light back in.

EXERCISE DETAILS

Goal: Capture 20 strong portraits. **Tools:** Camera; 85mm or similar length lens. **Light:** Soft, indirect light. **Locations:** Window and garage. **Theme:** Light. **Duration:** 10 to 15 minutes per person at each location.

› **TIPS**

Natural or available light photography can be challenging, but don't give up. Let Henri Cartier-Bresson's words inspire you: "Avoid making a commotion, just as you wouldn't stir up the water before fishing. Don't use a flash out of respect for the natural lighting, even when there isn't any."

Even the most ordinary window can create exquisite light.

When working with soft, indirect light, there's no need to rush. You will discover that because the light is subtle it requires a more calm approach. Take a deep breath and patiently capture what you see.

If you don't have a garage, any overhang will do. Experiment with positioning the subject closer and farther from the shadow's edge until you find the right combination. Try using a small stepladder or stool so that you can position the camera just above the subject's head. This will cause him to look up so that the light from the sky will brighten his eyes. Keep this session short, from 10 to 15 minutes. ▦

LEFT I found an old painter's drop cloth for a great backdrop. I stood on the red cooler to elevate the position of the camera so the light from the sky would reflect in his eyes. The subject was on his own turf and surrounded by his stuff: surfboards, skateboards, climbing gear, and cycling shoes. This made for a more relaxed and comfortable shoot. (See end of Exercise 5 for another picture.)

Canon 5DMii, 85mm lens, f/3.2

OPPOSITE Photographer Rodney Smith standing at a Dutch door at his home in New York. This setting provides the combination of a door and window together. He stands on the inside looking out as the diffused light illuminates the scene.

Canon 5DMii, 85mm lens, f/4

Rodney Smith 〉 Further Inspiration

Rodney Smith approaches the world with wonder and doesn't impose his ideas, asking deep, meaningful, and sometimes humorous questions. His photographs have a poetic cadence that is magnetic and timeless. The simplicity, geometry, proportion, and elegance draw you in. And he does all of this without the use of artificial light. Take some time to study his work and maybe even pick up one of his books. One of my favorites, which shows some of his early work, is entitled *In the Land of Light*. Visit rodneysmith.com to view his work.

"Light—with all its glorious variation from day to day, city to city, latitude to latitude—is my source of inspiration. I almost exclusively use natural light and I like to see the subject as our eyes view it but with more focus and more intent."
—Rodney Smith

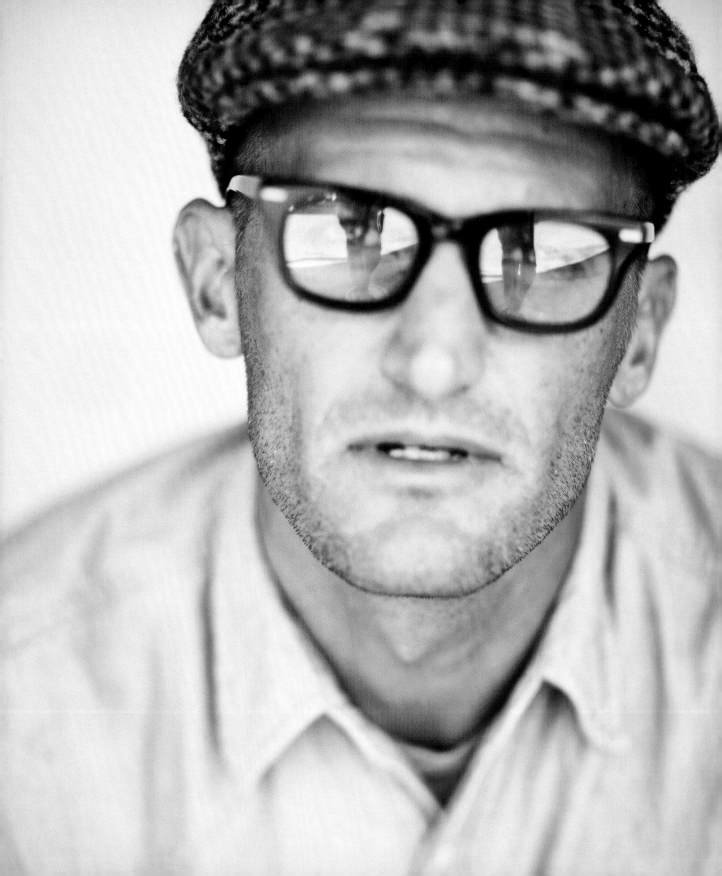

BLUR AND THE PASSAGE OF TIME

WE TAKE PICTURES to slow life down. We want to add permanence, perspective, and purpose to our lives. Pictures can etch our memories and experiences in stone so that the weather cannot wash them away. We create these photographs to bring clarity to what feels like an otherwise indescribable and fleeting time on this earth.

To intensify our story, we usually seek to create tack-sharp photographs. This is something that photography has been chasing since the 1930s when Group f/64 set out to promote an aesthetic of critical sharpness throughout the frame. The group, which included Ansel Adams and Edward Weston, used the term f/64 from the small aperture stop found on a large-format camera. This f-stop provided greater depth of field and rendered a photo sharper in the foreground and the background. Since that time and in the popular photographic forum for some, blur has become bad.

Most portrait course instructors will tell you that the eyes need to be tack sharp. Yet, every rule can be broken in order to create a different effect. In this case, the lack of focus and muted tones create a thoughtful mood and ambiguity that isn't resolved. The piercing yet blurry eye contact invites the viewer to think.

Canon 5DMii, 85mm lens, f/2.2

Blur to the Rescue

But ultrasharp and perfect pictures can fall short. They tell only one side of the story. The other side is imperfection and the passage of time. Blur comes to the rescue; it is the perfect tool to artistically convey that we don't always have everything figured out. Blur helps us to tell those often-overlooked aspects of life. For when we are confused, we don't see clearly. When tears stream, our vision is blurred. As we grow old, our eyes weaken. There is so much of life that passes by at motion-picture speed.

RIGHT In any portrait, we first look for the person in the frame. After discovering the person is out of focus in this shot, the eye travels down the tracks and then returns back. This can make for a more dynamic, thought provoking, and engaging frame.

Hasselblad 503CW, 80mm lens, Tri-X Black and White Film

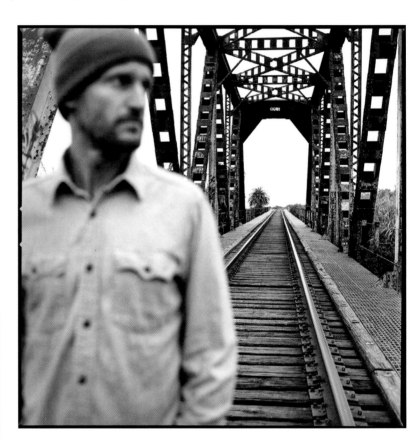

LEFT An out of focus blur looks more cohesive and smooth with film. The lack of focus creates a nostalgic and dreamlike effect of this newly married couple's connection and love.

Hasselblad 503CW, 80mm lens, f/5.6, Fujichrome Provia Film

EXERCISE ⟩ Blur Experiment

Whether for landscapes or people photographs, Ansel Adam's voice looms large. He said, "There is nothing worse than a sharp photograph of a fuzzy idea." What if for the sake of creative growth you ignored his advice? That's exactly what I want you to do. The results may or may not be satisfying, but the process will change how you work when photographing people. Here's the goal—set out to capture a fuzzy, uncertain, or soft-focused frame that is full of depth and story.

STEP 1 PREPARATION AND PLANNING

Arrange to photograph a subject for a creative and artistic photo shoot. Explain that your goal is to capture a bit of story using shallow depth of field, blur, and even some out-of-focus frames.

Before the shoot spend some time doing reading, writing, and research. Search online for blurry and out-of-focus photographs and you will discover that most feel like an overused cliché. Keep searching until you find a few that you like. Then do an online search for *poetry and the passage of time*. Read a few poems. Think about your own life and take a stab at writing about what you might like to represent in your photographs from your life.

STEP 2 FROM FOCUSED TO NOT

When you meet your subject, remind her of the goal of the photo shoot. Turn off autofocus and while in manual focus start by seeking to capture that which is sharp, clear, and concise. Get all the obvious or typical photographs out of your system for the first 5 minutes. Then progressively experiment with more focus variations. Try using different areas of focus, depths of field, frame orientation, and camera position. Experiment and play with whether the subject is in the foreground or background. Think of this as a chance to photographically study what type of blur looks best.

STEP 3 PRINT AND TITLE YOUR IMAGES

After the shoot is over, review your photographs and print out the images that you feel worked best. Give your photographs creative and thought-provoking titles. Try using descriptive and interesting words that express emotion and thought, for example "Forgotten Memories," "Distant Melody," or "Dreamscape." Really work at the titles and see what you can come up with.

⟩ TIPS

For an extra challenge, try to set your focus manually and then change the focus by physically moving around your subject.

While shooting out-of-focus frames, it's easy to feel like you are missing the shot. That's OK. Embrace the mystery and see where this creative endeavor may lead.

When breaking a photographic rule like focus and blur, don't hold back. A slight out-of-focus will look dull. A complete shift of focus and you may connect in a new way.

EXERCISE DETAILS

Goal: Capture 50 out-of-focus and expressive people pictures. **Tools:** Camera; wide-angle or normal-focal-length lens. **Light:** Natural or available light. **Location:** Indoors or outdoors. **Theme:** Artistic expression with blur. **Duration:** 30 minutes per shoot.

STEP 4 REVIEW YOUR WORK

Write down what types of focus tended to work best: Was it complete lack of focus and abstract backgrounds? Did you like focusing on color, shape, or form? What was the mood of the best images that brought you the most joy? Which pictures are poetic? Which pictures have soul?

STEP 5 RESHOOT

Many of us haven't been to photography school. We don't have the luxury of full-time study. Instead, we are self-taught and quick at learning and trying new things. One advantage that all photography school students have is the refined skill that comes from being required by a teacher to reshoot an assignment. The students who take the reshoot seriously develop tenacity, drive, and discipline. They excel far beyond the rest.

Here is your chance to try this entire exercise again. Start with Step 1 but dig deeper this time. Move to Step 2 and Step 3 with a more focused intent. Build off of the mistakes and success of the previous shoot.

ABOVE More extreme blur gives this artist's portrait an apparitional feel. Blur is often used to conceal— the less we know the more imagination takes effect.

Canon 5DMii, 50mm lens, f/1.2

OPPOSITE Keith Carter introduced me to the sculptor David Cargill. In this picture, David stands in front of a whimsical piece in his backyard. Using a shallow depth of field causes the viewer to look back and forth between the two subjects in the frame, which creates a strong connection between this artist and his art.

Hasselblad 503CW, 80mm lens, f/5.6, Tri-X Black and White Film

Keith Carter › Further Inspiration

Keith Carter is a fine-art photographer, mentor, and friend. His photographs are full of mystery and life. Keith is a visual poet who captures the world not as it is but as it might be. Visit keithcarter.com and take some time enjoying his work one image at a time.

You'll discover that each photograph is filled with lyrics and song. Rather than analyze his images, let them settle in your heart. You will soon see how his use of blur helps him create a timeless tale.

"I'm happiest when I'm making photographs."
—Keith Carter

THE FABRIC OF FAMILY

ASK PEOPLE WHAT MATTERS most, and family almost always comes near the top. Family is the most universally valued group that we belong to. And our experience of family, both frustrating and fun, is unquestionably complex.

We are strong as individuals yet we belong in a bunch. Like distinct fibers that are woven together, family forms a fabric in our lives that cannot easily be undone.

The task of the photographer is to understand, celebrate, and tell the stories. We must get close in order to make sense of the interconnected moments of birth, love, joy, illness, and death. Otherwise, rather than being authentic, the pictures will turn out to be trite. With family photographs, whether posed or candid, we want something that is honest and real. Pictures like these don't just happen on their own.

The physical closeness, bright smiles, and intimate connectedness of this photo warm my heart. Plus, it's a picture of people who mean the world to me—my sister and her family.

Canon 5DMii, 50mm lens, f/2.8

Find the Flaw to Add Dimension

Just before the shoot, I asked these boys what they liked to do. They said play music. So I asked them to bring their instruments to the park across the street. Having the instruments brought out their personalities and made the whole process much more colorful and fun.

Canon 5DMii, 70–200mm lens, f/4

Good family pictures are the result of courage and strength. They require looking, listening, and directing with a vision for something more. Rather than settling for the ordinary flattering shots, the photographer acts as a catalyst for bringing out the dimensions of family in a completely new way. Sometimes this is achieved by simply being present and putting the subjects at ease. Other times it requires a concerted effort to direct and elicit an emotional response.

Most importantly, family pictures aren't about shots of perfect moments—those are few and far between. Plus perfect is sterile and doesn't have much soul. Consider the Navajo weavers who would always include one imperfect "soul thread" in their tapestries. Let the flaw make the frame, and capture family with all of its complexity and grace.

EXERCISE › Stitch by Stitch

If the fabric of family is a grand tapestry that is made over time, why not try to capture a few recent threads? Tell the story of the individuals and how they relate. Then capture the group as a whole.

STEP 1 PLANNING

Set up a time to photograph a family that you enjoy. It could be an opportunity to photograph your own or to take pictures of another family. Explain that your goal is to capture them in an authentic, fun, and dynamic way. Ask them to dress in clothes that are comfortable and express their character. Request that they stay away from matching outfits and colors. You're looking for the personality of each member.

Choose a location that is close to the family's home. Ideally it's a spot with significance to them—a favorite park or beach. Ask the family to bring a few natural props—a Frisbee or soccer ball if they play, or instruments if they are musicians, or a family pet to include in the mix.

Tell the family to plan on 1.5 hours for the shoot. Ask them to show up to the location 1.5 hours before sunset. Even though the shoot will probably only last 60 minutes, including warm-up and wrap, families are almost always late so it's better to have them be there a bit early than to miss the golden light.

STEP 2 SETTING THE TONE

Photographing families is like the Wild West—there are no rules and often each person wants to go his or her own way. Rather than becoming a sheriff who lays down the law, try taking on the role of the wagon train leader who rallies to get everyone to a new spot. Make strong contact with each family member—shaking hands, giving high fives, asking questions—and having fun with them right from the start. Spend about 10 minutes on this.

It's often important to suggest that the parents let go of the reins. Typically, they want their kids to be well behaved. But good behavior can often look stiff or awkward in a still frame. Let them know you're the guide on this adventure and that if you lead it the result will be better photographs.

STEP 3 PHOTOGRAPHING THE ACTION

Get the family moving from one spot to the next. Don't let them stand still in one position for too long. Movement and play put people at ease. Watch how they interact and try to capture the moments as they unfold. When appropriate direct and position the family in a few different spots.

LEARNING OBJECTIVES

- Capture stylized yet natural pictures of a family.
- Explore how to direct and photograph a group of people.
- Refine your portrait skills while working quickly with a range of subjects.

› TIPS

When photographing families the biggest challenge is getting the kids to be on your side. Take extra time asking them about their interests, school, and life.

Try to get the family to interact and play. Look for the in-between moments and casually capture those frames.

Rather than solely letting the scene unfold, direct the family and try out different spots. By getting them to move it will help them be less stiff and it will keep the shoot moving so that focus is not lost.

EXERCISE DETAILS

Goal: 16 group portraits, 2 individual portraits of each family member. **Tools:** Camera; wide-angle and normal or zoom focal-length lenses. **Light:** Natural or available light. **Location:** Indoors or outdoors. **Theme:** Capturing the natural beauty of a family. **Duration:** 90 minutes.

ABOVE Photographs that include multiple generations become more valuable with time—especially after loved ones have passed on. Cousins Annie and Emi sit with their much loved Grandma.

Canon 5D, 70–200mm lens, f/2.8

With kids using contrasting phrases often works well. If you want everyone to look your way, try saying something like "OK everyone, whatever you do, don't look at me. Look at a tree or cloud over there." Next say, "Great! Now everyone look over at my lens." Fire off a few shots and then move on to what's next.

Throughout the shoot, look for opportunities to photograph each family member alone. Often these individual photographs are some of the most special of the set. Simply pull someone aside and capture a few frames, then get back to the group shots. Spend about 40 minutes on the shoot.

STEP 4 THE WRAP

In closing the shoot, have the family stand really close together and capture a few final frames. Then exclaim, "We are all done!" Give pats on the back or high fives all around. Spend ten minutes on the wrap. Keep the tone fun and thank each of them for their time. At some point, express a more calm appreciation to the parents and tell them that they did a good job. Point out a few things you notice they do well as parents—encouragement always goes a long way. ▪▪

OPPOSITE Whatever shape or form, family matters. It is the fabric that binds us together. Capturing those moments of connectedness can strengthen the bond for all those involved in the shot. What makes this photo a keeper for me is the light, family closeness, and lean of the little girl's head. Together these elements create a picture that speaks of family in a beautiful way.

Canon 5DMii, 70–200mm lens, f/2.8

The Family of Man > Further Inspiration

The Family of Man was originally a photography show of over 500 pictures of people from 68 countries. The exhibit was curated by Edward Steichen and first shown in 1955. The show toured around the world and was eventually turned into a book with an introduction by the poet Carl Sandburg. The photographs are a powerful display of culture, family, life, and death. They celebrate the connections we all have as humans. Some people refer to the collection as one of the most important photography shows of all time. To dig deeper into the topic of family pictures, consider viewing these images online or purchasing a used copy of the book. I feel this is a book every aspiring people photographer should have.

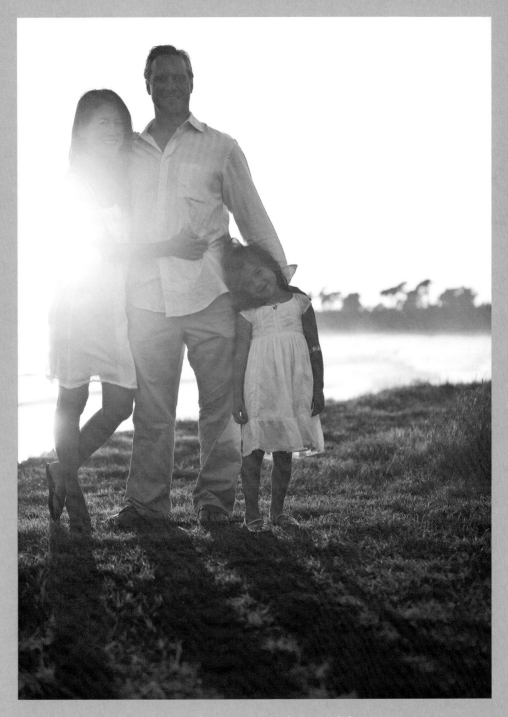

"The mission of photography is to explain man to
man and each to himself. And that is the most
complicated thing on earth."
—Edward Steichen

WIDE-EYED WONDER

16

CHILDREN LIKE TO RUN, push, poke, prod, jump, and play. They embody a sense of adventure, exploration, and joy. Kids haven't learned the subtleties of self-control or diplomacy. They are raw, honest creatures who approach the world with wide eyes and wonder. They wiggle and giggle and their imagination isn't something they restrict with a leash. For them real and pretend are one and the same.

While kids are full of character and vibrant life, they are also small and testing their boundaries, and their hopes can easily be squashed. To flourish kids require safety and trust. They need emotional and physical space that allows them to try out new ideas.

This space is limited because they are crowded with pressures from all sides: friends, parents, school, sports, schedules, music, and media, just to name a few. Most social scientists, psychologists, and parents agree, there is so much busyness that children don't always know who to be. And change happens quickly and they grow up too fast. Creating photographs of kids is an opportunity to slow down the clock and to savor the moments with them before they are gone.

Sophia races down the path to Rincon Beach. I was running next to her and trying to keep up. When kids are excited, they move fast and it's great to capture all that energy in a single frame.

Canon 5DMii, 24–70mm lens, f/5

1,000 Words Deep

My daughter Annika lept off the pool's edge with abandon and she swam towards me in the deep end. Her whole face is full of so much happiness and joy.

Canon 5DMii, 50mm lens, f/4.5, Del Mar Housing

The desire to capture the fleeting moments starts from day one. When you become an aunt or uncle, when a child is adopted or born, the experience expands your heart. The love that is formed is instantly 1,000 words deep. As kids grow, every mundane detail and moment is something brand-new. It's nearly impossible to express the joys and pains that can be felt watching them grow up. That's why we need pictures to provide a voice for the words tucked away in our heart.

EXERCISE › Follow the Leader

Letting kids be kids is the key to getting good shots. Rather than pushing and pulling and asking them to behave their best, let go and ask them to lead the way. Children like to be in charge and they love to play games. Let them lead and encourage them to have fun while you tag along. Make the photos just another element of the mix. By taking this approach and following the ideas below, you will create more natural and vibrant pictures with any subject.

STEP 1 WATCH

Kids are full of kinetic energy; they are like springs ready to explode. The next time you go for a walk, hike, or swim with your kids or a friend's kids, bring your camera along. Choose a normal or wide-focal-length lens that allows you to work close. Look for the key moments where there is a chance to run down a path, leap from the pool's edge, climb up a tree, or go for a swing. Select a high shutter speed to freeze the action or slow it down to pan with the movement so that the background becomes a blur.

STEP 2 ENCOURAGEMENT

To get the child to make an extraordinary leap, try using a gently questioning tone: "You probably aren't old enough to jump off the pool's edge? I'm sure that's too high?" Almost 100 percent of the time, the response will be, "Yes I can!" Kids love a challenge at any age. They want to show you how old and big they can be. Of course, before you goad them into doing something be sure that it is appropriate for their age. And if you are photographing someone else's kids make sure that you have their parents' consent. You may not know all the details of a child's abilities, so check ahead of time.

Be ready with your camera to capture their feat and make it an opportunity for praise—kids loving getting encouraging feedback for something new that they have accomplished. After the shot, lower your camera, give a high five, and share a few enthusiastic words.

› TIPS

Don't try to control kids or you are in for frustration and grief. Loosen up and let them come up with a few ideas, then follow their lead.

Remember that the goal isn't the photograph but to make a connection and to have a good time. If you have fun, the photographs will capture that excitement.

When photographing your own kids, try something different than what you typically do. How about borrowing an outlandish costume or prop? See if you can find something that will help make the shoot unique.

EXERCISE DETAILS

Goal: 5 action kid photos. **Tools:** Camera and lens of your choice. **Light:** Natural, full sun or shade. **Location:** The great outdoors. **Theme:** Capturing the exuberance of youth. **Duration:** No more than 10 minutes.

STEP 3 HAVE FUN

It's incredibly fun to capture photos of kids. Yet, it's important to remember that the child really just wants to have fun. Kids aren't that interested in whether you got the shot or not. So whenever you can, set your camera down and jump off the pool's edge or take a turn on the swing—be a kid yourself and make the connection real.

STEP 4 WRAP

With this type of assignment there is no need to overdo it; a few photos will do. Set out to capture five frames of a child in the midst of play. Later print out the pictures and give a few copies to the child to celebrate his or her amazing feat. ⊞

LEFT While camping in Yosemite, we set up a few rope balance beam lines. Sophia loved climbing and swinging on the ropes throughout the day.

Canon 5DMii, 70–200mm, f/4

OPPOSITE Why swing sitting down? Something caught Sophia's eye outside of the frame. It was a perfect moment of reflection before the action ensued.

Canon 5DMii, 24–70mm lens, f/5.6

Peggy Sirota > Further Inspiration

As a photographer, Peggy Sirota has done it all—from world-famous celebrities to major advertising campaigns and children's portraits. Her client list is a tour de force, but she's not a typical commercial photographer who is in it for the glamour and hype. She doesn't take herself too seriously and is known for her heartfelt, evocative slice-of-life imagery. She has an optimistic approach to life, which shows up in her work. Visit peggysirota.com and click on the link for kids to view her authentic, playful, and joy-filled work.

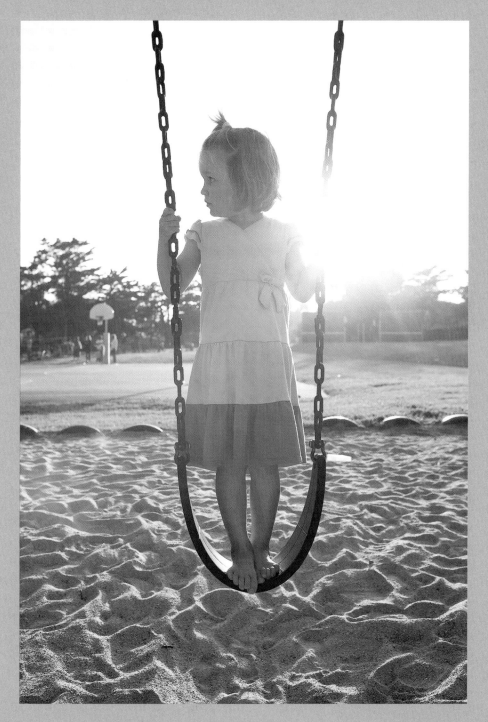

"As a photographer, I'm always striving to capture that instant when someone is willing to let their guard down and be completely genuine and real."
—Peggy Sirota

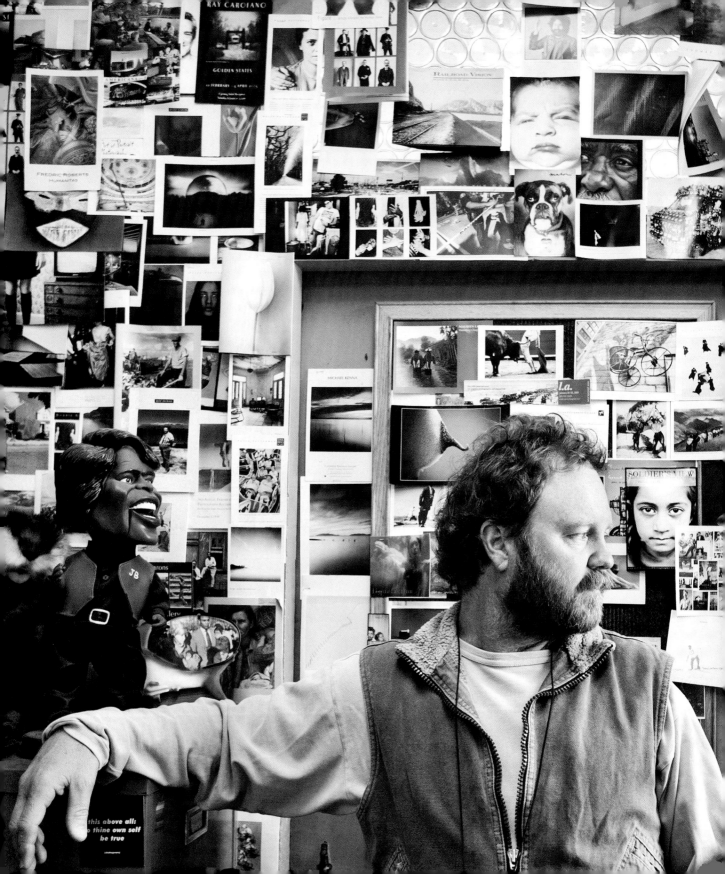

17

PEOPLE AND PLACE

ENVIRONMENTAL PORTRAITURE is a genre of photography that seeks to create portraits that are layered and full of story. The meaning and value of these pictures rely equally on the subject and setting. Good environmental portraits are those where everything fits together seamlessly, almost the way a character in a film fits into the frame—he or she just belongs there. The way to tell more of another's story is by stepping back and including more in the frame.

There is something special about photographing an artist in her studio, a shopkeeper minding his shop, or a world-class athlete practicing in his backyard. When you take a picture like this, you can achieve a special kind of intimacy and honesty.

When approaching environmental portraiture it is helpful to broaden your sources of information and inspiration to subjects like landscape and architecture photography or literature and film.

Fine art photographer and Brooks instructor Christopher Broughton in his office at the original Brooks residence and school. Christopher is always interested in getting his students out in the world, and his walls are layered with postcards that were collected on class field trips. A few weeks after this portrait was taken, he moved offices and his walls were bare.

Canon 5DMii, 16–35mm lens, f/2.8

Broaden Sources for Inspiration

An early pioneer of surfing and a world-famous surfboard shaper, Mickey Munoz stands in his shaping bay behind his home. Munoz has played a significant role in the history of surfing, and this unguarded moment provides a rare glimpse of this legendary figure surrounded by the elements of his craft.

Canon 5DMii, 16–35mm lens, f/2.8

Many great landscape photographers have quickly and easily transitioned to making strong environmental portraits because they work to understand the setting and then place a person within it. Architectural photographers know how to capture the essence of a structure. And by combining architecture with a person they can often say more.

Reading literature or watching films can give you clues and insight into how you can tell your own story when you are striving to position a person "within" rather than simply "in front of" a location. Read a favorite book or watch an award-winning film and ask yourself what makes the story more engaging and real. Then try to create your own photographs that have similar narrative depth and impact.

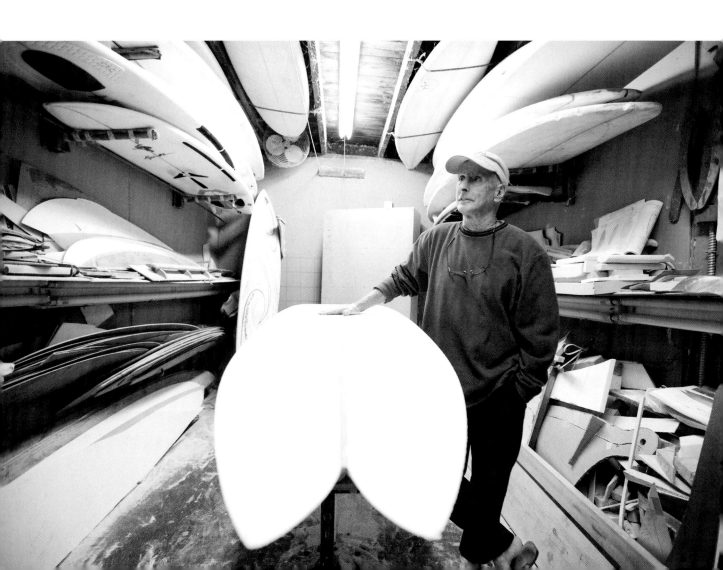

EXERCISE ❯ 5 People + 5 Locations

This exercise is about creating a body of work that is tied together with a common thread—a person and a place. This may seem like a daunting task, but with a bit of planning, the assignment will be easy to accomplish.

The goal is to photograph five people in five locations in a short amount of time. Plan for about 10 to 15 minutes for each shoot. Choose locations near where you live or work. Use natural or available light. This isn't about setting up pictures but getting out there and finding photographs, combining the traditions of portraiture and documentary photography. For each subject don't overshoot but be intentional and concentrate, capturing only five frames. The final result will be 25 pictures (five shots of five people in five locations).

STEP 1 PLANNING

Take 10 minutes to brainstorm a list of people and locations. Try to come up with options that are close to where you live and that you find interesting. Write the list without being critical of your ideas. Include places you'd like to go to, that you regularly pass by, or that catch your interest, both indoors and outdoors. Consider restaurants, rivers, mountaintops, structures, parks, picnic areas, shops, homes, offices, churches, buildings, and beaches.

Next think about the people found at those locations. Do you know anyone who frequents a particular spot? Is there someone who has an interesting home or office? Ask yourself who you would like to photograph—family members, friends, colleagues, coworkers, shop owners, or strangers? After making your brainstorming list, select your top five choices.

STEP 2 PHOTO SHOOTS

Create five environmental portraits that will fit together in a collection. Use a wide-angle or normal-focal-length lens. Use the same lens for the entire assignment. In this way you will gain a more intimate understanding of your lens of choice.

When shooting, intentionally limit the amount of time you will be spending at each location. Don't overstay your welcome, and seek to create the photographs quickly.

Position the subject so that she fits within the scene rather than in front of it. Talk with the subject up close and then explain that you are going to back up to create a picture that includes a larger perspective of the environment.

❯ TIPS

Rather than overthinking the process of creating an environmental portrait, trust your gut.

Create a composition where your subject fits within the scene rather than simply stands in front of it.

Resist the urge to embellish or idealize. Create an authentic and layered story that strives to be a concentration of the subject.

EXERCISE DETAILS

Goal: Capture 25 environmental portraits; show and share the best 5. **Tools:** Camera, wide-angle or normal-focal-length lens. **Light:** Natural or available light. **Location:** Indoors or outdoors. **Theme:** Person in his or her natural environment. **Duration:** 10 to 15 minutes per person or location.

OPPOSITE All dressed up for the end of the year play, my daughter Annika sits on top of the playground gymnastics bar. This is the pause before the spin—a small slice of time—that allows me to see into her eyes and imagine her all grown up. And I can imagine myself as an old man with tears in my eyes, looking at this picture and remembering how precious these early years were.

Fuji FinePix X100, 35mm lens, f/2

Carefully compose the frame by paying attention to the foreground, subject, and background. Pay special attention to the edges of the frames. You want the photograph to include enough, but not too much.

STEP 3 CRITIQUE AND SELECTION

After you have photographed all five subjects in their locations, share your pictures with a trusted friend. Do this in a way that is most convenient: email or prints. Most important, don't post your photographs on your blog or on Flickr. Don't show them to anyone but your friend.

A common mistake many aspiring photographers make is to show too much of their work and to show it too soon. Wait until you have selected the best of the best and then show your work. It will not only make the work stronger, but it will help you become a better photographer.

When sharing your photographs with your trusted friend, ask him to select a favorite photograph from each set of five. Do this as a way to see what someone else thinks. Next, trust your own gut and make your selection of the top photograph from each set. At this point you should have whittled the photographs down from 25 to 5.

STEP 4 SHARE YOUR WORK

Write down a short blurb or artist statement about the set of pictures. Keep it brief, from one to three sentences (for an example artist statement, see below). Share your work on your blog or one of the social media sites that you use. When sharing or presenting your work, be sure to include the artist statement.

Sample artist statement: My father struggled his entire life as a small business owner, yet he provided for our family in wonderful ways. Because of his influence, I have always been intrigued by the efforts of other small business owners, from shopkeepers to artisans, who run mom-and-pop-style stores. These pictures pay tribute to this great yet disappearing group of people.

STEP 5 REFLECTIONS

Write down three skills that you gained from this exercise. ▦

Arnold Newman ❯ Further Inspiration

If photographing a person in a place has caught your interest, consider studying the work of Arnold Newman. View his work and you will discover that each portrait is like the "concentrate" version of the subject.

He creates environmental portraits that typically become the consummate portrait of someone's life.

He is interested in personality and focuses on the individual and her essential quest, her raison d'être. View his work here: arnoldnewmanarchive.com. Ask yourself what makes it strong and how you would define his style.

"We do not take pictures with cameras,
but with our hearts and minds."

—Arnold Newman

POINT OF VIEW

I WAS BRAND-NEW to mountain biking and proud of my unridden mountain bike glistening in the sun. Noticing my distracted gaze a friend said, "Hey, let's go get that thing dirty." And we were off to the trails. Up and up we went, climbing to the top of a peak. Elated and out of breath, we were ready to begin the descent. Halfway down the mountain we took a lesser-known trail that led to a huge drop. I looked over the edge to a practically vertical trail. Without hesitation, my friend careened his way down. After 10 minutes, I had conjured up enough courage to make the 35-foot drop. I took the plunge and was proud of my incredible feat.

A year later, my friend and I revisited that same spot. I was excited to go back and retrace my glory steps. Upon arriving at the drop, I couldn't believe my eyes. Had I taken the wrong trail? The drop was no longer 35 feet high. It was just a measly 10 feet at best, and it wasn't vertical at all. I turned to my friend to ask if something had changed. His reply, "Absolutely not." What had changed was me.

Size and scale are relative to who we are and how we see. The drop appeared bigger, because I was a novice just starting out. In life, size completely depends on us. There is nothing that is really big or small. In photography, this concept is even more exaggerated, because we can combine camera position and certain type of lens to construct a unique view of the world.

I had just received some devastating news before traveling to the coastal town of Brighton in the UK. When I arrived, I walked around capturing photographs, like this one. I was looking to compose images that felt small, sad, lonely, and blue. While no picture reflected how I felt, it was cathartic to try.

Canon 5DMii, 70–200mm lens, f/10

Size Depends on Perspective

Two photographs, captured within feet of each other, using the same camera and lens.
LEFT An eye-level perspective depicts the subject as squared off in front of a construction barricade.
RIGHT An extremely low camera position portrays the subject standing tall and gazing ahead.

Left: Canon 5DMii, 85mm lens, f/5
Right: Canon 5DMii, 85mm lens, f/5

Want to make a subject look tall? Ask him to stand on a table while you sit on the ground. Want to make a subject look small? Step back and compose with an ordinary lens so that he only fills a small portion of the frame. Want to make the subject seem closer to the background than he is? Use a high-powered telephoto lens to compress the depth of the scene. Want to make the subject look silly and round? Use a fish-eye lens to distort the entire scene. And the list of unique perspectives and lens combinations goes on.

The astute photographer picks up on this right away. Rather than being distraught by the relativity of the photographic frame, she embraces the subjective way that a camera and lens see. She experiments and explores how to exploit this new view of a nonlinear and nonmeasurable world.

EXERCISE 〉 Size and Scale

In photographic education, there are loads of examples of different lenses and their look. Yet, as with anything that is relative, it can be a slippery slope. Looking at examples doesn't really teach you how to stay balanced and harness the power of the different ways to see. The only way to learn how to work with size and scale is to take the plunge yourself. Here are a few ideas to get you started.

STEP 1 PRESHOOT PLANNING

Find a friend you consider a versatile subject for a portrait shoot. Ideally, ask someone who is a photographer to take part as he might be able to help or at least will understand the project. Explain that the goal of the shoot is to capture three distinct looks using different framing and lens combinations. Go on to say that this shoot is an exercise to learn about scale and you hope to capture a few different extremes.

Choose a location for the shoot that is wide open and sparse. In addition it should allow for shooting from above and below. Set up a time to meet your subject and allocate approximately one hour for the shoot.

STEP 2 SIMPLE AND SMALL

Position the subject in a location that is outdoors but relatively sparse. Using a normal or telephoto lens, step way back and compose a graphic and simple frame. Compose it in a way so that the subject appears minute and small. When choosing the composition, make sure the subject takes up only 25 percent or less of the frame.

While you are making the pictures, think about creating something that conveys the following ideas: isolation, loneliness, silence, or peace. Before you move to the next spot, compose a few photographs so that the subject only occupies 10 percent or less of the entire frame. Really exaggerate the perspective and surround him with other stuff so that he is almost completely lost in the scene.

Continue shooting for 20 minutes until you have made ten good shots.

STEP 3 GET DIRTY

Reposition the subject so that he is standing on a higher vantage point. Using a lens of your choice, lie down on the ground and point your camera up. Get as low as you can to make the subject seem larger than life. Compose the frame so that you include the full body. Shoot pictures up close (6 feet away) and far

〉 TIPS

While I've provided a few experimental ideas, try to come up with a few on your own. Learning to see requires that you make your own mistakes.

To increase the value of this exercise, shoot for the extremes. Don't worry about the results, but exaggerate the perspective as far as it can go.

If you have a typical "go to" portrait lens that you like best, don't exclusively use it for this exercise. Try out some of the more specialized lenses to see what is possible. If needed, rent a few different lenses from your local camera shop.

EXERCISE DETAILS

Goal: 30 size/scale portrait experiments. **Tools:** Camera; assortment of lenses. **Light:** Natural or available light. **Location:** Outdoors. **Theme:** Size and scale. **Duration:** One hour.

Leica M6, 50mm lens, f/8, Tri-X Black and White Film

away (20 to 100 feet away). Use the relative space in the frame to make the subject seem more substantial. Compose so that the subject fills 50 percent or less of the frame.

Continue shooting for 20 minutes until you have made ten good shots.

STEP 4 FILL THE FRAME

Walk with the subject to one more location where the light catches your eye. Look for a lighting scenario that is flattering and will allow you to capture a sparkle in his eyes. Position the subject and then use a tele-photo lens to get up really close. Fill the entire frame with the subject so that part of his body is cut off from the frame. Shoot pictures from three viewpoints: kneeling, standing, and above eye level. Think about creating portraits that are dynamic and have life. Try to capture images that convey the full intensity of the subject's presence.

Continue shooting for 20 minutes until you have made ten good shots.

STEP 5 PHOTO REVIEW

Review your favorite photos from each different view. Give the photographs a title that thematically summarizes that particular type of view. Jot down a few notes in a journal of the skills and techniques that were learned. ▪▪

OPPOSITE It's tough to get creative when you are photographing a live event, because you need to stay in one spot and not distract from the show. Most of my shots were the same until I recomposed so the artist, Jack Johnson, would appear small. This made for a quieter picture, which became one of my favorites from that day.

Canon 5DMii, 70–200mm lens, f/2.8

Michael Hanson 〉 Further Inspiration

Michael Hanson started his photographic career in an unlikely place—playing professional baseball for the Atlanta Braves. His work while at home and while traveling on the road with his team quickly became recognized as top-notch. Hanson traded in his baseball bat permanently for a camera. He gained a new way to see the world and had a unique perspective as a former player.

Hanson has since traveled the world photographing stories, people, and places. As a photographer he has an immense client list, has won numerous awards, and has been recognized as one of the world's best. View his work at michaelhansonphotography.com and pay careful attention to how he uses relative size and scale of the subject and environment to convey a wide range of ideas. Take some notes down on the images and perspectives that inspire you most.

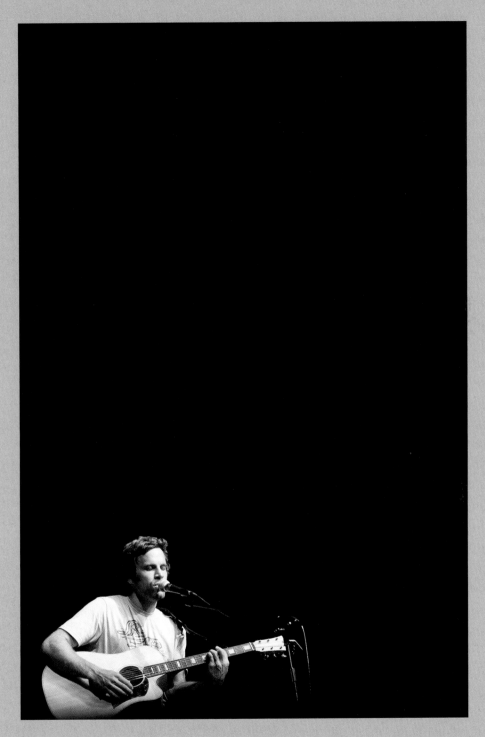

"One's destination is never a place but a new way
of looking at things."
—Henry Miller

CURIOUS COMPOSITION

PHOTOGRAPHY, like most art forms, requires a selective mind. Consider the musical composer who sets out to write a new song. The first step is to choose a key, and this is a defining event. Once the key is selected the creativity and composition can begin. This is one of the great paradoxes of creativity—restraint begets potential. The selection or limitation creates the space needed for the song to be born. Without a key, the composition wallows in self-doubt.

And composition is a curious thing. It can refer to music, painting, drawing, photography, dance, writing, poetry, and so on. At the same time, composition can refer to how one carries herself. Consider the athlete who is well-composed and calm in spite of a competitive threat. What connects all forms of composition is a certain amount of restraint. Good composition isn't reckless but well thought out. Great composition tends to bring order and peace to an otherwise cluttered and confusing world.

Using a 50mm lens allows you to physically get close. I was talking with my mentor and friend Keith Carter, a fine art photographer. At one point, he raised his glasses and pointed to his cancerous eye that might go blind. While listening, I quietly composed and created this frame as the conversation continued. The composition conveys what this picture is about. Fortunately the cancer has been cured and he is doing fine.

Canon 5DMii, 50mm lens, f/4

Relationship of Photographic Elements

The two kids climbed into the apple cart for a ride through the orchard. Knowing that sometimes a slice is as good as the whole, I moved up close to compose a picture with more poetic cadence and restraint.

Canon 5DMii, 50mm lens, f/4

In photography, composition refers to the way that we use space. At its most basic level, it refers to the use of the frame. Good framing requires that we leave, cut, crop, or intentionally compose something out. Ask a seasoned pro about composition and she will tell you, "What is left out is often as important as what's inside."

When making compositional decisions, a photograph relies on the lens and a particular point of view. Is the vantage point low or high? Is the lens an up-close zoom or something expansive and wide? Equally important are the spatial relationships of each of the photographic elements. The photographer is always asking, "How do the lines, density, tonality, color, contrast, and subject relate and interact?"

As all photographers know, improving photographic composition requires an inquisitive mind. Photography isn't something you ever truly figure out. It requires an insatiable curiosity to explore different ways to see.

EXERCISE › An Economy of Means

In people photography, composition is the language photographers use to express how they want the subject to be understood. With a slight compositional change a picture can go from cluttered to serene. The skill to make the change is something that is gained through practice over time. The better we get, the less we need to say. Like the novelist who learns how to use more precise language to express more profound ideas, composition is about the economy of means.

STEP 1 LEADING LINES

When you look at a photograph your eye follows the lines like a hiker sticking to a well-trodden path through the woods. In pictures, the lines lead and create a dynamic flow.

To learn how to harness the power of lines, find a location with well-defined straight or curved lines. When looking for the right spot, consider exploring park paths, bridges, city streets, stairways, or anything that provides distinct perspective. Position the subject so that the lines lead up to his spot. Strive to create a dramatic and obvious path. When composing the shots, carefully organize the scene. First look at the subject and then look around the frame. Pay careful attention to where each line starts and stops. Consider starting with a symmetrical approach. Next, change the composition to try different extremes. Create at least 15 dynamic line-filled shots in one location.

STEP 2 VANTAGE POINT

Too often, people photographers stand still hoping to find an interesting frame. As most seasoned photographers know, this doesn't work. The best photographs result from of a unique point of view. Good photography requires that you move.

Movement starts with what we wear, so throw on some functional clothes and a pair of running or hiking shoes. You have to plan to get dirty in order to learn how to see. Before the shoot, get out a few tools that will help you change the way you stand. Here are a few ideas: ladder, towel or drop cloth, some kneepads, and anything else that will get you off your feet.

Choose a location and subject that have potential for many perspectives. Before the shoot create a checklist of different vantage-point types of shots. Your list might include shooting from perspectives like this: bug, dog, upside-down bat, or bird in a tree. During the shoot make sure to capture each type of shot. As you experiment with these perspectives be sure to shoot both up close and far away. Choose five perspectives in your location and shoot at least five pictures of each.

EXERCISE DETAILS

Goal: 60 portraits that are different than anything you have ever done. **Tools:** Camera; wide, normal, or telephoto focal-length lens. **Light:** Natural or available light. **Location:** A natural environment that will provide you space to experiment and play. **Theme:** Composition curiosity. **Duration:** 30 minutes for each shoot.

STEP 3 OFFBEAT

Rodney Smith once said, "Composition is to photography as rhythm is to music." Rather than following your typical beat, I want you to veer a bit off the ordinary path. To prepare for this type of work, listen to a few songs by Miles Davis from the album *Kind of Blue*. (Look it up online if you don't own it.) Let go of whether you like the music or not and embrace the tunes. As you listen, remember that jazz is about creating mood, interpreting sound, and combining the improvisations of a group.

Set up a shoot and strive to collaborate with your subject to improvise in a completely different way. In particular, try taking pictures where you crop in a way that breaks all the rules.

Try some of these ideas: Photograph a person and vertically crop him in half. Try a portrait without showing his head. Ask him to hold up his hands and block the camera's view. Manually focus everything but the background to a blur. Turn your camera upside down. Get creative and loose. Let go of the old notion that the horizon needs to be level or that the eyes need to be sharp. Resist using your typical bag of tricks and bend the notes a bit. Create 19 photographs that belong in a set. ⚏

ABOVE In typical portraits the subject's face and eyes are located in the top half of the frame. Rather than follow that rule, I flipped the logic to create a different feel.

Fuji FinePix X100, 35mm lens, f/2

OPPOSITE Compositions like this are risky, and they will either turn out great or be a complete flop. In this case, I like the results of the portrait, because of the graphic composition and the focus on the hands. With your own pictures take chances to compose in subtle and dramatic ways.

Hasselblad 503CW, 80mm lens, f/2, Ilford HP5 Plus Black and White Film

Elliott Erwitt 〉 Further Inspiration

Elliott Erwitt's photographs reveal an uncanny approach to life. Study his work and you will find yourself drawn in by his irony, wit, and visual puns. While Erwitt's pictures might make you laugh, they are not surface deep. Look closely and you will discover subtle truths buried within each frame.

Take some time to study his work online at elliotterwitt.com or view one of his many books. While looking at the photographs take note of the many ways he uses composition to convey a wide array of vivid ideas.

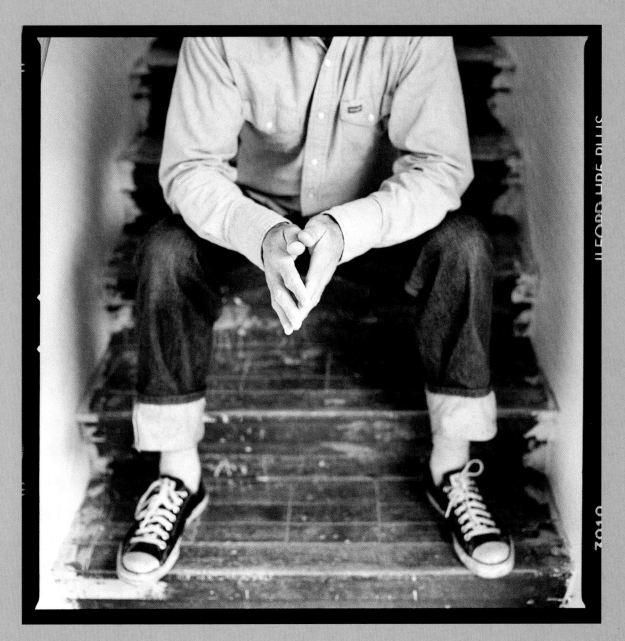

"You can find pictures anywhere. It's simply a matter of noticing things and organizing them."
—Elliott Erwitt

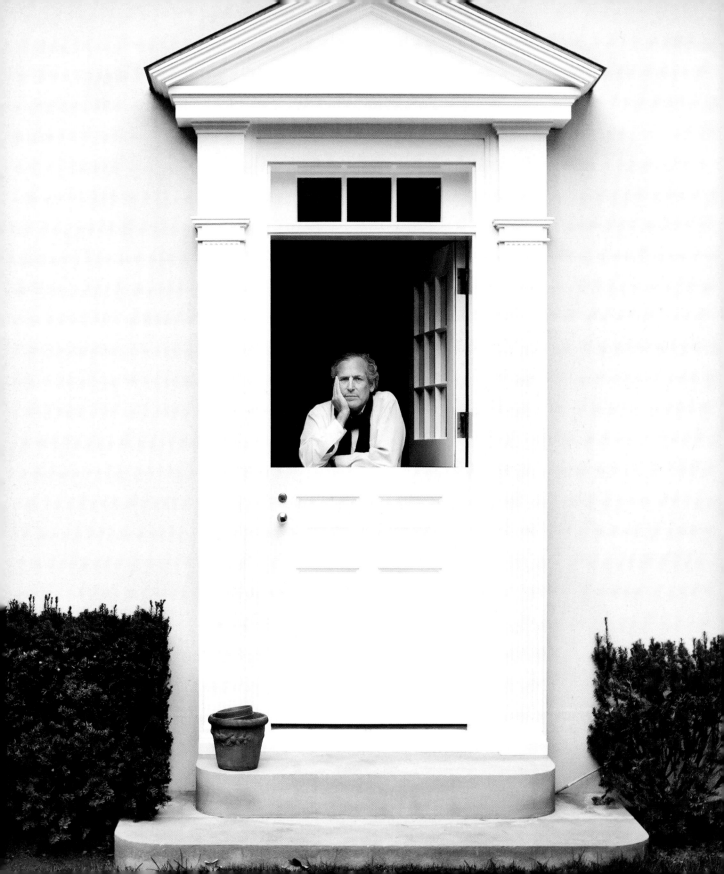

FRAMED

AIRPORTS ARE CURIOUS PLACES. They are filled with people, but nobody really belongs. Everyone is either coming or going, and this makes airports perfect for watching and wondering. It's like going to a museum and looking at art—no creative action is required. Photographing people starts with the same curiosity, but making pictures requires taking a decisive step.

In a sense, a photographer is one who moves beyond observation to make the art and then curates the museum show. The word *curator* comes from the Latin *cura*, which means to care. A photographer is one who sees, studies, and selectively determines what matters most. Photographers care. They care so much that they get up out of their seat and engage with those they observe.

Once you've crossed the threshold of deciding to make a picture, the process begins. The inexperienced photographer looks through the lens and is drawn to the subject alone. He pushes the shutter and is proud of what he has done. Later, he discovers that the picture didn't turn out right. All of the elements are small, crowded, cluttered, and confused. Nothing stands out and you don't know where to look. Like rushing through an airport, it all becomes an indefinable blur.

To make strong pictures, the photographer needs to look through the lens and then look around the frame. He must get close, slow down, and make a decision about what catches his eye. This will guide him in how to use the edges of the frame to compose a more orderly and organized shot. The four edges help convey what he cares about most. Frames, whether the edges of a picture or the physical artifact surrounding a picture hanging on a museum wall, define a photograph and set it apart.

Photographer Rodney Smith knows how to use a frame, and he has the most perfect composition of any contemporary photographer I know. His pictures have a poetic cadence that follows the beat of the human heart. Everything is in the right place, yet his pictures are not meticulous and sterile. When I photographed him at his home in New York, I wanted to create a portrait that reflected how I felt about him and his work.

Canon 5DMii, 35mm lens, f/4

Building a Frame

This London subway tunnel was the perfect frame for people passing by. I stopped to watch and noticed how the ceiling, floor, and walls created lines that directed the eye. Using a slower shutter speed I was able to capture the slight movement of this temporal scene.

Canon 5DMii, 16–35mm lens, f/2.8

Developing awareness and skill with how to use the frame is something every photographer must learn. Otherwise, all of one's pictures will seem bland and without a sense of space. Including a frame within the picture's edges is a tried-and-true technique that can help you hone and develop your framing and compositional skills. Rather than relying on the defined edges of a photograph, look for lines, edges, and frames in the world and compose to create your own.

Effectively experimenting with this technique can potentially help you in few different ways. First, it will heighten your awareness of how people fit within a defined space. Then later, whether or not you use the technique, it will improve your overall compositional techniques. Finally, it can lead to creating powerful and well-defined shots.

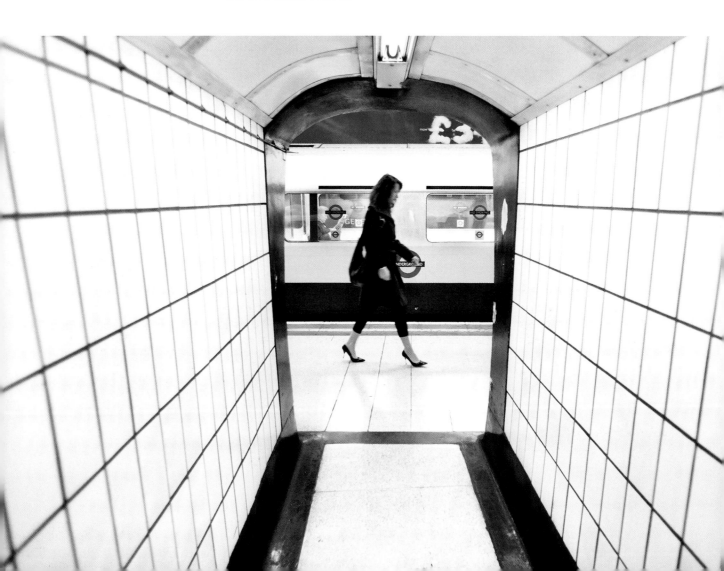

EXERCISE › Frame within a Frame

For many photographers, learning composition is a difficult thing to do. It requires developing a strong sense of how to use space. When you add the idea of a frame within a frame, it requires completely new eyes. Therefore, in this exercisewe will take a non-traditional approach by expanding how we see, and by putting our new vision to the test. Start by imagining that you are going to take a self-directed course called Introduction to Architecture. Architects are masters at creating frames and defining space. Let's see if we can learn something from them in order to gain a more architectural view on life.

STEP 1 LEARNING TO SEE

Take out your journal and begin by visiting a local bookstore. View at least six architectural design books (or if you can't get to a store, look up the books online). Study how the architect uses angle, line, and form. Write down any inspiring ideas. Next, drive to a nearby location in your town where the architectural design appeals to you. Go for a walk and observe the many elements of design. People-watch and pay special attention as pedestrians walk by the windows and doorways. Write down your observations and sketch out a few ideas for a framed portrait shot.

STEP 2 CHOOSING A SUBJECT

For this shoot, choose a subject who is a close friend. Explain that the goal is to try to use something in the physical world to create a frame within a frame. Creating these shots will take time and travel, so ask your friend if he is up for the job. Perhaps you could try to catch his interest by offering to buy him lunch after the shoot. Most importantly, make sure he is committed to the cause. Allocate two hours for this shoot.

STEP 3 WORKING WITH LOCATIONS

Rather than capturing these images as preconceived ideas, go out into the world and see what you can find. In one hour or longer, visit at least four different spots. Begin by picking a location with structures that you think might work. When you arrive, look for anything that could act as an edge: walls, windows, sculptures, telephone poles, trees, and so on. Relax, experiment, and have some fun. Don't get stuck on one idea but try framing in various ways, like up close and far away. If you don't find the perfect shot, move on to the next location.

EXERCISE DETAILS

Goal: 10 pictures. **Tools:** Camera and lens of your choice. **Light:** Natural or available light. **Location:** Outdoors or inside. **Theme:** Frame within a frame. **Duration:** One hour.

> TIPS

If you are stuck for ideas, start with something easy. Try framing the subject within a doorway, window, or two walls.

For a challenge, frame the subject with light, shadow, color density, and form.

If your first pictures aren't great, don't give up. Learning how to compose with this framing technique will take practice and time.

For a more literal interpretation of this exercise, consider buying an empty used picture frame at a thrift store. Hang the frame from the branch of a tree or ask the subject to hold the frame in front of himself.

The goal for visiting different locations is to start to develop the ability to frame and think on your feet. Try to make the images quickly and without much thought. For an extra challenge, try shooting at one location that is indoors. Keep shooting until you have captured ten pictures where your subject is framed. Call it a wrap and go buy your friend a good meal.

STEP 4 EVALUATING THE PHOTOGRAPHS

After the shoot is over, don't just view the pictures on a computer screen. Take the time to print out your ten favorite shots. Set them in a row and evaluate each one. In your journal, write down a few notes on the skills that you gained. ▪▪

LEFT Nate Rogers stands perfectly framed in the window of an old abandoned house in Baja California.

Canon 5D, 50mm lens, f/1.4

OPPOSITE Shawn Stussy is an artist and designer with a simple, edgy, and clean style. I wanted to make a picture that reflects the art and clothing that he creates. Here an ordinary warehouse door and an unfinished wooden surfboard become a geometric scene that makes this picture work.

Canon 5DMii, 85mm lens, f/1.4

Dwell 〉 Further Inspiration

Framing has as much to do with camera work as it does with how to see. It is a perfect combination of one's internal vision and where the camera's gaze is directed. When it comes to photographing people within a scene, framing gives the photographer the ability to make every piece fit. To develop your eye in this area, view the architectural magazine *Dwell* (dwell.com).

In particular, study the past covers of this magazine as each one contains a person within an interesting architectural space. Look at the interior of the magazine and you will discover *Dwell*'s photographic vision is to cleverly fit people within a distinct and interesting architectural design. Most of the architectural pictures are as devoted to the portraiture as they are to architecture. It is the perfect combination to study to see how you can further develop your own skills for creating frames within the outer edges of a photograph.

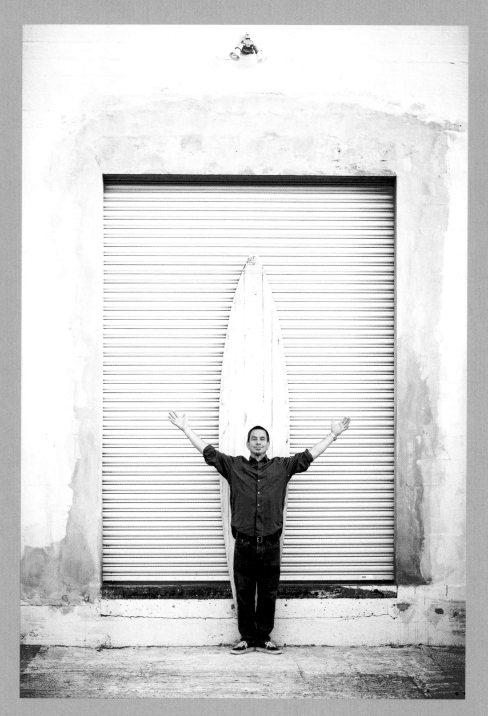

"To quote out of context is the essence of the photographer's craft. His central problem is a simple one: What shall he include, what shall he reject? The line of decision between in and out is the picture's edge."

—John Szarkowski

LIFE AS IT UNFOLDS

THE MAJORITY OF THE TIME, we make pictures of people that are planned, previsualized, storyboarded, or well thought out. We practice to capture something that is authentic and real. We collaborate with our subjects so our pictures reveal more. And to our surprise, every so often the preparation and collaboration perfectly coalesce. In those moments we proudly make photographs that provoke, move, and suggest. While this is the most common path, there is another type of photography with greater rewards that can be equally as fun.

Life unfiltered and raw is more primal and real. There's no rehearsal, acting, or need to unwind. With a camera in hand, you can capture moments that otherwise would have been lost. Life moves fast, and the camera has the capability to slow everything down. That is, of course, if you can keep up with the pace.

Keith and his wife, Patricia Carter, share a close and special bond— they are partners, soul mates, and friends. And there is nothing like catching that candid magical spark between a couple. When Patricia first walked in the room, everyone lit up with warmth and smiles. Fortunately, I had a camera close by.

Canon 5DMii, 35mm lens, f/2

Shooting Without a Pause Button

The main issue with photographing life as lived is the fast-paced speed. There's no pause button and no chance to replay a great scene. That's why most photographers fail miserably at capturing people in their natural element. Like photographing wild animals on the Serengeti, this type of work requires acute observation, inextinguishable patience, and great agility and speed.

These types of pictures are hard to achieve. Most photographers give up without even putting up a fight. They retreat to the comforts of their studio. The photographers who try and don't give up are rewarded for their dedication.

With their first success they are infused with a desire to not let anything slip by. There is purity to this pursuit that cleanses and renews. This experience changes their chemistry. The mundane seems magical and so does everything in between. The camera becomes something from which they cannot part. The camera is a lifeline that helps them live a more fulfilled life.

EXERCISE ＞ Walkabout

This exercise is the equivalent of an electric guitarist unplugging his amp or an NBA superstar playing a pickup game of basketball on the street. Shedding all of the baggage can make you feel free and also really exposed. This is photography at its core. All that is required is a camera and a good pair of walking shoes. It sounds simple—go out and take pictures of life as it is—but that's exactly what I want you to do. Yet we're going to do this in a few interesting ways.

STEP 1 DAY #1–YOUR OWN BACKYARD

Bring your camera with you for just one day. Don't take pictures of what you do, but photograph the people you meet. Bring your camera to work, lunch, and school. Whether you cross paths with an old friend, boss, or someone completely new, take pictures that show who they are and how they live. The pictures you make are completely up to you—capture candid shots or compose well-intentioned frames.

STEP 2 DAY #2–THE TOWN NEXT DOOR

It's easy to think that if only we traveled to Italy, our pictures would be great. While I doubt this would be true, travel does have a way of getting us to open our eyes. For this part of the exercise, I want you to travel to a nearby town without any preconceived ideas. Pretend that you are visiting the location for the first time. Bring your camera and one lens. Let go and leave your cell phone behind and go for a walk to scope out the town.

STEP 3 TOURISM AND TRAVEL IN THE TOWN NEXT DOOR

As you approach shooting the town next door, remember that tourism and travel go hand in hand, but each is a completely different world. Tourists know exactly what to look for (they've been told) and they follow the signs that tell them where to go. Travelers may not have a map or know where they're headed, but they will certainly have a better understanding of where they've been. When you visit this nearby town, I want you to be a traveler. Even if you are familiar with the place, try to find what isn't typically seen. Be patient and observe life as it is. Take pictures of the people who capture your eye. Get lost and go with the flow.

LEARNING OBJECTIVES

- Become a more observant photographer by photographing people in their natural element.
- Develop patience, lightning quick agility, and speed.
- Discover how to compose photographs without asking the subject to move.

> TIPS

Photographing life as it unfolds should be something that is relaxing and fun. If you are feeling pressure to perform, take a deep breath and set your camera down. Focus on the experience, not the pictures that are being made.

What makes life the most interesting is the people we know and meet by chance. That is what we will remember most. Try to see if you can capture this on film.

Photographing life as it is requires giving up control. Yet it's still up to you to make the most of what you have. Ask yourself how you can use the camera to arrange the frame to capture what is unique.

EXERCISE DETAILS

Goal: 10 strong pictures of unrehearsed life. **Tools:** Camera and lens of your choice. **Light:** Natural or available light. **Location:** Outdoors or inside. **Theme:** Capturing life as it unfolds. **Duration:** Three different days.

ABOVE With a camera on my shoulder, I walked down a hallway where I work and noticed the early morning light cut across the walls. This subject stepped through the light and I quickly asked if he would pause.

Leica M6, 50mm lens, Tri-X Black and White Film

STEP 4 DAY #3–ACROSS THE POND

Photography is one of the greatest excuses to hit the road. It is the perfect alibi. Choose a location that you would otherwise not visit for this last trip, whether that's across the big Atlantic "pond" or just a closer location that you haven't seen. Before you go, don't look at any travel pictures or books. Try to go with a fresh and open perspective so that you are surprised at what you will see.

STEP 5 POSTCARDS FROM ACROSS THE POND

Most commercial postcards show us the main buildings, fountains, or vistas that we should see. Rather than take those typical shots, tell the story of the place by photographing the people who live there. Take one full day to capture the activity of a town. Take pictures that are up close and far away. Capture all of the details but make sure each and every picture includes a person in the frame. Resist the urge to photograph the fountain with no one around. Wait until the old man hobbles up, throws in his coin, and makes his wish. Capture that moment. Aim for ten strong postcards of your own. ▪▪

OPPOSITE While traveling and shooting in Europe, my heart ached to return home to see my wife. It's no wonder that everywhere I looked I saw couples like this sitting on the beach. Using a shallow depth of field, I focused on the foreground so that the couple would become a dreamlike blur. Adding the tone and color in postproduction, together with the depth of field, helped communicate the feelings I was carrying around inside.

Canon 5DMii, 70–200mm lens, f/2.8

Robert Doisneau ❯ Further Inspiration

Robert Doisneau documented the French people in a memorable way. He constantly looked for the amusing or surreal in everyday life. His photographs are playful and feel unposed. While his pictures were made decades ago, the people in the frames seem like people you could know today.

Doisneau had a knack for making pictures with timeless appeal. Looking through his work you'll discover that he was an optimistic observer who never lost his zeal. Take some time to study his work on the Web and consider picking up one of his many books.

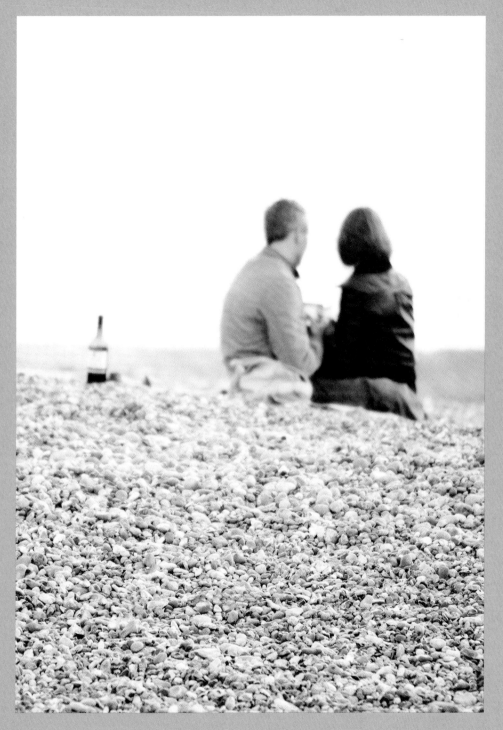

"The marvels of daily life are exciting; no movie director can arrange the unexpected that you find in the street."
—Robert Doisneau

UPBEAT AND ALIVE 22

THE HUMAN FACE is a landscape that is ever changing. Each angle, wrinkle, and scar tells a story of how one has lived—the longer the life, the less hidden the truth. Day in and day out, the 43 muscles of the face respond to everything that we see. The face receives, projects, and protects. And it's not just the face; the rest of the body is complex as well, made up of over 650 muscles. Each one contracts and expands in a way that reflects what's inside and what we value most.

When we were young, movement was less inhibited by habit or restraint. Children climb, jump, and play. The older we get, the more we retreat. The more we retreat the less we move. Life becomes busy, complex, and full of stress. The remedy is simple—get up and move. Even a simple movement like tapping your feet can subtly improve your mood. Go for a two-hour hike and you will feel brand-new. Movement melts stress like wax before a flame.

This isn't just a nice theory; biologically movement literally improves one's health. It causes the brain to release endorphins and the heart to dance to a new tune. Test it out for yourself. Stop reading this and take a deep breath and stretch your hands and arms. Open your eyes, stretch out your mouth, and then smile. Don't you feel better?

After creating some classic and static pictures on the Brooklyn Bridge, I asked the subject if he could stretch, jump, and move. What started as a few subtle movements turned into a succession of leaping and kicking of heels.

Canon 5DMii, 50mm lens, f/2.8

Point a camera at someone and the subject typically freezes. Suddenly we don't know how to move, let alone breathe. We stand still, frozen like a deer in the headlights, not knowing which way to go. Now self-consciousness, stress creeps in, and the muscles of the face brace themselves for the impact. In a defense mechanism, we grow cold. The only solution to a situation like this is to turn up the heat.

With a bit of movement we warm up. Movement requires an increased oxygen intake so we inhale and breathe. Self-consciousness and stress loosen their grasp. Blood flows more freely. Color returns to a previously slightly pale face. Furrowed brows relax and vision becomes clear.

Photographer Philippe Halsman once said, "When you ask a person to jump, his attention is mostly directed toward the act of jumping and the mask falls..." Here my daughter Annika leapt off the pool's edge. (See what happened next in the photo on page 102, Exercise 16.)

Canon 5DMii, 50mm lens, f/4.5, Del Mar Housing

EXERCISE › Move Your Feet

When we don't want to be noticed, we stand still—it's a disguise or a way to hide. When we are sad or depressed we stop and sink into a chair. Clearly, the lack of movement conveys a listless or languid mood. For certain types of pictures, that mood may be just right. Yet what if it shows up inadvertently? In those cases, it's time to get your subject to her feet. Get her to move and regardless of age, it can convey kinetic strength.

Movement translates into vigor, spirit, vivacity, and joy for life. When it comes to people pictures, movement has the potential to reveal who your subjects are. Getting your subject to move is arguably one of the portrait photographer's most important techniques. Follow these steps to expand your skills in enticing subjects not to be still.

STEP 1 SELECTING A SUBJECT

Choose a subject who interests you. Select someone who is young or old, stiff or flexible, animated or not. Regardless of one's age or being able-bodied or not, there are movements that we all can do. Don't limit your search to someone who is an athlete, dancer, or yoga guru. In fact, you will learn more if you choose to photograph someone old or just an ordinary Joe.

Contact the subject and explain the idea for the shoot. Request that the subject bring or wear clothes she can move in. Set up a time to meet that is near or during sunrise or sunset. The total time for the shoot is 45 minutes.

STEP 2 PRESHOOT PLANNING

Scout a location that is somewhere outside. Visit the local area to get an idea of the movements that are possible. Some spots like the beach might be conducive to running or jumping in the sand. Other locations might provide opportunities for the subject to balance or just stand. Still other spots might be perfect for someone to be sitting on a yoga mat. When scouting the location, imagine a few types of pictures that you would like to make and takes notes for the supplies that you might need.

STEP 3 THE WARM-UP

Warmly greet the subject and express gratitude for her time. Because these pictures are about movement, begin by asking the subject if it would be OK if you both did a few stretches. Keep the stretches simple and take a few deep

LEARNING OBJECTIVES

- **Rediscover why movement matters.**
- **Learn to create well-composed pictures with a moving subject.**
- **Explore how to mirror, model, and demonstrate movement for your subject.**

> **TIPS**

When you demonstrate the movements, be sure you have your camera secure so you don't drop it. Try tightly wrapping the strap around your hand.

If specific movement ideas are not turning out right, shrug it off. One movement will lead to another. It's more important to keep the flow going than to correct something that has gone wrong.

Throughout the entire shoot, smile and have fun yourself.

Consider turning on some music during the shoot. The right music can make people move like nothing else.

EXERCISE DETAILS

Goal: 22 pictures of a moving subject. **Tools:** Camera; lens of your choice. **Light:** Natural or available light. **Location:** Somewhere outside. **Theme:** Capturing the movement of life. **Duration:** 45 minutes.

OPPOSITE For the first few photographs, the subject was slightly stiff and self-conscious. So I asked her to stretch, walk, and turn around. This did the trick and after some movement, her mask of self-consciousness fell. I then suggested that she pause, look down, and then slightly look up, which resulted in a natural picture.

Canon 5DMii, 85mm lens, f/1.2

breaths. Make sure the stretches are appropriate to the fitness level or ability of the subject. Keep the tone casual and use the initial stretching to put you and your subject at ease. You'll be amazed at how stretching before a shoot can make you, the photographer, much more relaxed and engaged.

STEP 4 MOVE YOUR FEET

Begin by walking to the desired spot. Position the subject within the environment and ask if she has any particular movement ideas. Perhaps there is a favorite stretch, yoga pose, jump, or spin that she likes to do. If not, offer up a few ideas. Ask her to stretch raising both hands and arms up into the air. Then suggest a deep breath. Take a few pictures and have some fun. Keep the mood upbeat.

STEP 5 REST AND REPOSE

After a series of movements, ask the subject to stand at ease. While she is "resting" make a good frame. Often the photographs just after movement are best; these are the pictures when the subject has let down her guard.

STEP 6 MORE MOVEMENT

Continue to suggest movement ideas. Here are a few more to try: walking back and forth, jumping, leaning, sitting, looking in different directions, spinning around. Give her examples of your ideas by demonstrating a few movements yourself. This will help get everyone on the shoot, including you, more engaged.

STEP 7 THE FINAL SHOT

After some time, look for a place for the more static shot. This is often when the magic happens because both the photograph and subject are relaxed and at ease. Explain that you have captured more than you need but would like to make one more shot just because everything is going so well. Be patient with this picture and strive to compose something profound. After making the photograph, thank the subject for her time and call it a wrap. ▪

Philippe Halsman 〉 Further Inspiration

Philippe Halsman is regarded as one of the great portrait photographers in the history of our craft. He was an elite and respected Magnum photographer who captured celebrities and people of interest in sparkling and revealing ways.

Halsman's photographs are undoubtedly some of the best. Particular to the topic of this exercise is his book entitled *Jump Book*. Visit magnumphotos.com and do a search for his name. Click on the link to his book and view the portraits. Consider making some pictures of your own that feature exuberant movement.

"Lighting and fine camera equipment are useless if the photographer cannot make them drop the mask, at least for a moment, so he can capture their real, undistorted personality and character."

—Philippe Halsman

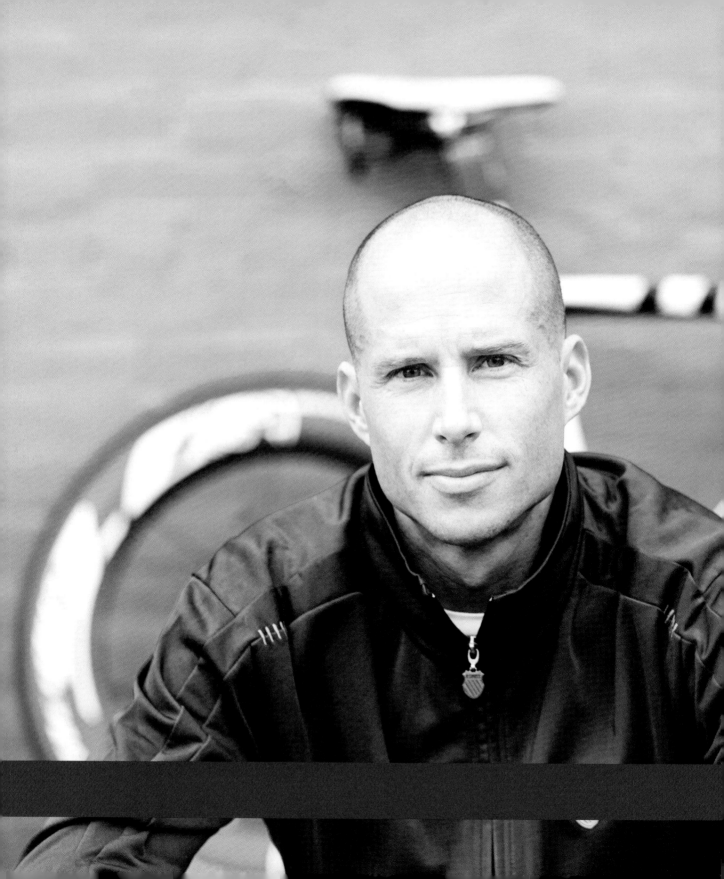

SECTION V **MAKING IT YOUR OWN**

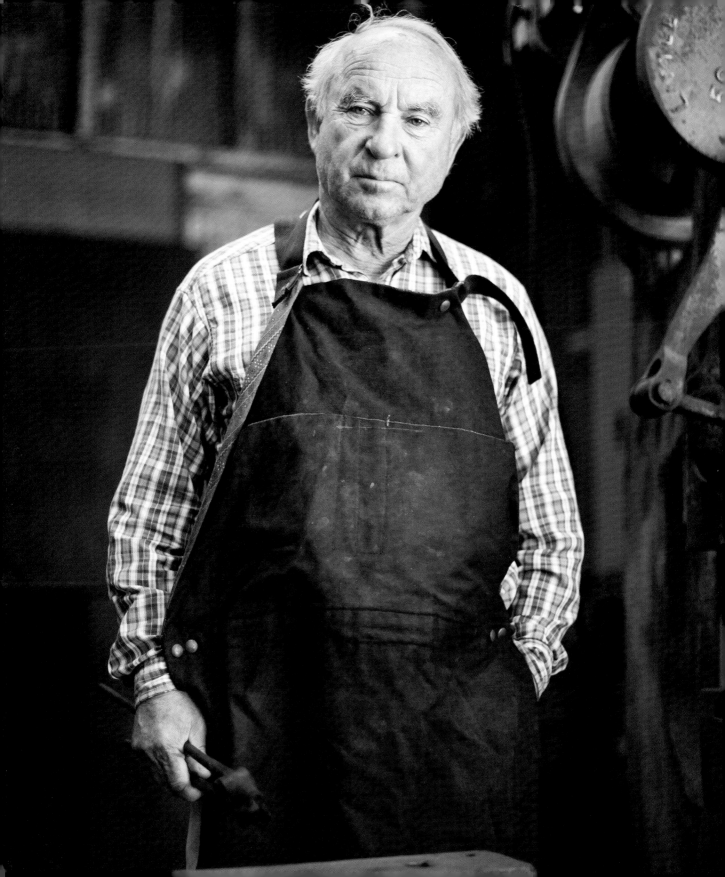

BE WHO YOU ARE

23

WHEN I WAS A CHILD, the neighborhood group of boys defined a poser as someone who pretended or falsely played the part. In skateboarding that meant if your board was not scratched it was not authentic. And you had to have a few scars from skinning your knees, too. More than anything I wanted those scratches and scars.

One summer afternoon, my grandfather and I walked into the small skateboard and baseball card shop in my town. The front door was plastered with stickers. The biggest sticker proclaimed, "No Posers Allowed!" My eight-year-old heart pounded as I walked into this boyhood sanctuary of stuff and looked up at the walls covered with posters, hats, bats, balls, wheels, decks, and gear. Grandpa and I looked everything over carefully and then he bought me my first skateboard. This was the real deal. With this skateboard I was on my way.

OPPOSITE Yvon Chouinard was an early climbing pioneer in Yosemite and made several important first ascents. Not satisfied with the available gear, he used his blacksmith skills to build his own. His gear and approach caught on like wildfire, and he started the company Patagonia. Chouinard is the real deal. Fifty years later, he stands in his original workshop and he is still as tough as steel.

Canon 5DMii, 50mm lens, f/2

PREVIOUS PAGE Making the transition from competitor to champion requires a choice. You can see that this world-class athlete's decision is clear by the calm yet unquestionable look in his eyes.

Canon 5DMii, 85mm lens, f/5.6

Risk of Taking Portraits

Joe Curren's photography has an understated and poetic style. His pictures convey subtle beauty, solitude, and peace. One morning after shooting some landscapes, I captured this frame as we returned to our cars.

Canon 5DMii, 16–35mm lens, f/5.6

Ever since those early skateboarding days, I've always had an adverse reaction to the photographic portrait concept of posing—it just seemed too awkward and unreal. And in most photographs, it is. The typical posing techniques are overdone, making the subject appear like he is trying too hard. What's worse is that the lack of authenticity prevents the picture from making its way from our eyes to our heart. It may be a perfect picture from a technical standpoint, but it definitely didn't capture the character, essence, or soul of the subject.

Here's where we discover the crux of it—admitting that making pictures of people is a risky task. Henri Cartier-Bresson once said, "It seems dangerous to be a portrait artist... because everyone wants to be flattered, so they pose in such a way that there's nothing left of the truth." Yet, it is a risk worth taking, like skateboarding down a steep hill. If we get it right, the rush is an authentic and incomparable thrill.

EXERCISE › Capturing Poise and Personality

The fastest way to improve your people pictures is to say something that is true. Rather than asking a subject to pose and pretend, draw out who he or she really is. Direct and lead but do not overbear. Every person projects a distinct poise, posture, and personality. Even when it comes to staging a shoot, let that shine and you will capture something that isn't just surface deep.

For this exercise, I want you to begin to think about the theater of life. If life is a stage with actors, props, and backdrops, how could you use what is already there in order to tell a tale?

STEP 1 SELECTING A SUBJECT

Choose a person to photograph whom you are comfortable with and know well. Seek out someone who has personality and depth. Perhaps you know an ambitious athlete, avid sports fan, enthusiastic hobbyist, or intriguing musician. Ask to photograph the subject in a location that reflects what he does.

STEP 2 DIRECTING THE SUBJECT

Photographer Rodney Smith begins most of his shoots the same way. He explains to the subject, "I don't want you to model. I want you to be you." Try this out. Explain that you are interested in creating a photograph that is natural so the subject doesn't need to try too hard.

As a director, take a playful and less controlling tone. Convey a sense that you don't have everything figured out but that you have some fun ideas. Begin by asking the subject to do what he does. If he is a musician, ask him to play one of his songs.

STEP 3 SETTING THE STAGE

Choose a location that is natural and conducive to getting your subject to play a natural part. Imagine that you are creating a scene from a play or movie of his life and that you want everything to fit just right. Look for any distracting elements that might be in the frame and move them out.

STEP 4 WORKING WITH PROPS

I want you to try two approaches with props. First, the best props are those that are found. Look in the natural environment for the shoot. Is there anything

› TIPS

Visit your local thrift, used sports, or army surplus stores to look for props that might work.

Rather than pose your subject, ask him to move naturally. Encourage him to change up his posture and position at a moderately quick pace.

Using props can be risky because the pictures can seem forced and trite. The solution is to keep it natural and try to create pictures where the prop fits right in. If you make a few mistakes, that is OK. Keep shooting until you've created something you like.

EXERCISE DETAILS

Goal: 10 portraits. **Tools:** Camera; normal or telephoto focal-length lens. **Light:** Natural or available light. **Location:** An environment that reveals who the subject is or what the subject does. **Theme:** The subject as an authentic performer on the stage of life. **Duration:** 35 minutes.

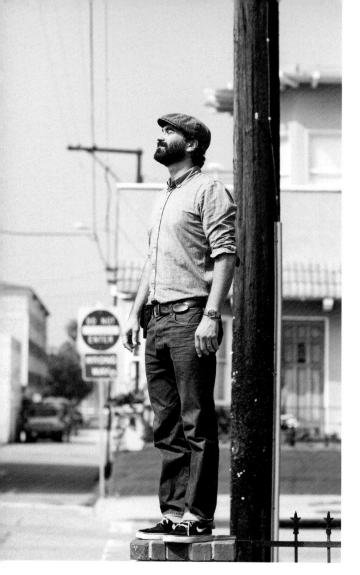

interesting and meaningful that could work? Second, try using something that you have brought along. Consider bringing an item that is unique, such as a vintage bike, an empty picture frame, a tennis racket, a typewriter, or an old wooden oar. Make sure it is a prop that fits naturally within the frame. Shoot for 30 minutes with the goal of capturing ten strong pictures.

STEP 5 WRAPPING UP STRONG

End the shoot on a high note and express your gratitude for the subject's time. Be sure to compliment the subject on what it is that he does and how that was expressed throughout the photo shoot. As a final wrap-up note, give him a warm handshake and let him know when he can expect to see the shots. ⠿

LEFT Jeff Lipsky closes his eyes and absorbs the morning sun a few blocks from his house in Venice Beach. Before asking him to look my way, I caught this small, natural moment.

Canon 5DMii, 85mm lens, f/3.2

OPPOSITE The oversized outrigger paddle was sitting in the garage. A perfect prop to create a classic and story-filled frame.

Hasselblad 503CW, 80mm lens, f/5.6, Tri-X Black and White Film

Dan Winters › Further Inspiration

Dan Winters is a photographer who takes time to develop his ideas. He isn't in a hurry to fire off 50 shots. Winters is methodical in his approach and has a deep reverence for those he photographs. Many of his pictures begin as detailed sketches in a journal. Eventually, these sketches become sets that convey a particular mood. The final photographs have a unique style and aesthetic sensibility that slow the viewer down. Many of his pictures will literally stop your gaze.

Explore his work at danwintersphoto.com and take note of how he sets the stage with props, sets, and styling. Next, imagine how he might have directed the subject and how he made the subject feel in order to create a particular look.

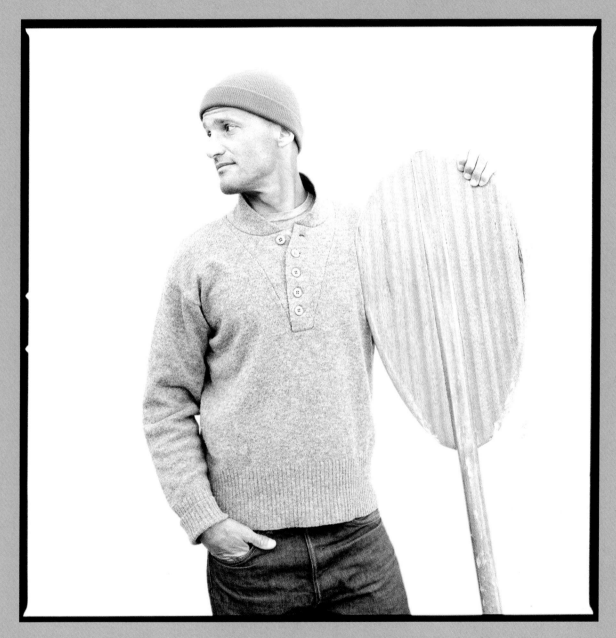

"People aren't going to remember the things that you do.
They are going to remember how you made people feel."
—Dan Winters

THE UNWRITTEN PORTRAIT CODE

24

SINCE ITS INVENTION there has been an unwritten code that comes with every camera. That is portrait etiquette instruction that informs the photographer and subject just what to do in order to make your picture turn out all right. While there are those who disregard or discredit the camera's advice, the majority trust the image-making machine.

This code is based on a choice that every people photographer or portrait sitter must decide. When staring down the glass barrel of a lens, a subject has a choice of how to respond: stoicism or a smile.

Early in the history of photography, the profundity of stoicism was preferred. After a few decades, the smile was introduced and gained instant popularity and fame.

Photographers were comparing notes on how to make the sitter smile pleasantly. Most of the techniques took too much time, and pictures needed to be made! In the face of this difficulty, photographers united their efforts and in a majority vote adopted a simple technical phrase, "Say cheese." And with that, a new epoch of people photography began.

There were those said that this was an oversimplification of things, that some smiles turn out trite and untrue. What about Mona Lisa's discreet, mysterious look? You can't overlook the power of Edvard Munch's *The Scream*. Some outright rejected this approach and started taking pictures that were contrary to the opinions of the hoi polloi. Photographs like Einstein sticking out his tongue, Che Guevara's defiance, and the migrant mother's despair made some purists cringe. But the masses and general public responded with praise and they wanted more!

Having a photographer in the family has has its pros and cons. While traveling down in Mexico I noticed an interesting wall and stopped to take some pictures. My daughter was exasperated while her cousin faked a smile. Later, when I opened this one up, it made me laugh out loud.

Canon 5DMii, 50mm lens, f/3.5

Beyond Stoicism and the Smile

While this is obviously written tongue in cheek, what we do really want in pictures is something that is real. That which is fake, contrived, or insincere doesn't draw us in. In fact, fake smiles, as scientists have shown, can actually make us sick. We want expressions that come from the inside and radiate out. Even honest disgust is more appealing that a faux smile. When our pictures capture emotion that is real, this strikes a chord in the viewer and elicits something true in return.

Emotion begets emotion. Knowing this, we typically settle for fabricating a smile or a strong gaze. That's like playing the piano and only using two notes. There is so much more music to be made. The human emotional repertoire is incredibly complex. Viewers of photographs can spot a fake from five miles away. In order to take more interesting pictures, we need to search for more subtle, wry, interesting, and complex expressive ways.

Annika waits for breakfast. Her bed-head hair and vacant expression reveal her exasperation with dad. She has given up the fight and is now pondering what it will be like to starve.

Hasselblad, 503CW, 80mm lens, f/2.8, Tri-X Black and White Film

EXERCISE › Unlikely Expressions

Discovering how to notice and capture a wider gamut of emotional nuance will deepen your love for the craft and give your pictures more appeal. In this exercise, we will study this range and aim to capture five strong images.

STEP 1 STUDYING EXPRESSIONS

The first step to expanding the range of expressions you will seek with your subjects involves doing a search and taking some notes. Begin by doing an online image search for expressions. You'll find hundreds of visual charts that depict different types. Next, do a Wikipedia search for emotions. Read about the many categories and types of human emotions. Consider these activities an opportunity to refresh and review what you already know. As you view the charts and words, write down a few photographic ideas. Think about what expressions you would like to capture most.

STEP 2 CAPTURING UNLIKELY EXPRESSIONS

Photographing unlikely expressions requires that people get comfortable with you, your camera, and your lens. This type of photography isn't something that you can do on command. Therefore dedicate one week to keeping your camera at your side with just one goal in mind—capturing unlikely expressions. Use a smaller-size camera and a normal-focal-length lens.

Resist the desire to take pictures of silence, strength, or smiles. Look for those candid moments that happen in between. Bring your camera on the bus, to the beach, the baseball stadium, the golf course, and more. Don't use the camera as a shield but interact with everyone you meet. Laugh, joke, cry, and be 100 percent real. Your own authenticity with your subject will affect the pictures that you make.

STEP 3 REVIEW YOUR PICTURES

The goal for this assignment isn't to capture a huge sum of emotion-laden photographs. When it comes to expression, think Mona Lisa; sometimes it's best if there is only one. Go through your photographs from the week and select a few that you like most. ⠿

LEARNING OBJECTIVES

- Broaden the type of expressions we look to photograph.
- Explore how to capture candid and authentic emotion.
- Increase one's awareness of the many nuances of expression.

› TIPS

Resist the temptation to ask someone to smile. If you want a smiling photograph, try to make the subject laugh.

Expressions are not limited just to the face. Pay attention to nonverbal cues, body posture, and the way someone walks.

Obvious expression and emotion can tell a story that sometimes is too loud. Look for the quiet candid moments when the subject has let down his guard.

EXERCISE DETAILS

Goal: 5 unlikely expressions. **Tools:** Camera; 50mm or similar normal-focal-length lens. **Light:** Natural or available light. **Location:** Outdoors or inside. **Theme:** Capturing authentic expression. **Duration:** One week.

LEFT While this boy and his dad talked it out about why he was upset, I made a few unnoticed frames that captured his pure frustration and sadness. Then a compromise was reached and moments later, he was smiling and skipping around the house.

Canon 5DMii, 50mm lens, f/2

OPPOSITE Unlikely expressions can evoke a surprising response. What does this picture make you think of or feel?

Canon 5DMii, 85mm lens, f/2

Top 100 › Further Inspiration

Rather than focusing on one single artist for additional inspiration, take some time viewing what others suggest are the top portraits of all time. What makes one portrait better than another is a completely subjective call, but it's interesting to view images that other people think are strong. Feel free to do your own searching or follow these guidelines to discover some fascinating work.

Begin by searching for *Outside magazine top 10 photographs*. This will lead you to a list from the magazine's showcase of its best work. Next search for *top 100 portraits of all time*. This list will show photographs, paintings, and drawings from all sorts of artists. As you look at the photographs ask yourself, What is the common thread? Also ask, What is it that makes a portrait memorable and strong?

"The revelation will come in a small fraction of a second with an unconscious gesture, a gleam of the eye, a brief lifting of the mask that all humans wear... In that fleeting interval of opportunity the photographer must act or lose his prize."

—Yousuf Karsh

STRENGTH OF CHARACTER

STRENGTH OF CHARACTER does not come easily and must be earned. It is gained through life experience and once built it's always there.

My dad put himself through college working construction. One day, he was high up on a roof and a crane operator accidentally knocked him off. He fell into the unconstructed house below. A sheet of plywood covering an unfinished stairwell "softened" his free-fall descent.

The foreman came running expecting the worse. He saw that my dad was stunned but OK. Relieved he said, "You're OK." Dusting himself off my dad responded, "Yes, seems like it. No broken bones." The foreman helped him to his feet and after a pause said, "Well, get back up there."

A free fall is scary, but it doesn't have to be scarring. My dad explained, "I had a choice. I could stay spooked and stay on the ground, or get over it and get back to work." Without skipping a beat, he climbed back up the ladder.

Ralph Clevenger is a focused, levelheaded, and hardworking man.
He is a photographer, author, teacher, and leader in his field. Ralph's
strength of character runs deep.

Canon 5DMii, 85mm lens, f/1.2

Find What Is Buried Deep

These two men are bound by something more than a hat and plaid shirt. One lives in war-torn Angola (left) and the other on a California coast ranch (right). They are worlds apart, but share a similar strength. Look closely and you can see it in their unflinching faces.

Left: Canon 5DMii, 50mm lens, f/1.2
Right: Canon 5DMii, 50mm lens, f/3

Strong character is forged through suffering of all sorts. Whether mental, physical, or emotional, the journey is often the same. It involves an immense amount of courage to confront pain, fear, or humiliation and to keep pressing on.

Look closely and you will discover that this kind of strength resides below the surface in many people that we know, whether they are cancer survivors, mountain climbers, or someone who got back up after a fall. I've always been attracted to people like this. I want to know their secrets. I want to have their same resolve.

Discovering strong character requires patience because it is buried so deep. Drawing it out and capturing it on film is an even more difficult task. If you can unveil this, the rewards will change who you are. For the closer we get, and the more we see of such strength, the more it will fortify our own.

EXERCISE › Inner Strength

Strong character is an elusive inner quality. Capturing it requires you to strengthen your own resolve and follow an intentional path of collaboration between you and your subject. Use the steps below to help you create pictures with substance and strength.

STEP 1 SELECT A SUBJECT

Find a subject who inspires you because of who he or she is or because of the obstacles that the person has overcome. Start off by creating a list of family members, then coworkers, and finally people who live in your town. Next, make a few phone calls or e-mail a couple friends and ask others who they might recommend. Pick the person who embodies a strength that you would like to have.

STEP 2 CONTACT THE SUBJECT

Reach out to the subject in a personal tone—write a note or make an impromptu call rather than sending an e-mail. With sincerity and in your own words, explain that you are working on a photography project creating portraits of people you respect. The goal is to make honest and strong pictures. Let him know it would be an honor if he would consider participating in the project.

STEP 3 SCOUT A LOCATION

Scout a location for the subject that will put that person at ease. Think about who he is and about what drives him most. Suggest a location to the subject and solicit location ideas from the subject as well. Then pick the location.

STEP 4 SET THE STAGE

Choose a camera and one lens that enables you to work quickly and close. Don't bring a camera bag or anything extra. Keep your approach simple and clean. Arrive at the location early and eager. Meet up with the subject and get through the usual chitchat for the first 5 minutes. Then begin shooting and patiently make your way. Ask the subject about his life and about what matters most. Don't shy away from difficult questions but also don't press too hard—strike a balance between inquiry and respect. Really listen to his story and make pictures in between his words.

› TIPS

Capturing inner strength requires letting go of shooting a high volume of frames. Slow down and patiently wait until the moment is right.

One photograph that reveals interior strength is all that you need.

Photographing someone significant to you will bring even more power to the picture.

EXERCISE DETAILS

Goal: 1 or 2 portraits that convey inner strength. **Tools:** Camera and one lens. **Light:** Natural or available light. **Location:** Indoors or outdoors. **Theme:** Strength of character. **Duration:** 30 minutes.

STEP 5 FIND WHAT LIES BENEATH

At the precise moment when you feel connected with the subject during the shoot, transition to a different type of shot. Explain that you want to create a strong portrait, a deep portrait, a portrait that conveys just a bit more. Position the subject and then explain that you will point the camera and then simply wait, taking a few images when the moment is right. Ask him to take a deep breath and look your way. Don't take a picture right away. Let him settle into his shoes. Gingerly press the shutter release and capture a few frames. Lower the camera, make eye contact, and thank him for that gift. ▪

LEFT Every big name was once small. And they started out by digging deep and fighting their way to the top. That's no exception here. After decades, Shawn Stussy still has the edge.

Canon 5DMii, 85mm lens, f/6

OPPOSITE Christian Beamish is an explorer, pioneer, big wave surfer, and sailor, who has been through many trials at sea. His intellect is sharp and vision strong. Here it's unquestionable that he is as tough as nails. Compare this to the more relaxed opening shot of him in Exercise 5, page 30.

Canon 5DMii, 50mm lens, f/2.8

Historical Greats 〉 Further Inspiration

One of the best ways to move forward with more meaningful character portraits is to study what came before us. Take some time looking up those individuals who have made a significant impact. Do an image search for their portraits. Study the portraits and look deeply into their eyes. Get to know the wrinkles on their face, the resolve in their posture, and the force of their gaze.

The following is a slightly eclectic list of people whose portraits speak volumes. Start with these historical figures and then look up your own: Ernest Shackleton, Nelson Mandela, Theodore Roosevelt, Martin Luther King, Abraham Lincoln, Helen Keller, Maya Angelou, Ralph Waldo Emerson, Winston Churchill, Sir Edmund Hillary, Amelia Earhart, Harriet Beecher Stowe, Eleanor Roosevelt, Mother Teresa, Rosa Parks, Jackie Robinson.

"Character cannot be developed in ease and quiet. Only through experience of trial and suffering can the soul be strengthened, vision cleared, ambition inspired, and success achieved."
—Helen Keller

ORDER WITHIN CHAOS

<div style="text-align: right">26</div>

GROWING UP in a relatively small and sleepy town, it was always exciting to go to "The City," as it was affectionately known. As far as we were concerned, it was the one and only city, the city that captivated our hearts. Crossing the Bay Bridge and arriving in San Francisco was an experience that was expectant and full of hope.

The city was bursting with life and there were endless adventures waiting. With crooked streets, cable cars, and the hustle and bustle of it all, it was impossible not to encounter something new. Even with a charming and quaint city like San Francisco, when you first arrive it can seem like a confusing mess.

The clatter of the cable car tracks, the intense aroma of boiling crab, the honking cars, and the buildings pointing toward the skies—to pick up on the rhythm of such a place takes time. But once you do, this cacophony becomes a song, a familiar and nostalgic tune. And this reminds us that there is order within the chaos and the tumult drives the beat home.

The wood planks of the Brooklyn Bridge bike and walking path are worn smooth from the constant traffic of exercise fanatics. On this fall morning the hustle and bustle was intense. Yet, musician and Broadway performer Jared Mason was poised and engaged. Through patience and careful composition it looks as if no one else was there, which creates a simpler, stronger picture.

Canon 5DMii, 85mm lens, f/3.5

Finding the Moments in Between

During the Brooklyn Bridge shoot, I noticed this man walking down the path. I asked if he'd mind joining us for a photo. The visual juxtaposition of these two New Yorkers is fabulous.

Canon 5DMii, 85mm lens, f/2

As a photographer, the calm found amidst such disarray is what catches our eye. Those moments in between, like the silence between notes, is where your heart lingers. Yet finding the quiet in the middle of noise is not an easy task. Rather than fighting the crowds and going against the tide, finding silence and peace requires a more amicable approach.

Bob Dylan once wrote, "Chaos is a friend of mine," and this is the kind of portrait that I want you to make. Rather than retreating to a quiet, soft location like a studio or neighborhood park, go out into the eye of the storm and strive to capture something that resonates with that mood. Become a friend of the busyness of it all. Feed off the energy of the crowd and simultaneously keep your eyes open for the simple beat.

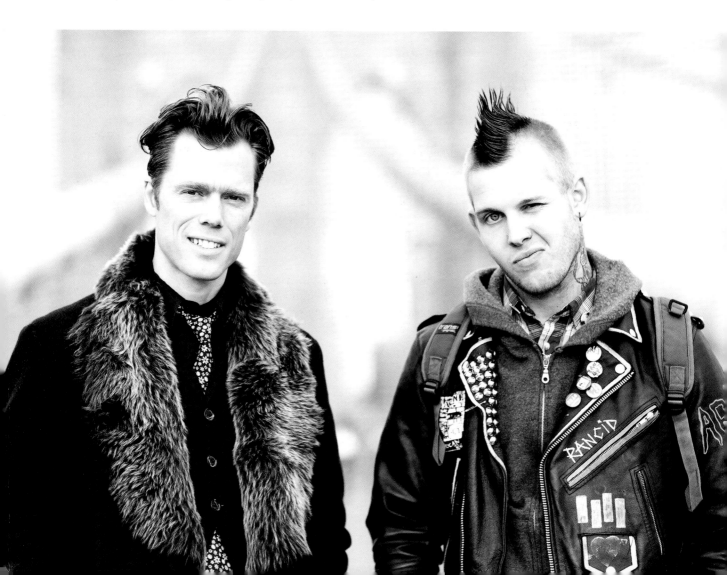

EXERCISE » Streetscape Portrait

Mario Andretti once said, "If everything is under control you are not going fast enough." This exercise requires that you put the pedal to the metal and step out of your photographic comfort zone. Begin by choosing a subject who really excels at what he does.

STEP 1 CHOOSE A STRONG SUBJECT

Rather than photographing someone you are comfortable with, why not try for someone who is considered big? For example, instead of photographing a colleague at work, create a portrait of the CEO. Instead of a soccer player in your local league, why not the captain of a professional team?

Strive to photograph someone whose talent you admire. While it might be a challenge to get access to that person, don't give up. Keep trying until you find someone whom you respect and who is well above your level at whatever his area of expertise may be.

STEP 2 STORYBOARD

Next, choose a location that is not serene and secluded but one that is busy and vibrant. For an extra challenge, find a setting that is iconic and well known. Be sure to pick a location that has some relevance to the subject and to the story that you want to tell.

Before the shoot, take 20 minutes and create at least five storyboard ideas for the shoot and sketch them out. Do this as an attempt to visualize what type of pictures you want to create. Even if you don't consider yourself good at drawing, make sure to include this step. Add simple descriptive words to each one that clarify the intent of each shot. (To view the story boards for my Brooklyn Bridge shoot, visit 30peoplepictures.com/storyboard.)

STEP 3 ON LOCATION

Arrive at the location 20 minutes early in order to walk around. Be on the lookout for different angles and perspectives and take a few shots. Continue to warm up your senses in the same way a runner stretches or jogs before a big race. Run a few visual laps and get familiar with the scene.

LEARNING OBJECTIVES

- **Develop visualization skills by creating unique storyboard sketches.**
- **Sharpen your focus on image making while working within a busy and distracting location.**
- **Quicken your compositional skills by shooting with a compressed amount of time.**

› TIPS

Good portraiture requires great concentration, connection, and resolve. Stay focused and strong.

Ask your subject to follow your lead and keep him moving from one spot to the next.

Don't skip the storyboard step; it's important to visualize your shoot with your subject.

Set the tone for remaining engaged even amid the distracting noise. Keep your subject engaged with strong eye contact and keen conversation.

EXERCISE DETAILS

Goal: 20 portraits, with 5 that follow your visualized storyboard ideas. **Tools:** Camera; one wide-angle lens and one normal- to telephoto-focal-length lens. **Light:** Natural or available light. **Location:** Busy outdoor scene. **Themes:** Finding order within chaos and stepping out of your comfort zone. **Duration:** 45 minutes.

STEP 4 MEET AND GREET

While wearing your camera on your shoulder, meet the subject with gusto and grace. Give a firm handshake and express your gratitude and enthusiasm for the photo shoot. Ask him some initial questions and really listen to what he says. Make sure your body posture is engaged and your eyes focused, too. Spend about five minutes on this step.

STEP 5 THE SHOOT

Next, fire off a few shots. This will break the ice early and create a more natural flow. Walk with your subject to the center of the scene and start taking pictures amid the chaos for 20 minutes. Don't let the busyness slow you down. Think like a race car driver and stay focused on the checkered finish flag. Remember your goal is to capture each of your storyboard ideas.

While working with the subject in various spots, create 20 photographs that are resonant and full of peace. In other words, create pictures that make the complexity of the environment fade away.

STEP 6 WRAP AND REFLECTION

At the end of the shoot, thank your subject for his time. Provide him with a small thank-you gift and say good-bye. Before leaving the location, open up your storyboard sketches and reflect to see if you actually got each shot. Then while the location is still fresh, sketch out any shots that you may have missed. Ask yourself how you could have improved working within such a complex location. Give yourself some feedback and write notes on how you want to improve next time. ▨

OPPOSITE This frame seems like it could have been taken yesterday or perhaps long ago. Jared is confident, alive, and anchored with one hand. And he is perfectly framed by the bridge and cityscape in the scene.

Canon 5DMii, 16–35mm lens, f/2.8

Street Smarts

When creating pictures of people in busy locations it's easy to become distracted or overwhelmed. Visualization sketches can help, but perhaps even more helpful is noticing details, trusting your gut, and quickly capturing what you see. To further your skills try studying the work of some renowned street photographers. These are the ones who have elevated observation, intuition, and speed to an art form.

Start off with an online Google video search for Cheryl Dunn and Joel Meyerowitz. Then search for Joel Meyerowitz by himself. Watch the videos that you find. Next, do an online search for other photographers who get out in the world and quickly capture what they see. Try Robert Frank, Garry Winogrand, and Diane Arbus. After looking at their work, head out to your own city streets and put your skills to the test.

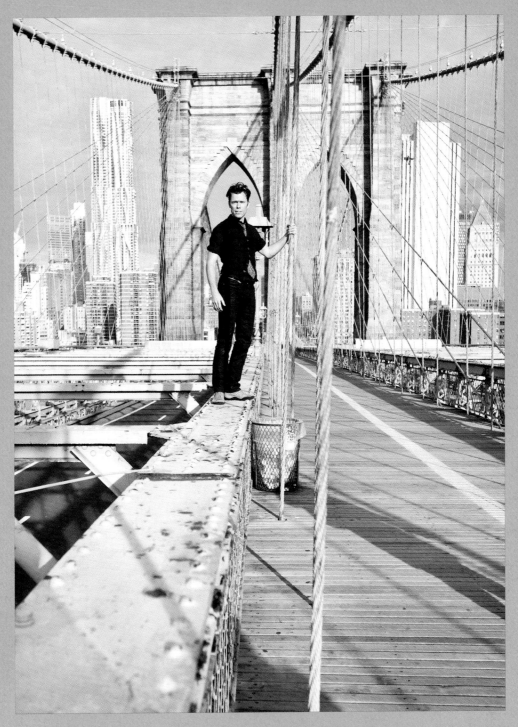

"Photography is a response that has to do with the momentary recognition of things."
—Joel Meyerowitz

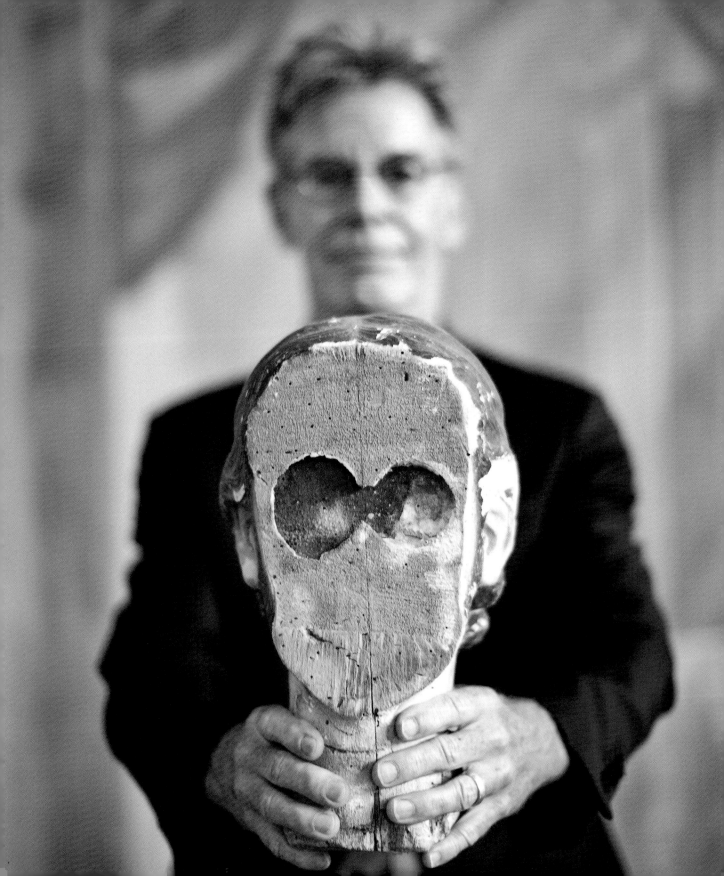

ECLECTIC AND ECCENTRIC

27

IN THE CURRENT global economy, mass production is king. Profit is defined by volume and how quickly something can be made. By using cookie-cutter and carbon-copy techniques, we've invented a cycle of production that feeds off the ability to replicate. The result is a lot of perhaps high-quality goods, yet so much of life looks the same. You can walk into a brand X coffee shop anywhere in the world and not really know where you are. And everyone, even some photographers, is now catching on to this cycle.

I think that is why I like things that are handmade—my young daughters' drawings, pencil-written notes, and the old driftwood gate in our backyard. There is something special about those things that cannot be mass-produced. This is one of the reasons I make pictures. As photographers, we aren't technicians who repeatedly follow the same steps. We make our own path. We are driven to create something that is one of a kind. We want to express our unique voice and vision. It is something we have to do. Taking pictures satisfies an internal thirst—it is an essential part of who we are.

Sustaining this inner drive requires resisting the urge to quickly impersonate. True artistic creativity requires a more eclectic approach. The eclectic artist derives ideas, style, and inspiration from a broad range of unlikely sources. Rather than following the flow of the latest popular trend, the eclectic photographer strikes out on his own path. And this path has no end. It's a journey that lasts a lifetime.

Just before I took this picture of Keith Carter holding a faceless religious statue head, I was reading a few handwritten quotes on the walls of his darkroom. "Try to make pictures that are wise rather than clever." "Life for a photographer cannot be a matter of indifference." This portrait is a small attempt to make some of those words come alive.

Canon 5DMii, 50mm lens, f/1.2

Turning the Page

The painter Robert Henri wrote in his book *The Art Spirit*, "When the artist is alive in any person, whatever kind of work it may be, he becomes an inventive, searching, daring, self-expressive, and self-expressing creature. He becomes interesting to other people. He disturbs, upsets, enlightens, and opens ways for a better understanding. Where those who are not artists are trying to close the book, he opens it and shows that there are more pages possible."

Vibrant and growing artists find possibility around every bend. Eccentric artists take that to a whole new degree. Rather than opening a book, they invent a new world. They come up with unrealistic and unconventional ideas like Cubism or a Disneyland theme park. The eccentrics are those who operate on the fringe. They turn logic on its head. They have no comfort zone.

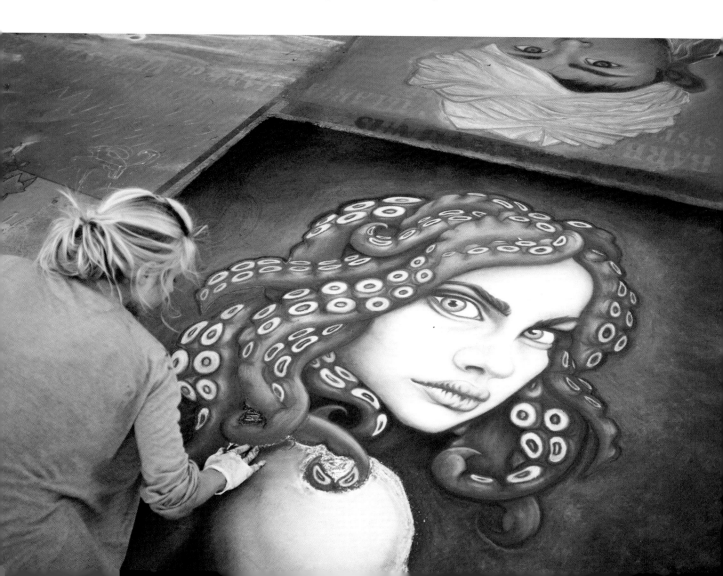

EXERCISE ❯ One-of-a-Kind People

Creative inspiration can be found in the typical ways—folk music, literature, or independent films. Or you can go straight to the source. Spend some time with an eccentric person, whether a butterfly collector, sidewalk chalk artist, or someone who custom-paints cars, and you will be inspired in a whole new way. For this exercise that is exactly what I want you to do. Why? Because you can never underestimate the power of finding inspiration from an eclectic source.

STEP 1 CHOOSING A LEVEL OF ECCENTRICITY

Eccentricity ranges from the peculiar to the legitimately insane. Choosing how deep you want to go is completely up to you. For starters, you might pick someone to photograph who goes just slightly against the tide. Whoever you choose, make sure she fits the requirement of truly being one-of-a-kind.

Maybe you know an architect who refuses to use computers and draws everything by hand. Or perhaps you have a business acquaintance who constantly dreams up off-the-wall entrepreneurial ideas. Then there is the ubiquitous "cat lady" who lives at the end of your street. Of course, you can always go more extreme. Trust your gut and reach out to an eccentric person and ask if you can meet for 30 minutes to create her portrait and to learn more about her life. Ask if you can photograph the subject in her home, studio, or workspace.

STEP 2 PRESHOOT PLANNING?

From a distance, the eccentric can seem unscheduled, erratic, and completely untamed. In the face of such uncertainty, it might seem like a good idea to go into the photo shoot with a plan. Here's what I suggest. Throw your agenda out the window. Preshoot planning—don't do it. Get out your camera bag, pack every type of lens that you own, and go for it.

STEP 3 PHOTO SHOOT

Every person has a story, and every story can teach you something. Let your guard down and approach the subject with an authentic enthusiasm for who she is and what she does. Often, eccentric people are marginalized and don't have an avenue for sharing their voice. Ask them questions and provide them with an opportunity for sharing what means the most. As they talk, take pictures in between.



LEARNING OBJECTIVES

- Further your passion to create something that is one of a kind.
- Discover the value of gaining inspiration from an unlikely source.
- Capture effective photographs in creative locations.

❯ TIPS

Don't worry about the photographic results and don't impose any preconceived ideas. Watch, wait, and listen. Let the eclectic subject lead the way. Take pictures as the conversation unfolds.

If you start having trouble connecting with the subject, ask about how she started out or what inspires her most.

In order to create photographs that say something, try this: Imagine that the pictures are for a documentary about this person's life.



EXERCISE DETAILS

Goal: 25 portraits of an eccentric subject. **Tools:** Camera, lenses—try everything from fish-eye to telephoto. **Light:** Natural or available light. **Location:** Subject's home. **Theme:** Inspiration from eccentric people. **Duration:** 30 to 60 minutes.

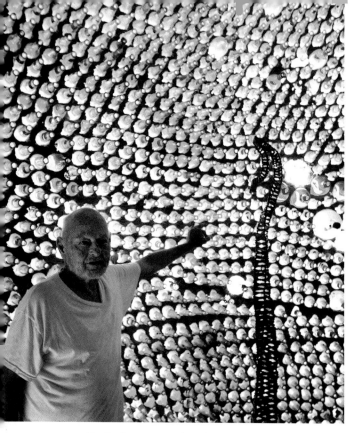

Near the end of the meeting (at about 20 minutes) ask if you can arrange a couple of shots. Have the subject stand in a few particular spots. Give her feedback that she is doing just fine. Explain that you want a photograph that captures her personality and not some preconceived idea. Wrap the shoot and say good-bye.

STEP 4 JOURNAL

Immediately after the photo shoot, go to a coffee shop with journal in hand. Sit down for 10 to 15 minutes and record your thoughts. What did you learn? How did this person affect the way that you see? While you may not want to become as eccentric as your subject is, perhaps she has a new way of thinking that you might integrate to a lesser degree.

STEP 5 SHARE

Make prints of your favorite pictures and share the experience with another colleague or friend. ▪▪

ABOVE Charles is an eccentric artist, who lives completely off the grid. This is a impressive room inside his house he built alone from concrete and glass bottles.

Canon 5DMii, 16–35mm lens, f/2.8

OPPOSITE With this artist I noticed a unique sculpture hanging in the corner of the garage. Rather than photograph it in the garage, I asked if he wouldn't mind carrying the piece out into the street. The out-of-place sculpture seemed to work better there, bringing out the strangeness of the piece that became even more pronounced.

Canon 5DMii, 50mm lens, f/2.8

Diane and Amy Arbus 〉 Further Inspiration

Diane and Amy Arbus, mother and daughter, are unique portrait photographers of substantial acclaim.

Diane, who died many years ago, is known for her revealing and honest portraits of those on the fringes of society. Her style is sparse, direct, yet not without empathy. Explore her work online for ideas about photographing those who are marginalized in an interesting way.

Amy, who is still photographing and teaching today, takes a bit more humanistic approach. Amy defines a good portrait as one that "...captures the magical moment of recognition between photographer and subject." Amy photographs people as they are with an honesty and urgency that is real. Examine her pictures and pay attention to their effect. Ask yourself if the portraits challenge, amuse, enlighten, or disturb?

"A photograph is a secret about a secret. The more it tells you the less you know."

—Diane Arbus

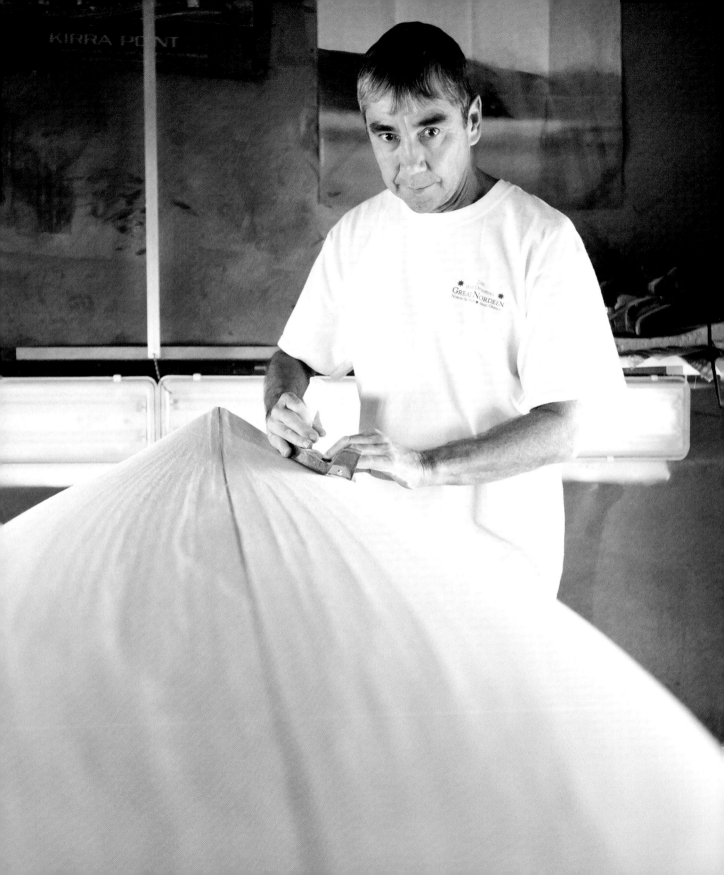

CATALYST

28

AT THE PHOTOGRAPHY SCHOOL where I teach there are two different programs: Visual Journalism (VJ) and Commercial Photography (CP). While both programs focus on similar techniques, each one attracts and produces a different kind of student. I once heard a colleague differentiate between the two like this. He wryly explained, "The VJ students are great at going out and finding pictures. They aren't very good at making them. The CP students can make beautiful pictures but couldn't find a photograph to save their life." And just like those students, some of us are good at finding pictures, while others excel at making them.

While the debate over which approach is better takes many forms, what's most interesting to me is that some students, regardless of being picture finders or picture makers, develop a knack for stirring up the pot. They show up in the classroom and everyone turns around. They deliver fascinating work even when the assignment requirements seem dull. They show their work in critique sessions and everyone sits up straight and is interested in what they have to say. These students affect the whole bunch. They are catalysts in the truest sense of the word.

A catalyst is someone who causes or accelerates change. Her demeanor, enthusiasm, and energy encourage others to be more animated and alive. Whether finding or making photographs, her work looks and feels less temporal and more timeless and strong. Being a catalyst matters.

Gerry Lopez, legendary surfer and surfboard shaper, working with soft foam that will soon be covered with fiberglass resin mixed with catalyst to make the surfboard complete.

Canon 5DMii, 16–35mm lens, f/2.8

Stirring Up the Pot

I like finding pictures as they occur, but here was a chance to arrange one. I repositioned the ladders and directed the subjects to sit or stand, turning a dingy corner into something more grand.

Canon 5DMii, 16–35mm lens, f/7

One of my favorite activities is surfing and I love surfboard design. When building a board you need a large sum of foam, fiberglass, and resin. The critical ingredient is a small eyedropper bottle of catalyst. Without the drops of catalyst the resin remains sticky and gooey like maple syrup. Add a little catalyst and the resin will cure, becoming waterproof and hard.

In surfboard construction and photography, there are certain corners that cannot be cut. We all know this, yet it's easy to become distracted during a shoot and overlook adding those important few drops. The final result doesn't seem right; it's a soft and gooey mess. So what are the catalyzing drops that we all need? Let's see.

EXERCISE › Mojo for Making, Not Taking

In photography, it's easy to feel defeated and blue. We spend time looking at blogs and constantly reading about what everyone else has accomplished. We compare our work to someone who has been shooting for over 40 years. This may get us moving, but it's like we are stuck in first gear. This happens to us all.

Becoming a catalyst is something that we all can do. It starts by taking an intentional step. Great photography isn't something that happens overnight. It takes a commitment, regardless of what or how you shoot, to make and not to take.

If you've lost a bit of your mojo or just want some more, these simple steps can help you get on track.

STEP 1 ASPIRE

Being an artist requires that you have a particular point of view. Writing down some ideas is an integral step to making sure your perspective is clear. Begin by taking some time to write down what you want to do. If you want to be great, you have to know what great looks like. What are your ultimate goals—enjoy a pastime or hobby, win contests, be the best in the world? What types of photography would you like to do—editorial, commercial, fine art? Who are clients you would like to work for? What does your ideal studio look like?

STEP 2 SHOOT LIKE YOU MEAN IT

Most of us lose the catalytic spark because we've let our discipline slide. Or perhaps it's a result of pushing the shutter release too many times. Either way, the goal here is to commit to making one good photograph for ten days straight. Each time you press the shutter, press it with focus, intention, conviction, and resolve. Make each image count. Choose people and locations that are bold and strong. And don't show anyone your work—no blog posting, no e-mail, no Facebook. Think of this as boot camp to get you back in visual shape. Do it for your own good. Do it to satisfy your own internal needs.

STEP 3 MAKE FINAL PRINTS

After the ten days have passed, it's time to bring the ten images to life. Too often we let our photographs gather digital dust on a hard drive. Without seeing the pictures, it's difficult to care. Make prints that are bold, big, and beautiful. Send them to an online printing service or print them yourself. Either way, choose the highest quality paper and a substantial size. ▪▪

EXERCISE DETAILS

Goal: 10 pictures of people in 10 days. **Tools:** Camera; lens of your choice. **Light:** Natural or available light. **Location:** Bold and telling environment. **Theme:** Becoming a catalyst. **Duration:** 15 minutes per day.

RIGHT Artist Kodiak Greenwood grew up in Big Sur, California. Like the towering Redwood trees that grow along that stretch of coast, his work is awe-inspiring and strong. Greenwood's pictures reach for the heavens without losing contact with the ground.

Wood large format 8 x 10, 300mm lens, Ilford Delta Black and White Film

OPPOSITE Surfer and musician Rob Machado (also featured on the book cover) doesn't back down. If the eye is the lamp of the body, this gaze gives us insight, which is intense, authentic, and real.

Wood large format 4 x 5, 150mm lens, f/5.6, Ilford HP5 Plus Black and White Film

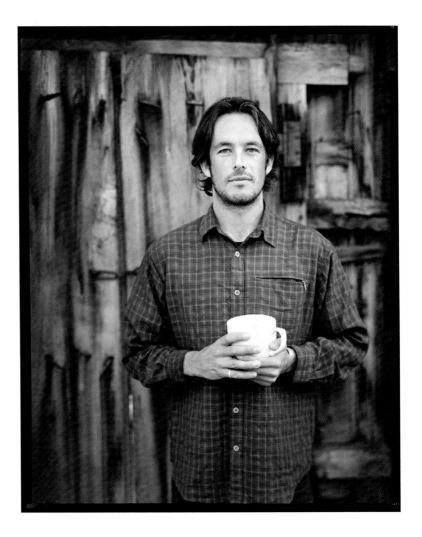

Anton Corbijn › Further Inspiration

Anton Corbijn is a photographer who stands on his own. His images are intense, grainy, high contrast, and full of deep, rich blacks. Corbijn works with natural light and odd and old film cameras and without an assistant or crew. While he photographs famous and familiar people, his images convey that which hasn't been seen.

Corbijn photographs people not as they are but as he sees them becoming, and he isn't afraid to tell the truth. Do an online image search using his name and explore the various types of pictures he makes. You'll soon discover that his photographs are anything but soft. Corbijn is a catalyst.

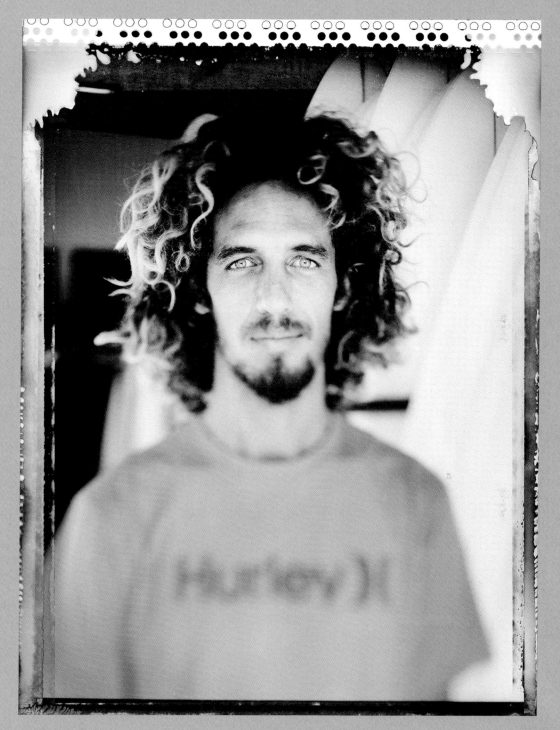

"The main strength of my pictures is the mood and feel."
—Anton Corbijn

IRRESISTIBLE PICTURES

WHEN A PHOTOGRAPHER HAPPENS upon an interesting character or a beautiful scene, she just can't resist. The picture has to be made. Making the pictures and recording the scene forever is a joy and something that can move our heart. Whether wildflowers illuminated by the setting sun or a daughter taking her first steps, these moments are irresistible and free. Digital capture removes any and every reason for not taking pictures. And once you take one picture, it requires more. Photography is contagious.

We shoot, shoot, and shoot some more without too much of a concern about whether the picture turns out right. It's the abundance of resources that weakens our critical mind. It's like a six-year-old boy who grows up on an apple farm. Without even looking, he picks an apple off of one of his father's trees. Not knowing if it is rotten or ripe, he sinks his teeth in. Why worry about quality when the apple fields seem to have no end? For him or an amateur photographer that approach is fine. Who cares if you aren't going to show or share your work?

Every aspiring photographer is guilty of making the same type of mistake—we capture too much and too many frames. The result is a mass of mediocre shots. We have too quickly picked the fruit from the tree. If you've made this mistake, there's good news—the issue can be solved.

Before the artist arrived, I wanted to create a portrait without her there. For me, the empty chair, art supplies, and unfinished painting, work on two levels. It's an insightful portrait of the artist and her work. And the scene is an invitation to step in, pick up a brush, and give painting a try.

Canon 5DMii, 16–35mm lens, f/2.8

How to Pick the Right Pictures?

I made a few portraits of photographer/author David duChemin, but I wasn't happy with the results. So I stepped back and waited. Something caught his eye and I then captured this frame as he swung his camera around. Rather than showing his face, the intent in his body depicts him as a photographer in the middle of his craft.

Canon 5DMii, 70–200mm lens, f/11

The logical approach might be to simply pick less fruit or shoot fewer frames. While this could temporarily help, there is a better way. The solution begins with intentionally pressing the shutter with more passion, focus, and resolve. It's not about changing how many pictures you make. It's about waiting to pick the apple when it's ripe.

The successful farmer knows this well. He has gained wisdom after decades of observing every detail that leads up to producing good fruit. His secret is to look at the apples but also to pay attention to everything else: weather, water, honeybees, bugs, branches, trunks, and leaves. He walks the fields purposefully, in season and out.

As a photographer, an excellent way to develop this type of observational skill is to photograph without focusing on the fruit. In other words, to take pictures where you intentionally leave something out. Rather than include everything, try to focus on one small element of the scene.

EXERCISE › With or Without You

For this exercise, you'll intentionally leave something out. Like taking a portrait and not including the subject's face. Or creating a portrait of your subject when he isn't there and instead photographing his workspace. Or you can move in close with your camera and create a portrait that focuses on specific features, like tanned and weathered hands. In each step create pictures that convey and share, without showing too much as is done in typical portrait shots.

Choose different subjects for the following steps.

STEP 1 WITHOUT A PERSON

Good portraits reveal who one person is. They tell a story by showing personality, perspective, and mood. The most common way to accomplish this is to make the subject the most prominent aspect of the frame. Yet sometimes it is worthwhile to stray from the path.

For this step, capture a portrait without the subject around. Find at least three subjects and photograph an environment that best describes who each person is. Consider photographing his office, studio, or barn. Choose the space that most closely reflects a core aspect of who he is. Make three separate portraits without the person.

STEP 2 WITHOUT THE FACE

The human face is the most interesting and telling feature we have. Ultimately, it is the face that tells each of us apart. The face is particular, individual, and one of a kind. What would happen if you were to block what matters most? Making photographs without the face opens up a huge array of possibilities. Sometimes the pictures turn out abstract and surreal. Other photographs take on a more generalized and archetypical form.

Coordinate to photograph someone you respect. Explain that your assignment is to capture portraits that are more conceptual and archetypical in scope. Ask the subject if he can bring an interesting object to include in the frame like a hat, wooden oar, book, vintage clock. Set a time and outdoor location to meet up for the 29-minute shoot. Bring a few of your own props that will sufficiently block the face. Ask the subject to hold the items in front of his view, and capture ten pictures that vary on this theme.

LEARNING OBJECTIVES

- Broaden your portrait repertoire to include capturing more conceptual, surreal, and archetypical portraits.
- Explore how to create interesting portraits by employing creative composition and framing techniques.
- Discover the value of slowing down and making intentional and focused pictures.

> ### TIPS

This assignment is involved and will require more creativity than most. These efforts will help you develop stronger observational skills of people.

Regardless of whether or not your subject is looking your way, provide encouraging words to maintain his trust.

When working with the subjects, resist the urge to capture the typical portrait shots. Continually ask yourself, "How can I say more by including less in the frame?"

EXERCISE DETAILS

Goal: 3 without person, 10 shots; without face, 10 shots; looking away, 10 shots; hands and feet, 10 shots. **Tools:** Camera; assortment of lenses. **Light:** Natural or available light. **Location:** Outdoors. **Theme:** What's left out. **Duration:** Varies by step.

ABOVE The sparkling eyes and slight glance out of the frame are details that make this portrait of a mentor and friend Lynda Weinman. She is one of the most vibrant and creative people that I know.

Canon 5DMii, 50mm lens, f/1.2

STEP 3 LOOKING AWAY

In pictures of people, strong eye contact creates connection that is difficult to dismiss. When the subject looks away, the lack of eye contact makes us wonder and think. Such pictures take on a more thoughtful and reflective tone.

Select a subject to photograph and choose a simple location for the shoot. From the outset, ask the subject to look away from the lens. Try the typical profile shots but also experiment with having the subject avert his gaze. Take pictures up close and far away. Continue shooting for 29 minutes until you have captured ten strong portraits.

STEP 4 HANDS AND FEET

Our hands and feet reveal much of who we are. Whether in flip-flops or cowboy boots, whether they feature blisters or French manicures, these details are most interesting in a group. Set out to photograph ten different sets of hands and feet. Choose to do this at your school, place of work, or local community event like a farmers' market or parade. Approach various people and explain that you are working on an assignment to capture interesting hands and feet. Ask the subjects if they would help you finish your task. Keep shooting until you have collected at least ten good photographs of each.

After the shoot, combine each set of ten photographs on one page. ▓

OPPOSITE The program director at the photography school where I teach constantly carries around and scribbles notes in his red moleskin journal. One day after a faculty meeting, I asked him to hold it in front of his face for a picture, making the portrait enigmatic and specific at the same time.

Canon 5DMii, 50mm lens, f/1.2

Richard Schultz ❯ Further Inspiration

Richard Schultz is a people photographer with an optimistic and nostalgic style. He approaches commercial photography from his heart and gut. While he has a huge and diverse commercial client list, his style isn't something that wavers. He consistently creates images that feel honest and truthful—full of candid emotion—whether with sadness or joy. Visit rschultz.com to view his work and pay close attention to the way he captures moments when the subject looks away, blocks the face, or communicates with someone else in the frame.

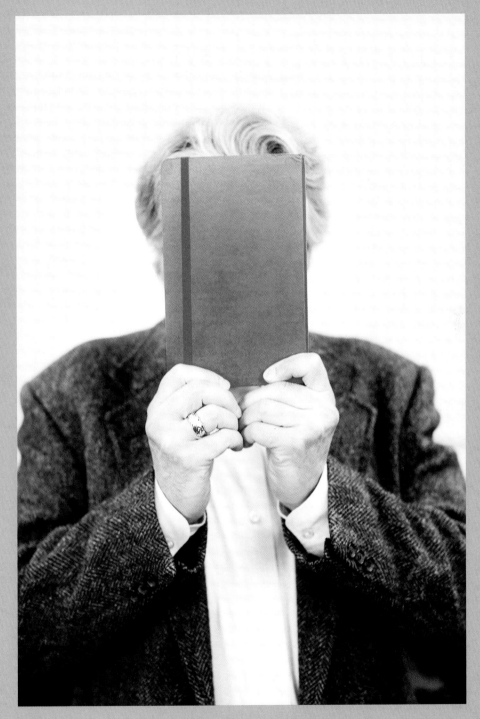

"In many good photographs, it's not so much what you see, but what you don't."

—Evan Chong

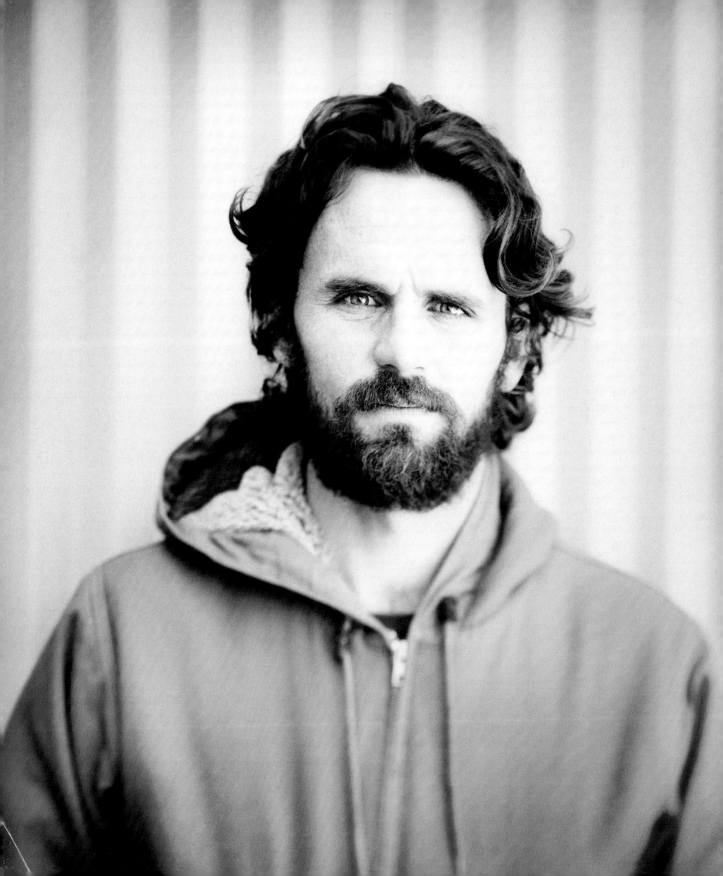

THE HUNGRY CAMERA

THE CAMERA IS NOT A PASSIVE DEVICE. It's hungry and full of a kinetic force. The camera wants to get out of your bag and record what it sees. Hold it up to your eye and this hunger will course through your veins. Unlike a telescope or microscope, the camera is mobile, you can bring it with you and it's hard to put away. It isn't just a tool to observe with but a tool to grasp, capture, consume, seize, and acquire. That's why we make pictures—to feed our soul.

Like all tools designed with power and force, the camera relies on its owner to know how to behave. It's the owner who determines if the camera will be used for good. The pictures we make truly are a reflection of who we are. The pictures reveal us from the inside out. They show the world how we see. And photography isn't just the pictures, it's much more of a two-way street.

My admiration and appreciation for Dan Malloy runs deep. He has a creative, humble, and generous soul. He is a wave rider with an inventive and expressive bent. Spending time with him has made me question and rethink who I am and how I approach life. He also reminds me of the importance of photographing those who will further your progress along your life path.

Wood large format 4 x 5, 90mm lens, f/5.6, Polaroid Type 55 Film

Shine Bright

What we photograph changes who we are. The camera not only reveals but also fortifies. Our pictures shape us and influence who we are to become. Make photographs of nature and it will deepen your love of the outdoors. Take pictures of surfing and it will broaden your appreciation for the sport. The camera does consume, yet so does the mouth. Eat junk food and you'll feel sick. Consume wisdom and your eyes will shine bright.

Camera manuals neglect to point out that it is a potentially powerful tool. The manual should include an advisory label, "Use at your own risk." The camera will change how you see and who you are. As humans, we move in the direction of our most dominant thoughts. Our life trajectory is magnetically pulled by what we see. So why not take the risk and try using your camera as a means to change, learn, and grow? How about devoting some time to photographing people you admire? Who knows, it might just fortify your own personal resolve.

Taylor Knox is one of world's top surfers, riding the waves with a powerful style. He lives like he surfs. Spend time with him and you quickly catch his contagious energy, focus, and passion.

Wood large format 4 x 5, 155mm lens, f/5.6, Polaroid Type 55 Film

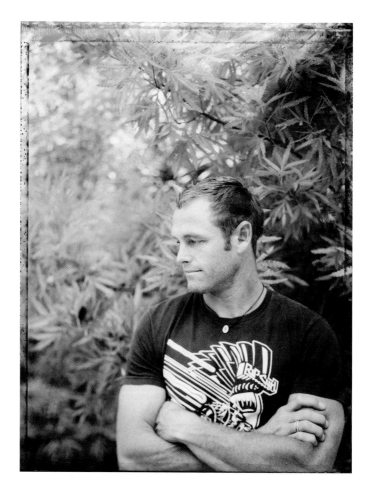

EXERCISE > For Your Own Good

The camera is one of the greatest note-taking tools that I have found. It allows you to stop time and absorb deep, hidden details that otherwise would be lost. In this exercise, I want you to focus on using this tool to study and learn from someone you admire. Approach the shoot with two agendas. First, use the portrait sitting as an opportunity to learn from someone whose strength you long to have. Second, strive to create pictures that reflect how you feel.

STEP 1 BRAINSTORMING

Begin by making a list of the top 20 to 50 people you admire. Include everyone from people you work with to local leaders, famous artists, mentors, past teachers, your grandfather, and your mom. Get creative and build a moderately exhaustive list. After the list is complete, write down the common qualities that this group of people share. Ask yourself, "What is it about these people that I respect? What are the qualities that I want to have—success, humor, strong will, compassion, creativity?" Then write down a response to the following questions, "How do I want to improve my life?" and "Who is it that I want to become?"

STEP 2 CONTACTING THE SUBJECT

After compiling your brainstorming list, narrow it down. Pretend you are creating a personal board of advisors or mentors; who would make the cut? Pick the people you trust and admire. Finally, select the top person from the group— maybe it's your grandmother or your college track coach.

Contact the person and explain that your photography instructor (that's me) has asked you to photograph someone you admire. Ask if he or she would be open to a simple photo shoot and a chance to talk. Set up a time and place to meet. Keep the exchange natural and low key.

STEP 3 PRESHOOT PLANNING

Before the photo shoot do your research and try to learn as much as you can about the person you have picked. Find out more about who she is and what she does. Take some time to read and watch all that you can find. As you do your research, compile a list of 10 to 15 questions that you would like to ask. Here are a few sample questions to give you some ideas:

- How would you describe your life philosophy?
- How do you define success?

LEARNING OBJECTIVES

- Use the camera as an active device to grow and develop.
- Discover the importance of photographing those we admire.
- Fine-tune your photo shoot conversational skills.

> TIPS

If you find it difficult to make portraits and interview the subject at the same time, break it up. Start off with the interview and then create the photographs.

It is easy to be intimidated or shy around someone you deeply admire. That's OK. Take a deep breath and rely on the questions in your notebook.

When you spend time with someone who inspires, you want to linger for more time. Resist that urge, respect their time, and keep the shoot short.

Make pictures that are meaningful to you and there is a greater chance they will mean something to others.

EXERCISE DETAILS

Goal: 10 portraits. **Tools:** Camera; normal or telephoto focal-length lens. **Light:** Natural or available light. **Location:** An environment that is conducive to conversation. **Theme:** Photographing those you admire. **Duration:** 30 minutes.

OPPOSITE What started as a one-year project has now grown into a three-year one. I have been focusing on photographing seasoned and wise men who have lived with intention, pursued grand goals, and done so with integrity and force. This is the most recent photograph from that project. As I write, it was captured just two weeks ago and it is one of the most significant photographs of my life. Pictured here is Anton Hoffmann, who nearly 20 years ago made a huge and lasting impact on my life. As a mentor, spiritual leader, and friend he has given me the resolve to keep up the good fight and to continually pursue the light.

Wood large format 4 x 5, 90mm lens, f/5.6, Polaroid Type 55 Film

- What is most important to you in your life?
- What lessons have you learned throughout your life?
- What advice do you have for someone just starting out?

STEP 4 THE SHOOT

Arrive at the shoot location early with one camera, one lens, a notebook, and a pencil. Keeping your supplies simple will help you focus more on interviewing and learning from your subject. Greet the subject and begin right away finding a good location to shoot. Along the way, with notebook in hand, ask the subject some of your questions. If something she says strikes a chord, ask permission to write it down. Not only will this help you remember her responses, it will show your interest and intent.

As you are asking questions, take pictures in between. Look for the pauses in between speech and try to capture what you can. Eventually, slow down the dialogue and make a few strong portraits. Continue talking and eventually wrap up the shoot. Don't drag it on, but end on time. The total shoot time will be 30 minutes.

STEP 5 PHOTO SHOOT FOLLOW-UP

Write a hand-written thank-you note reflecting back on a few of the things that you learned. Include at least one custom fine art print from the shoot as a gift to your subject. ⠿

One-Year Project 〉 Further Inspiration

Photography is a trade, passion, and hobby full of peaks and troughs. Over the last decade, I've crossed paths with many of my former photography students who have been through it all. While many of them make it, some of them don't. The ones who don't make it tend to share a common thread. I have heard them say, "You know it's interesting, after photo school no one tells you what to do." It's as if they never made the transition to making the practice of photography something they do for themselves and on their own.

In order to make sure this doesn't happen to you, come up with a personal project that you would like to complete. Perhaps you want to continue photographing people you admire? Choose something that reflects your passions and is personal—the more personal the better. Don't be concerned with what others will think; choose the project because it is what you desire. Whatever you select, define it and commit to completing a specific amount of photographs within a one-year timeline.

"Nobody can go back and start a new beginning, but anyone can start today and make a new ending."
—Maria Robinson

Conclusion

Congratulations on making it through all or most of the exercises in this book.

Now that you are here, I want to share with you my ultimate goal. Henry David Thoreau wrote, "A truly good book teaches me better than to read it. I must begin living on its hint." The end of this book is really just the beginning. And I'm not referring to incorporating the tips, exercises, or creative ideas in your daily photographic life. That is a good start, but my hope is much more grand.

I hope that this book serves as a backdrop for you to begin writing your own story, creating your own images, developing your own exercises, and sharing all of that with others. You have something valuable to say. And I, along with others, would love to hear and see what you makes you tick, what catches your eye, and how you capture that within a frame. Make sure to stop by the book's Flickr group and share your ideas and some of your results from the exercises with other readers at flickr.com/groups/30peoplepictures. Or post the photographs on your portfolio, blog, or preferred social media site and then send out a link.

So now, let the dialogue begin! I look forward to hearing from you and to crossing paths once again. Finally, I consider it a huge honor to have partnered with you in this journey as we explore how to create more compelling photographs.

Peace,

Photographer Rodney Smith in his New York studio glancing down at the first page of his most recent book.

Canon 5DMii, 35mm lens, f/4

INDEX